ROWLANDSON'S HUMAN COMEDY

A BIOGRAPHY OF THE REGENCY ARTIST

STEPHEN WADE

AMBERLEY

First published 2011

Amberley Publishing
The Hill, Stroud
Gloucestershire GL5 4 ER

www.amberley-books.com

Copyright © Stephen Wade 2011

British Library Cataloguing in Publication Data.
A catalogue record for this book is available from the British Library.

ISBN 978-1-84868-233-7

Typeset in 10pt on 12pt Sabon.
Typesetting and Origination by Amberley Publishing.
Printed in the UK.

Contents

Acknowledgements

Undertaking a work such as this has required help from many quarters. The developments in terms of new material on Rowlandson's life since the first real biography by Bernard Falk in 1949 have been few, and the work done has been still mainly critical appraisal. Yet I have needed assistance from both quarters: biography and criticism, since I write as a crime and social historian who has perceived in Rowlandson a rare and still only partly understood genius. His works are scattered across the globe, in collections ranging from those of royalty to provincial museums; his contemporaries were not often forthcoming about him, and anecdotes are not exactly free-flowing.

For all these reasons, I have to thank in particular Jackie Logan at York Art Gallery, Katherine Wodehouse at the Ashmolean Museum in Oxford, Matthew Bailey at the National Portrait Gallery and Emyr Evans at the national Library of Wales. Discussions with Vicki Schofield have also been very helpful, and with Andy Wade.

In terms of work in print, inspiration has come from Vic Gatrell, whose monumental work, *City of Laughter*, directed thought to exactly where Rowlandson's achievement may be most clearly seen and understood. Also, writings by John Hayes, Amanda Vickery and Peter Ackroyd have been essential in the preparation to gather thoughts on this incredibly talented artist in his time and place. I could have called the book 'Rowlandson of London' but that would have both reduced the subject too much and equally diminished the sense of the scope of his work.

Most of the influences on my approach are writers and critics scattered across many journals and periodicals, but their names are in the text when their work is mentioned, of course. The Regency in general has attracted much attention from scholars and historians lately, and the spin-off interests in social history coming from the continued interest in the life and work of Jane Austen have meant that other artists and writers of that age have been made more prominent in all kinds of contexts. The specialists in those areas of research have helped me to see the network of professionals in the arts in Rowlandson's world.

Picture credits are in the plate section. Regarding the selection and use of illustrations, I have had to use only a small selection of images from the huge canon of works, but these should represent the range of the art, across genres and methods in the craft. Anything less than that would have kept the man to the simplistic label of 'satirist' and that would have been an intolerable distortion.

List of Illustrations

Introduction:
The Enigmatic Man

Beginnings and Questions

The drawing compels attention: a young woman having a noose secured around her neck as she listens to a podgy clergyman holding a prayer book; a repulsive hangman grasps the knot of rope on her neck. His expression is a foul leer, a facial expression conveying a perverted delight in seeing the girl 'stretched.' Her coffin stands behind her. Beneath we have the words, 'Mary Evans, hung at York Aug. 10th 1799 for poisoning her husband...' The signature below the coffin is simply 'Rowlandson.' The image is harsh, explicit, and relates to all that body of hanging literature that made men rich on the streets when they sold chapbooks and broadsides about the gory deaths and noisy repentances on the scaffold.

What kind of imagination could conceive of such a thing? Was it a twisted and vicarious vision of pain, by a mind sick with the sexual kick such an image might give a perverted mind? Why imagine such a despicable thing? I was amazed when the artist turned out to be someone who, while showing a profound interest in all aspects of the criminal justice system of his time, was quite clearly not a horrendous deviant, and was in fact a man who saw and represented the worst aspects of 'man's inhumanity to man' that he saw around him. After all, as I discovered, he would have been a man who, until Tyburn was no longer for executions in 1800, would have seen the cart with the condemned person rolling along the streets of London outside his home. A quick glance at a biographical summary told me that the artist was a Londoner, and that he would have known the city very well. This raised the question of whether he knew York. Not only did I speculate that he imagined the hanging, but he may have imagined York. The city was well known for York Castle of course. John Palmer, alias Dick Turpin, had been hanged at York in 1739. No doubt Rowlandson, as a boy, had heard mention of the villain's name and read about him in the street ballads and chap books of the time.

This was not my first encounter with the remarkable artist. I am a crime historian and his work is to be found everywhere in studies of social history. But this work arrested the attention. I had to know more, and when I researched my book, *Hanged at York*, in 2008, I naturally tried to follow up the narrative in that image. But the problem was that there was no such hanging, and nor was there a Mary Evans hanged at York. The information below the drawing is so precise, a date given and a name, with an offence. Yet it was all a fabrication, a flash of grim imaginative depiction, naturally of a scene that would often be seen at York at that time, but certainly not a document of fact. That made the image all the more fascinating – that it was not apparently fact, but imaginative projection, done

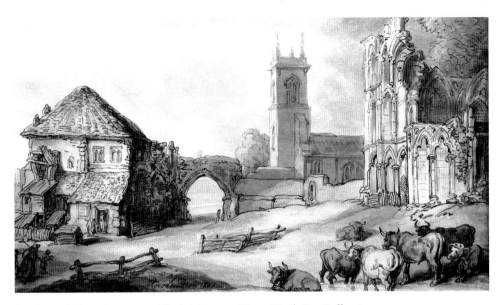

St Mary's Abbey, Courtesy of York Museums Trust (*York Art Gallery*).

with what aim? To shock, the wallow in various pleasure? It had to be made by someone who felt a need to express the horror within the surface simplicity: what was just another job for the hangman was a significant event for the artist and for his need to betray his society for what it was – callous, inhumane and stained with corruption and violence.

Strangely, that anomaly did not deter me at all: in fact it heightened my interest in the man who drew it. The artist had to be a man who wanted to point out a gross cruelty, the very essence of man's inhumanity to man. In fact, just ten years before the date given on the drawing, a wife who poisoned her husband would not have been hanged – she would have been burned at the stake, because her crime would have been petty treason, not murder. In other words, the society in which Thomas Rowlandson lived was barbarous and heartless to its transgressors. Yet it was also a society in which 'manners' were highly valued and its literature suggests the genteel world of Jane Austen and the 'men of feeling' in the novels of the 1790s, following Henry Mackenzie's best-seller of that title. Rowlandson, as a man desiring to show the world its own heartless self, was an intriguing figure. Suddenly, all the images of dangerous travel, accidents in the street, fat men and women filling up with ale, grotesque couplings and bloated bodies, fell into place. They were parts of a steady, unified vision, of a world brimming with human dynamism, sometimes killing its own and sometimes celebrating life and its giddy sensuality.

Surely there was a biography of this man? That was my question to myself as these thoughts grew. One would expect such a creative soul to be steeped in the life around him, to be known by many, and to be the subject of a thousand memoirs and anecdotes. But no, he was a shadowy figure. The fact is that Rowlandson was always too busy to do what Joseph Conrad advised, to immerse oneself in the 'destructive element' of life with all its pains and struggles, joys and horrors. I then found out that he had squandered an immense fortune at the gaming tables. He was very much a man of his time: a Regency rake without the dandy, and a passionate man without the commitment.

In short, he was an enigma. I had to try to write his life. Explaining his art is quite another matter, but the story of the enigmatic man needs to be retold. It has been exactly sixty years since Bernard Falk attempted to put together the puzzling tessellated pavement of this secretive, marginalised man's life. He did a wonderful job, challenging the written statements and searching for the truth. Even his obituary in *The Gentleman's Magazine* was full of errors, almost as if someone was delighting in creating a false trail to the man's real self. Falk wrote in his preface, 'In the absence of more convincing material, the authors of ... critical appraisals of his work have been compelled to preface their remarks with the gist of the circumstantial and connected account ... Unfortunately that memoir was weakened by so many glaring omissions as to be wholly inadequate to its assigned purpose.'[1]

Sometimes in biography the challenge is to piece together a thousand elements which one feels will surely, eventually, make a composite and complete picture. Conversely, the task may be to simply expand on what is already there and embellish or add what is more latterly available. This book is a mix of both, but primarily, I knew from the start, the aim was to make the man and his work more widely known, and not in a fragmented form. That is, Rowlandson's name has been in a myriad places in print; the internet shows very quickly just what a huge scale of purchases have been made as modern collections have been assembled. I have around forty books on my history shelves which use Rowlandson illustrations. Nevertheless, it is now the time to integrate all the knowledge we have and all the applications of his name and work as he has been mediated through different periods.

As with all artists, there have been changing perceptions through time as different periods have seen changing material in his work. In 1902 for instance, Ralph Nevill, writing in *The Connoisseur*, wrote: 'French influence, indeed, is occasionally very apparent in his work, and at the present day he is far more highly appreciated across the Channel than in the country which gave him birth.'[2]

*

At the heart of Rowlandson's art is a massive creative energy that always confronted and then accessed the morals, behaviour and sheer élan of the life around him. His work has attracted such interest in other areas of history simply because he was curious about everything and he lived in London, which at that time – the late eighteenth and early nineteenth centuries – was arguably the most exhilarating and modern city in the world. His focus on London provides my second preface to this book. The reason is that he is hidden away today, as so many artists of the past are; but once again, my quest for his life began with a coincidence. I was staying at the Charing Cross Hotel, and on my first day of this particular visit, I came across a book which summarised the lives of all those people who were commemorated in the city with blue plaques. At the time I had no idea where Rowlandson lived at any specific time in his life. I looked in the book, checked the map for his house with the plaque, and discovered that it was in a street visible from the corridor next to my room in the hotel. This was in John Street, clearly marked on a London map of 1843, where the words were: 'Thomas Rowlandson, artist and caricaturist, lived in a house on this site.'

My first impressions expanded into speculations as to who this character could be, what mark he made in his art, and where he came from. The basic dictionary accounts did little to answer any important question in this respect. None of the brief accounts

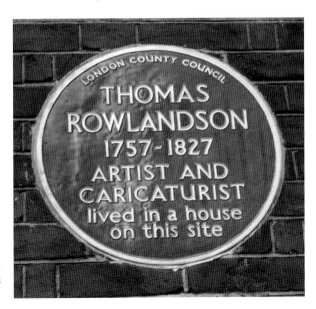

The blue plaque, now at John Street, behind the Charing Cross Hotel (*Author*)

of him appeared to offer anything that might explain how such an imagination might thrive there and then.

The first obituary of Rowlandson, as will be further explained in the next chapter, initiated a series of misapprehensions and false information that only emphasises, even further, the aesthetic distance of the Regency art from our own times. In December 2009, *The Times* ran a piece concerning the discovery of some Gillray cartoons. Gillray, a contemporary of Rowlandson and like him, a caricaturist, had a large and varied output, some of his material being impounded by the Victorian police. Jack Malvern in the article, notes that, 'The cartoons were considered bawdy fun when they were first published individually in the late 18th century, but by the 1840s, when they were printed as a collection, they were sufficiently outrageous for the publisher to withhold the name from the title page.' What had the offending images to offer? Malvern describes: 'On one page Napoleon peeks through a set of curtains to spy on cavorting nudes. On another the Duke of York is in carnal embrace with his diminutive wife. A third depicts George III defecating into a hat.'[3] What strikes the reader here is how 'bawdy fun' became serious deviance by the year 1840.

What this tells us is that the satirical art that Rowlandson was immersed in, in the Regency and in the last decade of the eighteenth century, was a flowering of a very special kind of creativity: libidinous, whimsical, free from moral structures in the way that D. H. Lawrence would have admired. Sexual play was an integral part of a larger, unrestrained world of sensual and physical exuberance. He was part of a culture of massive contradictions: the underclass and the poorer working class were subject to savage punitive criminal laws, with over 200 capital crimes on the statute books, and until 1829 there was no professional police force; yet, there were certain liberties, moral and imaginative, that opened up the social world to liberal fun and carnival. If we consider Rowlandson's best period, when he was most involved in satire and social commentary with England at war with France and coping with sedition and revolt in the new industries, we can see that his work thrived on the oppositions straining in a culture teeming with vitality as well as violence.

An enquiry into Rowlandson's life must therefore incorporate this context. Warren Hodge has shown how the grounding, the foundation for the art and the context described above, were also inherent in Hogarth's work, the artist whom none of the Regency painters and draughtsmen could ignore: 'Hogarth's subjects ... were animated, mortal, common and alight with malice. While powdered young English lords on the Grand Tour gazed adoringly on classical antiquities in Italy, Hogarth stayed at home and memorialized politicians, merchants, thieves, prostitutes and men on the make.'[4] The paradoxes and anomalies in Hogarth's world show the kernel of Rowlandson's drawings and satires: it is as if the Regency artist saw that Hogarth's depiction of the sickness of the soul on the mean streets of London needed not merely dissection on paper but an art that stretched on tiptoe, showed the exaggerated forms of that sickness in shapes much larger than life.

His work has also long been recognised by historians as something offering unique insights into this vibrant life. For instance, Donald A. Low, writing in 1982, concisely explains this value: 'Thanks largely ... to the irreverent genius of Rowlandson, the life of another, much less respectable London kept breaking in. Billingsgate Market, for instance, became something more than a topographically exact representation of the riverside trading area where fish were bought and sold. As handled by Rowlandson, it is a scene of anarchic energy...'[5]

In our assessments of Rowlandson, we also have to be aware that he was at one level, a typical product of the draughtsmen and all-rounders in the production of art of his generation. He may be little known, but compared with Richard Newton, for instance, who was also very productive and worked in London, he is more current in discourses of that period today. Newton produced over 300 prints; he worked in the early years of the nineteenth century for the same print seller, William Holland, as Rowlandson, Wigstead, Gillray and Isaac Cruikshank. He has been claimed as the pioneer of today's comic-strip, and certainly he was talented; he had no formal training as an artist but, as Mark Bryant claimed in an article introducing Newton, 'He showed a prodigious talent for drawing.'[6] As will be seen later in the present work, Holland was sent to Newgate prison for producing political pamphlets which were thought of as seditious; consequently, Newton himself opened a print shop. Had he not died of TB in 1798, he may well have been a talent to rival Rowlandson and others.

This makes it clear that Rowlandson's creative milieu had many special features – unique in terms of the aesthetics of the time – and because of Rowlandson's tendency to be shadowed and marginal, the questions arise from this milieu with increasing rapidity and force as we try to dredge out the facts of his life.

Reading Bernard Falk's biography, it may be seen just how much detective work was needed in order to elucidate the artist's life; there was so much falsification, and Falk had to use all his logic and common sense, with considerable historical knowledge and information on London in the Regency, making his efforts impressive and extremely challenging. But thanks to his work, there is a point of new departure established.

My aims are therefore to tell the story of Thomas Rowlandson's life, enlarging a little on Falk's work, and to bring to bear on that narrative the later scholarship done by art historians, particularly since the 1970s. I take my cue from the argument of Vic Gatrell's book, *City of Laughter*: that Rowlandson's world was one in which joy,

delight and sheer anarchic fun have their own perspective to give us on a given period in time. Backing me up in this is the Regency farceur and wit *par excellence*, Charles Lamb, a man who knew the extremes of a person suffering (his sister, insane, murdered their mother). Lamb's *Essays of Elia*, published in *The London Magazine* between 1820 and 1823, exemplify this spirit of laughter most perfectly. In fact, as I will argue later, there is a great affinity between this and Gatrell's thesis of fun and chortling, and the modern philosophy of the Absurd.

Lamb has an essay called 'The Comedy of the Last Century', in which he writes of an actor named Munden, and there he writes:

> So the gusto of Munden antiquates and ennobles what it touches. His pots and his ladles are as grand and primal as the seething-pots and hooks seen in old prophetic vision. A tub of butter, contemplated by him, amounts to a Platonic idea. He stands wondering, amid the commonplace materials of life, like primeval man with the sun and stars about him.[7]

That explains Rowlandson very neatly indeed, and also defines my present springboard into the life of this most remarkable, vital, curious artist, deep in life as a booted fisherman, out to expect anything on an average day.

It has to be said that an 'average day' in the London of *c*. 1800 was hard to find. Most were extraordinary. A glance at the press, for instance, for the year 1807 provides an exciting account of a 'Fox chase' at Blackness, full of verve and incident; a report on 'a ludicrous performance' by Madame Catalani who 'attempted' to sing God Save the King'; a parade of 'fashionables' at Sloane Place, and most indicative of the mores of the time, was this advertisement in *The Morning Chronicle* for 30 April:

> 'Patronage – Wanted, by a Gentleman of high honour and character, a respectable official situation, in England (either a sinecure, which does not require constant attendance) for which an adequate compensation will be given, according to the annual produce. The most satisfactory reference will be given and required, previous to any treaty being entered into...'[8]

What is most remarkable in this, with Rowlandson's subjects in mind, is the sheer 'front' of it. Society was packed with people on the make, veering from solvency to debt and respectability to destitution in hours; the Fleet prison was always one mistake away for many artists, and Rowlandson was absolutely typical of that: he squandered two fortunes at the gaming table.

Sometimes the satire, ridicule and harsh social commentary could go too far. In a print called 'Filial Piety' Rowlandson depicts the Prince of Wales walking with two drunks towards the bedroom where the King was ill, and the Prince says, 'Damme, come along. I'll see if the old fellow's ... or not!' The subjects of his art would ordinarily be open to a treatment of raciness and irony, but at times he followed Gillray into the overtly political.

Every subject of a biography has an elusive element, but Thomas Rowlandson has more than most, as if he hid from posterity as he hid from creditors at times. I hope this book goes somewhere near to the man as the world knew him.

Reputation and Appraisals

As with most artists, Rowlandson's reputation, in terms of assessments of his achievements, has suffered ups and downs. That pattern applies even to the greats of course, but with Rowlandson, this has been complicated by the erroneous inclusion of a supposed long stay in France in his formative years, and thus a French influence. The research done by Falk, discussed in the next chapter, concerning that French influence and experience, makes a convincing case for the fact that he was in France only a matter of weeks. Yet, writings on him persist in including this aspect of his art in assessments.

That issue aside, how has his reputation fared? The obituary in *The Gentleman's Magazine* immediately after his death in 1827, states, 'It is not generally known that, however coarse and slight may be the generality of his humorous and political etchings, many of which were the careless effusions of a few hours, his early works were wrought with care; and his studies from the human figure at the Royal Academy were scarcely inferior to those of the justly admired Mortimer.' [John Hamilton Mortimer, *d.* 1779][9]

There has been a middle ground of criticism, though. This often rates his work as being marred by too much haste, as he was extremely prolific. Every critic argues for a different special talent in the man, however, and many are very precise in this, as is the case with Ralph Nevill when he says, 'Rowlandson ... is seen at his best in his drawings of women. Almost invariably graceful and elegant, their smiling faces breathe a spirit of fun and good nature which is captivating in the extreme...'[10] Writers have tended to focus on specific subjects within the Rowlandson oeuvre and find one outstanding virtue there, isolating simply to show a minor talent.

If we search for comprehensive and judgemental statements, there tends to be a view that he was a refined humorist, and when compared to Gillray and others, an artist who could have done more and better, as in the verdict in one of the standard biographical dictionaries: '... even among the exaggerated caricature of his later time we find hints that this master of the humorous spirit might have attained to the beautiful had he so willed.'[11]

More common is the tendency to use Rowlandson in contextual ways; he is the artist of occasion and social context *in extremis*: because he was inextricably bound up with the morality and amorality of his time, his representations are certain to be appropriated for other purposes, and so his genuine nature and ability has perhaps been eclipsed by these parallel purposes. It is in the nature of art to be appropriated of course, but Rowlandson, as with most very prolific generators of purposeful art, socially committed in its vision, the social uses of the products will be multiple and will change and expand as time goes on.

More recent assessments have given us Rowlandson the chronicler, the innovative caricaturist, the exploiter of the picturesque genre themes, and the watercolourist who should have done better. He has to be assessed in the various media in which he practised, of course: drawing, designs for publication, book illustrator and watercolour portraits. As a student, he was awarded the silver medal of the academy for a bas-relief figure.

As is often said these days, the jury is still out on Rowlandson's achievement, but the consensus seems to be that, as Richard Godfrey wrote, 'Rowlandson's watercolour drawings are the most attractive aspect of his work, and the innumerable prints that he etched himself or that were etched after his design are of secondary interest.'[12] John Hayes in his book

on Rowlandson, offers the most exact summary, noting that it was the Dr Syntax books, done with William Combe that made Rowlandson successful and well known during his lifetime. But Hayes, writing in 1972, pointed out that 'Forty years after his death he was unknown. A Birmingham collector, William Bates, wrote in 1869 that "even among the artists and professed picture men, few in London, none out, have ever heard his name..."'[13] The distortions go on and even as recently as 2007 a note appended to a Rowlandson exhibition stated the old myth about France again:' he spent two years in Paris.'[14]

Often, a reputation is expressed most reductively in books which try to survey a span of time on a wide array of artists. In this retrospective, Rowlandson has been seen as limited or marred, but there is almost always a singularity expressed, as in William Vaughan's verdict: 'He too was inspired by the freedom of Mortimer's line ... There is certainly a rococo feel too much of his work. It has a rotundity to it that contrasts with the urgent angularity of Gillray...'[15]

It is surely significant that, fifty years after his death, people would not know his name until the words, 'Dr Syntax' were spoken, and then they would know. In other words, without William Combe, the writer, the artist's name would have been known at that time only to print collectors and art historians.

Rowlandson has suffered from being compartmentalised; for a century and a half he had been largely placed in the realms of comic depiction and satire, the man who was obsessed with the England of John Bull and the regency social upheaval. Of course, he was this, but he was so much more, and we are just beginning to see what else he was, as new volumes come along with more contextual accounts of his trade, business contacts and commissions.

There has been a tendency to challenge the standard views when writers have been given the task of writing on him in reference works. David Rogers, for instance, helpfully notes, 'Although he is commonly thought of as a satirist, most of his drawings are gently humorous, and in some cases, objective records of rural life.'[16] This kind of comment is valuable, though at times the need to compress has led to distortions and he has suffered from a reductive attitude from art historians.

Portraits of the Artist

What did he look like? Do we have any clues to character from the images? These questions are particularly important in the cases of writers and artists who have never directly mediated themselves, never projected a profile of the self into the public domain. Rowlandson, as almost every commentator on his life has noted, remained marginal, shadowy. But there are several portraits of him in existence: one by John Jackson, dated 1815; one by John Raphael Smith, of a younger Rowlandson, dated around 1795; Jack Bannister provided a profile of his friend from around the same time as the work done by Smith; the image done by George Harlow from 1814 gives us the animated man, and finally the artist in old age was captured by John Thomas Smith in 1824, the subject concentrating over a page, spectacles lodged firmly on his hook nose.

Putting these together and trying to express a response is quite a challenge: all that may be said for sure is that the pictures all suggest animation, strength of personality and

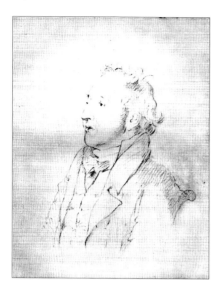

Portrait of Thomas Rowlandson by George Henry Harlow, Courtesy of the National Portrait Gallery.

a certain air of assurance. The approachable man is there, and the character who enjoyed lively talk. In the drawing by Harlow he sits with a sheet before him, as if commenting on the work done. It is ironical that we have so many images of him and yet there are so few documentary texts from his hand or reports of him by others in any depth.

He also produced a number of depictions of himself and these present some tantalising insights and speculations. Many of these are of him with friends such as the picture of the two friends breakfasting, done in 1784 (pen and watercolour over pencil) and here 'Rolly' pours the tea while Wigstead, with his slouch and incipient paunch, relaxes and makes some comment. Several drawings of the two men on the journey to Spithead give hints about Rowlandson. They stayed in Salisbury for instance, and *A Monument in Salisbury Cathedral* shows Rolly and Wigstead listening to a man who is apparently in the role of local guide. Add to this the comedy of *Buying Leather Breeches – Previous to Our Journey* in which retailers struggle to fit the clothing, and we have all the fun of a young man's jaunt – the self-deprecating humour, the shared experience of the bizarre and the uncomfortable elements in the journey.

Joseph Grego, writing in 1880, offers one of the most vivid accounts of Rowlandson's appearance:

> His figure, we hear, was large, well set up, muscular, and above the average height in fact; his person was a noticeable one; his features were regular and defined, his eye remarkably full and fearless, his glance being described as Penetrating and suggestive of command; his mouth and chin expressed firmness.[17]

Grego recalls that he met and spoke with George Cruikshank, a man who had met Rowlandson earlier in his life, and he says that Cruikshank was happy to talk and give his opinions. Grego, although his writing is infused with Victorian purple prose, was more than likely expressing the truth here. Rowlandson was surely robust and hardy: he lived a long and active life, his work no doubt contributing to his durability.

I

The Family Story

The whitewashed wall, the nicely sanded floor,
The varnished clock that clicked behind the door
The chest contrived a double debt to pay...

Oliver Goldsmith *The Deserted Village*

An account of Rowlandson's life has to begin with the desperate and sad note that in the one full obituary notice of his death in 1827, the anonymous author produced something that is erratic, often wrong and most likely very hurried. There may have been a copy deadline; the writer may have been too keen to have his friend's demise marked in this important publication before his memory went cold. After all, he had been in the back room, toiling away, out of sight, for a long time, and his death must have prompted his friends to act.

Drawings of him show a man working or at least looking involved and preoccupied. There he is in all representations: hook-nosed, fixed on inner thoughts perhaps, or uttering a concise and witty opinion. In the few letters we have, notably in the letter to 'Friend Heath' about money worries, there is evidence of a man with a sharp and incisive turn of phrase; we can imagine him in company as a listener rather than a combatant in debate, but perhaps the kind of man who interposed with a memorable statement. His imagery was strong. In that letter he says, '... we shall verify the old proverb of short reckonings make long friends.' He also notes that he has 'little sway' with 'the long pursed gentry.'

That personality is absent from the first biographical sketch, but we have to begin his story with that account, probably written by one of his two or three very close friends; it is also necessary to summarise the faults and errors there, as Bernard Falk did so methodically in 1949. The readers of *The Gentleman's Magazine* in 1827 were given an impression of an artist who had wasted massive sums of money and who had moved from libertine to dedicated labourer in graphic art with dizzy regularity over the years. But what the writer does get right is the basic facts of the early life.

Rowlandson's family were Huguenot in origin, and the family story begins in the East End, centred in Spitalfields; his surname comes from the Dutch *Roelantsoen*. His immediate forebears settled in the East End in the first years of the eighteenth century, and we know that in 1734 a trader called Rowlandson was involved in a legal action in the process of a bankruptcy case. In the late seventeenth century, it has been estimated that more than 45,000 Huguenots came to Britain, settling in London in Spitalfields and in Soho, and across several other areas, including Norwich and Southampton.

The Huguenots stimulated trade in all kinds of goods, including sailcloth, hats, soap and paper. They came with technical skills that were very rare in the native British population; many of them were already wealthy and experienced entrepreneurs, and in economic terms, their presence meant that there was an increase in the numbers of the labouring class earning wages in the city. In the years before the Industrial revolution, it is fair to say, that expansion was restricted by the limits of skilled labour available and the Huguenot immigrants played an important part in increasing the skilled element in the working population.

Thomas would have known his grandmother well, because Jane Rowlandson was still alive in 1783. Falk notes that it was likely from Jane that Rowlandson took his sturdy, resilient nature. She had a daughter, Alice, who remained single, James and William – Thomas's father. The family off-shoots remain blurred in the overall picture.

William Rowlandson was a dealer in wool and silk, and he and his brother James lived close to each other in Tower Hamlets; James was in the Old Artillery Ground area, and he was in the silk weaving trade, his looms being near Artillery Lane, very close to the centre of the silk production centre. The area was a French neighbourhood, and was formerly known as Hogge lane, and earlier Bereward's lane. After the revocation of the Edict of Nantes in 1685, the Calvinistic Protestant Huguenots were open to persecution and state protection was lost. Many applied for naturalisation, came to England, and adapted their surnames to English forms. The Edict had been in place since 1598 so it was a massive social change, a sudden revolution in fact, creating a thriving new industry in London as a result.

The Old Artillery Ground area was one of the liberties of the Tower of London, and was Crown Land; it had in the past been the outer precinct of the priory and Hospital of St Mary Spital, and it was made into an artillery ground in 1538, to be used by the Fraternity or Guild of Artillery of Longbows, Crossbows and Handguns. This association was referred to as the Fraternity of St George, and later on as the Honourable Artillery Company. Close to the Tower, there were clearly links with the gunners there. The Company moved to Bunhill Fields in 1658.

By the late 1750s the Rowlandson brothers were doing well; the more sophisticated versions of silk at the more refined end of the spectrum had been introduced – materials such as satin and English taffetas – and Spitalfields was by that time a tightly populated mass of streets with French culture and language all around them. They were still close to the countryside, of course, as London at the time was close to open fields. The fact that Spitalfields became the silk production centre was not a matter of chance though: local weavers and tradesmen were well organised, and in Basinghall Street there was the central base of the Weavers Company.

James married a French woman: Jane Chevalier, a descendant of some of the very first Huguenots to arrive in England. Falk makes her domesticity a major attraction, noting that 'As the womenfolk of these Huguenot descendants were thoroughly domesticated, we are safe in concluding that on the score of comfort James had little to complain of.'[18] Falk then explains that oxtail soup was introduced by the Huguenots, a fact signposting their homely tastes and culture. Jane was wrongly written into the 1827 obituary as 'a mademoiselle Chattelier' – one of several pieces of misinformation in that text.

Aunt Jane was very fond of her nephew Thomas and, as will become clear, he owed most of the springboard of his career to her; it seems likely that Thomas was in the

habit of referring to his rich French aunt, and by anecdote and oral tradition, the falsifications of the 1827 obituary emerged. She had been confused with her sister, Elizabeth Chastellier, in that tribute. Aunt Jane and Thomas must have hit it off well from the start; there was a very special friendship there, and reading between the lines, we can see that they must have shared humour, fun and an ironic take on life.

Around the time of Thomas's birth, the Rowlandson family consisted of Jane's sons James and William, both married, Alice their sister, and another sister who had married Thomas Gaudy. We can extend this to Jane's sister, married to Chastellier.

James did very well indeed in business, whereas William began to fail. Although he had, paradoxically, been so esteemed that he had been appointed as an assignee of a bankrupt in Old Swan Lane, he too was to become a bankrupt. The family moved to Old Jewry, near Poultry, a good address, though further away from the family in the midst of the silk industry further east. When Thomas was born is debatable. In the register of students at the Royal Academy, which he entered on 6 November, 1772, it's stated that he turned fifteen on 14 July that year. There have been contradictory details in various sources which offer other dates, notably the burial register at St Paul's Covent Garden, where he was interred: that source gives his age at death as 72. Once again, there may have been unreliable anecdotal sources at work. But in a portrait of the artist by Harlow, there is an inscription: 'Tho. Rowlandson, Aged 58, 1814.' This appears to say that the obituary date was correct: 'July, 1756'

Today Old Jewry nestles between high and impressive business addresses, huddled in the centre of the new developments around Poultry and Wood Street, a few hundred yards from the Bank of England. A generation after Rowlandson's birth it was destined to be the first headquarters of the new City of London Police. Also at that address was born his sister, Elizabeth, who extended to artistic culture wrapped around the family by marrying the painter Samuel Howitt. The visitor has to look very hard and use the far reaches of the imagination to see the street as it was when young Thomas was born there.

William Rowlandson stepped deeper into trouble in the years following Thomas's birth; the obituarist has this summing-up of Rowlandson pere: 'The elder Rowlandson, who was of a speculative disposition, lost considerable sums experimenting upon various branches of manufactures, which were tried on too large a scale for his means; hence his affairs became embarrassed…'[19] He sank into serious disaster and on 16 January 1759, he was officially a bankrupt. The press always had the habit at that time of providing lists of bankrupts, to ensure that the business community were well informed, so *The Gentleman's Magazine* had: 'BANKRUPTS: Wm. Rowlandson of the Old Jewry, chapman.' The word 'chapman' is interesting because the word originally meant a pedlar, then later it was a term used of a general trader – someone who would turn their hand to any enterprise. That in itself says a great deal about the Regency period: the risky, entrepreneurial venture was a daily event in that time of shiftless and ephemeral status. There is more though: because he was a 'chapman' he was a privileged debtor. It gave him a long-term possibility of redemption back into life. Bankruptcy then meant a spell in prison, out of the commerce of life. Legally, they were not criminals, and in London there were prisons specifically meant to house debtors – the King's Bench, the Whitecross Street, the Fleet and the Marshalsea. Debtors were imprisoned until the year 1861.

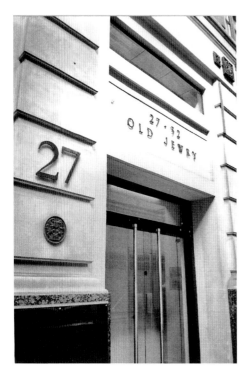

Old Jewry, the street where Rowlandson was born (*Author*).

Debt was a common part of life, as it is now. In a cartoon by Henry Heath, of 1830, he shows a debtor being served with a writ, with the caption 'Too civil by half' as the pursuer almost faints with fatigue in pursuit of his prey. *The Gentleman's Magazine* in 1750 estimated that there were 20,000 debtors in jail. Usually, the imprisonment was just short term, but treatment could be cruel. Just thirty years before William was in jail, a committee of MP's looked at conditions for debtors, and found that there was 'barbarous and cruel treatment of debtor inmates in high violation and contempt of the laws of this kingdom.'[20]

It was a fate suffered by many in the arts. There was humiliation and disgrace of course; but we have a mass of information from artists and writers imprisoned for debt at that time, and into the early Victorian years, and so we understand what William had to suffer. Benjamin Haydon, painter and friend of John Keats, painted scenes he saw in the King's Bench, and he kept a diary in which he wrote that he, '... had to battle with creditors and get the next month as clear as possible to work.'

To William's advantage, however, was the fact that his brother was appointed an assignee, along with a merchant called Thomas Myles. The case was dealt with at the Bankruptcy Court at the Guildhall, just around the corner from the Rowlandson home. In keeping with the mystery and providential privacy of the Rowlandsons, the papers relating to this case were lost in later floods. But the Rowlandsons did apply for help to other quarters, mainly to the Lord Keeper, for charity. This was Sir Robert Henley, who had only just been placed in office, in 1757. The Lord Keeper was later to be the office of Lord Chancellor, and one of the responsibilities at that time was to make decisions in what are called 'pleas of conscience.'

In other words, William had been assisted by an aspect of the laws relating to insolvent debtors; this can be understood with reference to a discussion in parliament in 1815 regarding a new Insolvent Debtors Bill. Sir Samuel Romilly, the great humanitarian campaigner, spoke, and this was reported in Hansard:

> It was hostile to all the soundest principles of legislation, to compel a man to make a declaration on oath, and then, if that declaration was not true in every respect, to punish him as a felon. He was aware that in the bankrupt laws such a practice prevailed; but it dod not therefore, follow that it was wise to adopt that practice with all debtors. It was torturing a man's conscience against himself...'[21]

William Rowlandson must have applied to the Court of Common Pleas for the Lord Keeper himself to be involved. Whatever happened, it certainly helped.

In addition, it was worked out, no doubt with the active help of brother James, that a dividend could be paid to the creditors by 30 April 1761. There was light at the end of the tunnel. There is no information on exactly when William was discharged, but it was probably around 1766. The only note of optimism for the family was that there would eventually be a proportion of the small dividend coming their way. The stipulation in the laws relating to debt was that a bankrupt who had assets of fifteen shillings in every pound could take 10 per cent. That had a ceiling of £300.

It was a really tough period in the Rowlandson family's life. James must have been their main support; what then emerges in the life of Thomas is that James and his wife Jane became the true supporters and benefactors of their young and talented nephew. When William died, they looked after Thomas and there is evidence of this when we note the registers of the French Church of the Artillery, (whose worshippers at the time were mostly weavers and sailors) during 1759 and 1761, when two births were announced: cousins of Thomas. He was immersed in the French Huguenot community by means of the tragic side of life rather than by design. Yet this was to be the making of him as an artist, backed by true affection as well as by money.

As a boy, Rowlandson, in keeping with the mythology of notable artists, was supposedly specially gifted. The 1827 Obituary states:

> At a very early period of his childhood, Rowlandson gave presage of his future talent; and he drew humorous characters of his master and many of his scholars before he was ten years old. The margins of his school books were covered with these his handy works.[22]

There does seem to be some truth in this: Falk says that 'It is borne out by the whole of the Rowlandson tradition, and what may be regarded as more substantial proof, it is corroborated by the obvious willingness of his sharp-witted aunt to encourage his artistic inclinations.'[23] More important and also probably more convincing is the fact that there were plenty of artists within the French community around him. The art and design of that community had been embroiled in vitality but also in open dissent. In the early eighteenth century there had been a fashion for wearing calico from India and the painted linen was the reason for trouble in the streets in 1719, when over 40,000 silk weavers walked the streets, attacking any women wearing the offensive cloth. The

Trained Bands, later painted by Rowlandson (and clearly from personal observation) were used to suppress this riot.

But this vitality has its talented artists within it too. At the centre of this creativity with patterns was Beaudoin. He was a refugee who benefited from the importation of secret designs brought to London by a man called Mongeorge. This led to the manufacture of lustrings and alamode silks. This very special art was established and regulated by the formation of the Royal Lustring Company which was chartered in 1698. James Rowlandson would have had to meet and cultivate the inheritors of Beaudouin's craft, and obviously young Thomas would watch and learn.

Spitalfields was also the home of Thomas Stothard, the painter (1755–1834), who was very much involved in the influence of drawn patterns for silk, having been apprenticed to that trade in Spital Square. Like Rowlandson, he later went on to other things, mainly the production of historical paintings, and also working on the staircase decorations at Burghley House. We today perhaps know the nature of the workshops of this community most clearly through William Hogarth's print in the Industry and Idleness series that shows the interior of a weaver's cottage in Spitalfields. This image, 'The Fellow 'Prentices at their Looms,' expresses a powerful message with all the power of the long and contentious history of apprentices behind it. The word itself always suggested social violence, unrest and carnival in the streets, embedded in the severe master and servant laws of the Elizabethan years. But here Hogarth contrast the drunken man with the hard-working and sober one, with the proverb beneath the positive image of 'The hand of the diligent maketh rich.' Francis Goodchild is clearly compared to Thomas Idle. It is surely not too fanciful to state that the inspiration here is from Spitalfields and the benign influence of religion fusing the work ethic with genuine sustenance and vigour.

James Rowlandson died of a fever in 1764 and he was buried in St Botolph's, Bishopsgate. Jane inherited all his wealth. The very pleasing situation for her, after such personal tragedy, was that she was secure. Many widows were of course bound for destitution at the time. It also meant a quandary for the Rowlandson tribe: what would she do? Would she marry again? Certainly Jane would have been a very good prospect for a man looking for a wealthy wife. She was only thirty-six.

Yet all was well. Jane decided to sell up and move. She went to Soho Square, the place where Dr Barvis ran a school, a man mentioned in the 1827 obituary: 'He was educated at the school of Dr Barvis ... and subsequently an academy of some celebrity. Richard Burke, son of Edmund Burke, MP was his schoolfellow. Mr Holman, the celebrated tragedian, was also educated there...'[24]

Thomas Rowlandson's career as an artist was about to begin, with a good general education and an aunt who knew and encouraged him for what he was: a rare talent. As Falk also noted, there were other attractions in that part of the city too: 'But unconcerned with the propriety or wisdom of the move, all that precocious Master Rowlandson, the chief beneficiary of the change, visualised in the transfer was the prospect of so much more welcome excitement implicit in the gay, colourful sights – almost at his very doorstep!'[25]

He had the right disposition for the profession; he also had the innate talent, and he had the backing. Adults around him believed that he could be somebody, achieve great things, or at least make a good living from his talent.

Learning the Trade

An art can only be learned in the workshop of those
who are winning their bread by it.

Samuel Butler *Erewhon*

There may not be any really annotated account of Rowlandson's education as an artist, but we can glean quite a lot from references to his schooling and by looking at the education of his contemporaries.

Established at number 4 Soho Square, he and Aunt Jane must have been happy in their spacious rented accommodation, and Thomas had only a short walk to Barvis's school for the first stage of his schooling. Little is known for sure about what he did there, but he did later go to Paris, before beginning serious art education at the Royal Academy Schools at Somerset House in 1772. Nothing supports the previously held view that he actually enrolled as a student in France. More likely, John Hayes is right in saying that he had a series of short stays there, and elsewhere in Europe, in his own version of the celebrated 'Grand Tour' which young aristocrats undertook, and which was *de rigueur* for their cultivation and accomplishments.

Between 1725 and 1805 a number of schoolmasters occupied number 8 Soho Square. At first the academy in question was at number 1, owned by a certain Martin Clare. He wrote a text book called, *Youth's Introduction to Trade and Business*, and advertised himself as 'M. Clare, school master ... with whom youth may board and be fitted for business.' His place became the Soho Academy from 1726 and as time went on it became one of the best London private boarding schools. By 1740 Clare had Cuthbert Barwis as a partner, who later took over the running of the place. In the 1740s the annual fee was £40. It is significant that the students had a pew in St Anne's Church but also in the Huguenot chapel which was close by. The curriculum consisted of French, drawing, dancing and fencing, with additional lectures on moral themes and modern philosophy. It was completely in line with the fashions and requirements of the new breed of commercial families, the regime reflecting the modern as opposed to the classical curriculum.

It was twenty years after the new partnership that Rowlandson arrived. Most significant in the later changes was the establishment of theatrical performances. Dr John Barwis was in charge when Rowlandson came, remaining there until his death in 1782, and a later master, William Barrow said that several of the actors who have since

attained considerable eminence in the public theatres, had discovered in the Academy their first passion for the stage. Notable among these was John Bannister, one of Rowlandson's closest friends through life. Drawing and painting were also taught, of course; then later, in a book published in 1804, Barrow reflected that he thought the drama had exposed the boys to 'moral danger.' That was something Thomas Rowlandson and friends must have relished.

What kind of schooling did Rowlandson have there, taught by John Barvis and possibly by Barrow? We know quite a lot about this, because William Barrow wrote a book on his teaching methods and obviously, these had been implemented in Soho Square. This work, *An Essay on Education*, came out in 1802. A review in *The Monthly Review* ran through his credentials: '... the essay of Dr Barrow on Education is intitled [sic] to the attention of all who consult the interests of the rising generation: since he long presided with credit and success of one of the principal academies of the metropolis.'[26] His philosophy appears to have been tolerant and enlightened, and there are hints in his ideas that the Academy was just the right sort of place for a man of Rowlandson's character:

> That total disguise of sentiment which constitutes hypocrisy; that dishonourable suppression of feeling, which is subservient only to private interest; the passive submission of a slave, and the artful sycophancy of a courtier; these ought to excite in the ingenuous minds of youth only contempt and abhorrence. But that decent and settled command of temper which a good education is known to give, and habit to confirm, this is useful and creditable alike to the individual and society. To the former in preserves tranquillity of mind, and to the latter good humours and manners. It guards the pleasure of the lighter amusements...[27]

It is not stretching matters too far to see in this a definition of the kind of gentleman Rowlandson was; Barrow's views included amusement as well as discipline of mind. The notion of 'sensibility' behind this had been criticised and ridiculed at the time, notably by Jane Austen in her novel *Sense and Sensibility*, that she wrote in 1797 though it was not published until 1811; and she, like the satirists of her age, felt moved to write on the hypocrisy of those whose education in these things had been deficient. Much may be inferred from Barrow's sentence about 'good humours and manners.' He was clearly by no means the kind of scholar ridiculed by Rowlandson later in Dr Syntax.

In 1775 Aunt Jane and he were in Soho Square, but two years later they had moved to 103 Wardour Street, apparently always with a housekeeper, and it is not difficult to imagine their lives: his aunt was clearly a person who relished society and the company of younger people. She had actively chosen to live among artists and writers, and also in a place in which the Huguenot population was close to her. When they did move, it was always to rented accommodation, so undoubtedly she had chosen to enjoy that frisson of excitement which is always associated from a lifestyle with no roots and with change being an easy option. He was still a student, and in that year he won the silver medal of the Academy. He made several visits to France and it is most likely that he spent some time there after completing his first year as a student in London; one

of his closest friends, a fencing master called Henry Angelo, went with him to France sometime between 1773 and 1775. It was probably in July 1774, because Angelo lived there and in his memoir wrote that Rowlandson and his friend Higginson came to visit. It was certainly a momentous moment to be there, in terms of French history: Louis XV died on 10 May 1774, so it is very likely that Rowlandson experienced something of the aftermath of that event.

The company he kept at the time offers some interesting speculations: Angelo says that Rowlandson was in France again in the 1780s, and on one occasion he went with a group of friends, most likely in July 1785 because he sketched scenes of such a journey at that time; with him was George Morland, another painter who was destined to have a very sad life, and the satirist Peter Pindar (real name John Wolcot) who was to make his name ridiculing George III and was once asked if he had been a good subject of that sovereign. His reply was that he didn't know, 'But I do know the King has been a devilish good subject for me.' A pattern emerges, then of the assiduous student travelling extensively between time at the school.

There were various routes to stepping into a career as a draughtsman and artist around 1770. An interesting comparison may be made with William Blake, his contemporary; Blake kept a sketchbook of drawings and learned simply by doing, at first. Then he attended a drawing school at the establishment of Henry Pars at 101 The Strand. This was known as a preparatory school for those intending to enter the Royal Academy of Painting and Sculpture, which was at St Martin's Lane. Every young artist following that course would have first had to master the art of drawing; but as Peter Ackroyd makes clear, there was another dimension necessary: 'But he was also being trained in what was called the language of art, and in particular, the work of the "Ancients".'[28] This was all part of the process of having both templates and influences. In Blake's case he looked to the Gothic – partly old stones and ruins – so typical of his age. Interestingly, one of his influences was the same person who influenced Rowlandson: the painter John Hamilton Mortimer. Mortimer was a massive influence on a number of artists: Blake, for instance, learned from Mortimer, and Blake's biographer explains that he chose to respect and follow Mortimer, among others: 'His art is to be associated with Barry or Mortimer, not with Constable or Turner...'[29]

Mortimer crammed a great deal into his thirty-nine years; he is now known for paintings which illustrate much of what we think of as Romantic from that period, and his range included conversation pieces as well as scenes of conflict. He at first studied at the Duke of Richmond's Academy and was a close friend of Joseph Wright of Derby. He was involved in the establishment of the Society of Artists in 1761, that had as its aims the promotion of work by contemporary artists, and it had links with Paris. There had been an earlier society formed by William Shipley, but the new one succeeded very well indeed and in 1765, with a membership of over two hundred, it was given a charter and became reborn as The Incorporated Society of Artists of Great Britain. Joshua Reynolds had been one of the founders. After various divisions, the Royal Academy was created in 1769.

All this meant that Mortimer was a source of inspiration in many ways for both Blake and Rowlandson; he was a skilled copyist, clearly he was able to teach well, and his subjects appealed to the younger men. Very little of his work survives, but his

impact was considerable on Rowlandson. This had much to do with the depiction of war and particularly of a very topical subject, that of European banditti. Publications of tales of the bandits and robbers in Italy were popular at the time, and this would have appealed to young men who were acutely aware of the new fashions and interests in popular culture.

John Hamilton Mortimer was a profoundly important influence on several artists, including Blake. He had had an eventful life; after studying at William Shipley's academy in the Strand, he won second prize in 1763 in the Society of Arts competition, and this was for a painting with a subject from English history; he submitted Edward the Confessor Stripping his Mother of her Effects. He was a central figure in the arts culture of the day; he had a large output in themes of banditti, and also of portraits. Peter Walch says of these: 'For Mortimer's contemporaries, and according to anecdote, for the artist also, his life and art were foreshadowed by the picaresque career of Salvator Rosa, best known for his paintings and etchings of banditti and pirates ...The legends surrounding Rosa's life, and his depictions of raffish soldiers and wild gypsies on the Neapolitan coast, provided Mortimer with his model.'[30] His influence was limited, but there is no doubt that Rowlandson knew him and learned from him. Walch notes that

> His impact on English art was restricted, although it affected his close friend Joseph Wright of Derby ... and was mainly exerted by way of encouraging other artists to explore exotic and emotionally charged subject matter. Even the archetype of the Romantic artist, which Mortimer had helped to create, was one that found its subsequent expression in Britain more among poets than among painters.[31]

The question of influence is interesting. It was obviously something discussed in the society of the artists of the day. The diarist Joseph Faringdon, for instance, recorded a conversation he had about Blake, referring to the influential figure of Henry Fuseli: 'We supped together and had a laughable conversation. Blake's eccentric designs were mentioned. Stothard supported his claims to genius, but allowed he had been misled to extravagance in his art and he knew by whom...'[32]

Rowlandson clearly made an impression at the Academy. His early work from *c*. 1772 shows a remarkable quality, as seen in his watercolour of the City militia. The genuine nature of this has been assured by Bernard Falk, who notes that, with reference to a Rowlandson signature on this, 'Had one of the unscrupulous gentry, whose speciality was affixing Rowlandson signatures to drawings ... been at work, we should expect to find the familiar cursive script with the curly "d".'[33]

It is clear that Rowlandson, in the years between entering the Royal Academy schools in 1772, met a crowd of friends and peers with whom he learned about life and about art. It was an exciting time to be entering the profession of artist. As advertisements in the press made clear at the time, there were specialists around in all categories: painters who offered landscape, flowers, history and life; limners and practitioners doing seascapes and still life images.

He was learning by doing; but he was also discussing and asking questions. He was seeing what other creative minds were aiming at, and his friendships make it

Advertisement from Houghton's Collection 1695.

clear exactly what type of person he was close to. Rowlandson loved life: we can put together, from scraps of anecdotes, from the drawings he did in the 1780s and from the activities of his peers, a vignette of a man who was sensual, vibrant and full of good humour. He laughed at himself, as true comedians do, and it is hard to imagine him having any arrogance. The word one most wants to apply to him is *genial*.

He was also absorbing French culture and French aspects of artistic style; he spoke fluent French and lived in a bilingual household as a child, then following that he was living with and later still close to, his aunt, who was French of course. But analysts of his style and influences generally stress the very English features, with pen and wash, watercolour and tinting as the staple method. Certainly that suited the subjects he chose. By the late 1780s, and after he had been left seven thousand pounds by his aunt, on her death in April 1789, he was moving house often and travelling when he could. He was exhibiting some watercolour portraits at the Academy, and many would argue that 1784 was the year in which he produced some of his very best work, with Vauxhall Gardens and Serpentine River being produced. But above all he was mixing in the bohemian community around central London.

Around late 1784 he was living with his aunt in Poland Street, off Oxford Street, and it was an area full of life and incident – one of which was an attack and robbery on Rowlandson one night. He was not seriously hurt and there was help at hand in the shape of the St James Infirmary, which was on Poland Street then; the Rowlandsons also had a servant, one Mary Chateauvert.

The robber attacked him, but Rowlandson had a certain revenge on the criminal community because he identified a man the next day, and that led to the culprit's execution. The artist was reported as saying later to Henry Angelo, '... I got knocked down, and lost my watch and money, and did not find the thief, I have been the means of hanging one man. Come, that's doing something.'[34] Rowlandson was one of very many in the London streets at that time who was a victim of one of the thousands of footpads abroad at night, dodging the old 'charleys' – the amateur watch officers who were notoriously inept.

Poland Street was definitely a location that exemplified the heady mix of cultures, classes and habits of that time. Tradesmen, such as one Henry Dawes who lived there, offered his 'reverberator' – a machine that, he claimed, would 'prevent the most noisome stenches from drains.' Crime was very common, and while Rowlandson was living there, several other attacks took place such as the attack on a tradesman in Oxford Street in October 1787, in which three footpads robbed him of fifty five shillings. But Rowlandson was established by that time. He was advertised in details of an auction being held at rooms on King Street and Hart Street, with this advert placed in the *Morning Herald*: '... a genuine collection of drawings by Rowlandson, Hewitt etc...'

The poet Shelley came to live there shortly after Rowlandson moved to James Street, and he overlooked the local dangers, thinking of something totally dreamy. As his biographer notes, 'Shelley was taken by the name Poland, because it made him think of Thaddeus of Warsaw, and therefore seemed symbolic of independence and freedom.'[35] But it says something about the location that Shelley took to going to his friends, the Westbrooks, to talk and work, as Poland Street was clearly not conducive to creative endeavour. Like Rowlandson, Shelley was only ten minutes walk away from company and the gaming tables when he was in the mood.

Between his entry into the Academy in 1772 and the death of his aunt, Thomas Rowlandson had made a name for himself as a draughtsman, someone deeply involved in the trades of engravings, prints and drawings for which there was an insatiable demand. But it is now known also, thanks to the research efforts of John Kiely, that his father had written to a respectable gallery, just three weeks after Thomas was accepted by the Academy. Father William wrote to the Duke of Richmond's sculpture gallery which had been open since 1758, to try to have his son accepted there. Kiely points out that Thomas was taken and was to be 'permitted to draw' but what is of intriguing interest is the fact that the award given to Thomas by the Academy in 1777 was for a bas relief sculpture. Had he been attending both places and having tuition in sculpture too? It seems most likely.[36]

William Rowlandson had written this letter to William Thompson, who was administrating the Gallery, by that time absorbed into the Incorporated Society of Artists:

> Sir,
> The bearer, Master Thomas Rowlandson, being desirous of becoming a Student in his Grace the Duke of Richmond's gallery, the recomendry [sic] Figure delivered you by him being his own performance and it being necessary he find security for his good behaviour on admission – I humbly offer myself for that purpose and am with much respects Sir
> Your humble servant,
> William Rowlandson.

As John Kiely notes, 'Rowlandson, even towards the end of his life made numerous drawings of antique busts, sculpture, vases and other decorative objects...' and he relates this to Rowlandson the 'brilliant figure draughtsman.'[37] This is a tantalising snippet of biographical detail. His father was aware of the importance of connections,

and of how crucial it was for a young artist to be thought of as 'genteel' – having a gentlemanly and respectable curriculum vitae as the years went by and preferment was applied for from patrons.

Of several biographical lacunae in Rowlandson's life there is also the question of his relationship with his sister Elizabeth and her husband, Samuel Howitt. Howitt, celebrated as a painter and etcher of sporting prints, was almost exactly Rowlandson's contemporary, being born in 1756/57. He married Elizabeth on 2 October 1779 and they had three children; but the marriage did not work out and they separated. The fragments we have of his life suggest that he had property in Chigwell, and that he was self-taught, working at first in oils and then watercolour, and expanding into etching and illustration. He exhibited at the Incorporated Society of Artists in 1783, and at the Royal Academy.

Writings from the nineteenth century, notably by Grego, recall that he was friendly with his brother-in-law, Thomas. They surely must have spoken often and the self-taught man must have learned some technique from Rowlandson. Howitt did become a specialist though, focusing mainly on hunting scenes and sporting illustrations. If we are to believe Grego, he was a difficult man to know and he must have made a trying, demanding husband: 'He was ... somewhat of a spoiled child – a wayward genius, of a convivial soul and vivacious impulses, a trifle too given to yield to careless convivial company, or the allurements which the hour might hold forth, oblivious of sober consequences to follow.'[38]

Howitt visited Yorkshire, but was based in London, working from Charton Street in Somers Town. He died in 1823, being buried at St Pancras old cemetery on 21 February. Like Rowlandson, he had always found a market for his work, much of it for The *Sporting Magazine*, and he had most likely been ruined by a combination of his temperament and the circumstances of the jobbing artist's life at that time.

The biographer would sacrifice more than a dozen accounts of picture sales for a few pages of information about the two men and Elizabeth, merely enjoying a dinner together, and the two men discussing the state of Ackermann of Fores' business and the prospects for the future for the Rowlandson and Howitt families.

3

Friends, Community and Travel

From quiet homes and first beginning
Out to the undiscovered ends,
There's nothing worth the wear of winning
But laughter and the love of friends

Hilaire Belloc *Dedicatory Ode*

On 29 August 1782, HMS *Royal George* began to take on water while being repaired at Spithead. The vessel capsized and nine hundred deaths ensued. There were hundreds of women and children on board at the time, visiting the ship and talking to their men folk before departure. This horrendous disaster was a momentous event, with the emotional perspective given that of sixty children on board, just one survived, a boy found clinging to a sheep which had been on the ship.

Two years later the wreck was still there and had become a tourist attraction; in late 1784 Rowlandson and his friend and fellow artist Henry Wigstead took a holiday there for two weeks, travelling by post chaise. It was a partnership that was to endure, as Rowlandson and Wigstead were later to tour Brighton and then, in 1797, Wales. Rowlandson produced over sixty watercolours on the journey. Wigstead died in 1800, and after that there were other new friends. There was always someone to travel with, and many men loved to be in the company of the man that one of the friends affectionately called 'Roly.'

The concept of an excursion was very much an important element in education as well as being fun at the time. The trips to France and Germany, and then to Spithead, are entirely typical of the time and of Rowlandson's class, but more important, what we see is a man with a circle of close friends. In the age of the club, of jaunts and social conversation, dinner parties and professional societies, Rowlandson found an outlet for his playfulness and love of fraternity. Angelo wrote in his memoirs of Rowlandson at the Academy, blowing a pea-shooter at a model and almost being expelled. That could almost be a metaphor for his artistic life. There is no doubt that he adored ridicule, and like Swift, when it came to satire, he surely would have said that he criticised mankind but loved Tom, Dick and Harry.

The friends closest to him tell their own narrative of Rowlandson's personality. George Morland, Henry Wigstead, Jack Bannister, Henry Angelo, Matthew Michell – a mix of rakes, drinkers and debtors, together with more steady and reliable, more rational types – that tells us a great deal. In the heart of this social self he projected there was also the gambler. As the 1827 obituary said, after pointing out that Aunt Jane had left him a

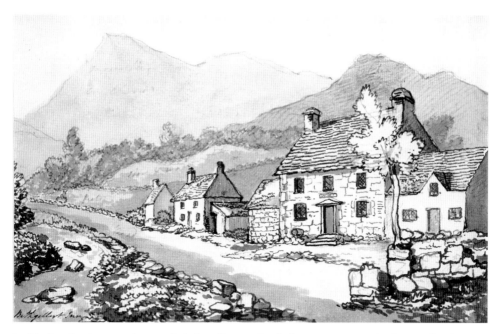

Beddgelert Inn, By permission of Llyfergell Genedlaethol Cymru/National Library of Wales.

fortune: 'He then indulged his predilection for a joyous life, and mixed himself with the gayest of the gay ... He was known in London at many of the fashionable gaming houses, alternately lost and won without emotion, till at length he was minus several thousand pounds. He thus dissipated the amount of more than one valuable legacy.'[39]

An interesting contrast may here be made with arguably his closest friend, the actor, John 'Jack' Bannister. Bannister had been one of the scholars involved in the theatricals at the academy in Soho Square, and he was to become famous in his time. He also inherited a substantial legacy. Jack used to be friendly with a Mr Rundell of Ludgate Hill, who was his wife's uncle. Rundell said that he had passed many happy hours at the Bannister home in Gower Street and at his death, in the same year as Rowlandson, he left Jack a sum of ten thousand pounds.

He was a major figure in the theatre of Rowlandson's time. In fact, in one of William Hazlitt's essays, 'English Characteristics,' there is a summary of the greatest names associated with the theatre and this is his list: ' Our recollections of the state, of the masterpieces of wit and pathos that support it, of the proud and happy names that adorn it, of the Siddonses, the Kembles, the Jordans. The Lewises, the Bannisters...'[40] Bannister was ranked with those performers we still know and write about today.

Jack Bannister has entered the chronicles of English literature in various ways. David Garrick taught him to play the role of Zaphna in Voltaire's play, *Seide*. He was mentioned in the classic works by Charles Lamb and William Hazlitt on theatre, and stories of his sense of fun and good companionship were everywhere. On one occasion he saw Sir George Rose across the street and shouted, 'Stop a moment Sir George, and I will come over to you.

Sir George replied, 'I never yet made you cross, and I will not begin now!'[41]

Bannister was a kind and sociable man, very much a part of the theatrical establishment of his time, and he lived a long, busy life, dying in 1836 aged 73. In 1822 he gave two guineas to the benefit fund for a young actor, John Emery, who had died, leaving a wife and family in straitened circumstances. He was, as his portrait done by Rowlandson shows, a man with fine features and an intelligent face: clearly a man who was a pleasure to be with. His path in life crossed that of many other theatrical greats, including Joe Grimaldi, the great clown. In 1804, as Grimaldi went in search of a patron, visiting John Wroughton in the green room at Drury Lane, Joe's brother went to chat with Bannister, who was there and who saw Grimaldi take his first step towards fame.[42]

A memoir written about him in *The Mirror* paper says:

> He was affecting because he was natural and simple; in society he was distinguished by the same characteristics. His unaffected hilarity in conversation, the flexibility of his mind in adapting itself to every subject ... and the almost puerile good humour with which he recalled and recited the incidents of his earliest life ... formed a picture altogether singular and interesting.[43]

We also have an insight into what Bannister must have been like in company in the memoirs of the fencing-master, Angelo. He recalled a time when he and the actor paid a visit to a rake called Munden:

> Munden had his casino at Kentish Town. Bannister and myself, taking our Sunday walk that way one day called on him. After dinner, he insisted on us having more wine, when a few grave speeches ensued. Under the table was a trapdoor, and underneath was a cellar for his choice nectar, only for his particular friends ... After opening it, down Joe descended, when Bannister jumped after him. Then followed the grave scene from Hamlet...[44]

Jack Bannister's particular skill was in mimicking others, as Angelo notes, referring to a time when he pulled a face and impersonated someone: 'Bannister used to give a certain trait of Macklin's advice to a young actor, not only imitating his voice and gesture, but his countenance, putting forward his face...'[45]

If we judge a man by the company he keeps, then in this case there seem to be two categories of friend: the men of his profession who were rather like the famous French poetes maudits – destined to suffer for their creativity; and in contrast there were other people, men of business and solid professions, who perhaps tried to advise him against his profligacy and yet still loved him well. It appears that the obituarist knew him well, and was perhaps Angelo or Bannister, and that writer attempted to dig a little deeper into Rowlandson's addiction to the gaming tables: 'This uncontrollable passion for gaming, strange to say, subverted not his principles. He was scrupulously upright in all his pecuniary transactions, and ever avoided getting into debt. He has been known, after having lost all he possessed, to return home to his professional studies, sit down coolly to fabricate a series of new designs and to exclaim with stoical philosophy, "I have played the fool, but," holding up his pencil, "here is my resource."'[46]

This has the smack of truth about it, as if the words really were spoken and the writer had them lodged in memory as being indicative of a complex and puzzling

personality. In an age of rakes and sportsmen, this must have seemed crazy in the extreme, a serious character flaw. Here was a man of shuddering extremes: hard work juxtaposed with sheer wild extravagance and hazard. It was part of the deal for his art, we might argue. George Morland had immense debts in his life and at one point had to run from London to hide from his creditors, but was later arrested and sent to the Kings Bench prison, and then in 1803 he put himself in the Marshalsea prison to escape other creditors. He died of a brain fever at the age of only forty-one.

Like Rowlandson, he had a special talent – painting rural scenes in particular – went to the Academy and gathered an enviable reputation, only to lose all happiness. Rowlandson somehow stood outside this, with amazing self-control and resilience. His father's fate must have always been there in his mind to exert a strong influence. But we know, if we are to trust Henry Angelo, that when Rowlandson was sharing a lodging with Morland, probably around the early 1780s, that the two friends had fun, living rather dangerously in terms of their clients. Certainly in the case of Morland, we can see in one memory from Angelo why that painter had a spell in gaol:

> Rowlandson lodged at Mrs Lay's print shop a few doors from Carlton House, Pall Mall, and one morning when I called on him we heard a knocking at the street door, and looking out of the window, he said, "There's Colonel Thornton – knock again! He may be at his game three months longer; he's come for his picture, but Morland having touched fifty pounds in advance, is never at home to him now. He is in the next room which he has for painting. You had better go and do the same with him and drink gin and water, he'll like your company and make you a drawing for nothing." This was in the middle of the day.[47]

This gives us a convincing picture of the young Rowlandson: we can infer that, living with Morland, he was the industrious one, and he was accessible (Angelo had walked in, as others must have done); and in contrast Morland was really pushing his luck. Fifty pounds was a very large sum of money then, and he was exploiting the rich customers, while drinking gin in the middle of the day, painting what he wanted to, and probably delaying the commissions to the last moment. There was no reference on Angelo's part

King's Bench prison, Contemporary print (*Author*).

to Rowlandson sharing any of Morland's attitudes, and in fact he was enjoying the comments about his flat-mate, seeing both a frolic and a risk in that way of life.

Rowlandson loved to take a jaunt to Greenwich. We can glean some idea of the charms and pleasures of this from Robert Southey's account of that journey from the heart of London at this very time. In Southey's *Letters from England* (1807) he describes that trip, starting with the thought that 'As it was my wish to see the whole course of the river through the metropolis, I breakfasted at the west end of the town with W. who had promised to accompany me and we took boat at Westminster Bridge.' At Greenwich he describes exactly what Rowlandson would have seen, and his account has the visual dimension which compares very well with the artist's interest:

> At length we came in sight of green fields and trees. The marshes of Essex from whence London is so often covered with fogs, were on one side; the Kentish hills, not far distant, on the other; the famous observatory of Greenwich, from whence the English calculate their longitude; and the Hospital, a truly noble building worthy of the nation which has erected it ... About 200 disabled seamen are supported here, and boys are educated for the navy. We saw the refectory and the church ...What volumes could be compiled from the tales which these old chroniclers could tell![48]

Basically, Rowlandson adored waterside scenes and the life around it: fishermen, sailors, bridges, ships, water as a place of play: these all attracted his mind and his pencil and brush. His jaunts to Greenwich may well have been for leisure and a few drinks with friends, but his eye was clearly always fixed on potential subjects.

In 1797 Rowlandson and Wigstead set out on a journey to Wales. Wigstead was to write the text and Rowlandson provide the drawings of what was to be called, *Remarks on a Tour to North and South Wales in the Year 1797*. It was very much in fashion. Wealthy young men had moved up and down the length of Britain in search of the sublime and the picturesque, arguably the two key concepts in understanding the late eighteenth century sensibility. In broad terms, both ideas were aspects of natural beauty, the sublime being immense grandeur as might be evidenced in massive mountain ranges, and the picturesque being landscape with plentiful and absorbing detail. From the early eighteenth century, with the influential landscapes of Nicolas Poussin behind it, the theory was expounded notably in an essay in *The Spectator* by Joseph Addison in 1712. In that essay, Addison writes on 'the pleasures of the imagination' – there he argues that we derive special pleasure from poignant comparison of original objects we know in our minds, with what we see before us in nature. He talks of this as a 'secondary pleasure.' The logical extension of this is that the traveller experiences the picturesque impression when he sees something to compare with a known work of art.

Wigstead gives us a perfect example when he writes about the sight of the Welsh landscape as he and Rowlandson travelled towards Carmarthen, more breathtaking that full of picturesque detail:

> We witnessed here a remarkable phenomenon: looking into the vale beneath us, the dark clouds were revolving and veiling the country in perfect night; whilst on the

other hand the mountain brows and sides are gilded with the sun's beams... this gave a masterly finish to the landscape, novel and sublime in the extreme...'[49]

The trip began, according to Wigstead's preface, with Wales specifically in mind. He wrote, 'We left London in August, 1797, highly expectant of gratification: nor were our fullest hopes in the last frustrated ... I was induced to visit this principality with my friend Mr Rowlandson, whose abilities as an artist need no encomium from me...'[50]

Rowlandson was forty years old. He and his friend were indulging in a very topical pursuit, and it was just the right time to do it in terms of their careers also. Had Wigstead lived, no doubt it would have been something that brought him an enhanced reputation. For Rowlandson it was yet another excursion and the prospect of an array of new places and subjects. Wales had been a popular destination for travellers and antiquarians, and for poets and writers, for some time; one influential factor was the general enthusiasm for things Cambrian, as old castles and abbeys were exactly right for picturesque and sublime topics.

Back in the early decades of the eighteenth century the fondness for regional antiquities took off, as may be seen from the success of Samuel and Nathaniel Buck's five volumes of *Antiquities or Venerable Remains of above Four Hundred Castles, Monasteries, Palaces etc. in England and Wales*, published between 1725 and 1752. Thomas Gray's poem, *The Bard*, appeared in 1757, using the Welsh mountains as a setting. But by the 1790s, regional tours were incredibly popular. The wars with France and Napoleon had meant that tours to Europe were suspended and so other areas, particularly Wales, the Lakes and Devon were popular destinations.

As Wigstead and Rowlandson were on the road in mid-Wales, arguably the most influential writer on the picturesque, William Gilpin, published his book, *Observations on the Western Parts of England Relating Chiefly to Picturesque Beauty*. Local historical writing, travel writing with pictures and theoretical works on art and landscape were extremely popular. Only three years before their Welsh journey, William Wordsworth had been in Wales, walking in the Wye valley, where he wrote his celebrated poem on Tintern Abbey. In a very important sense, the Romantic writings of the 1790s from all kinds of authors, initiated the beginnings of a new literature and art of curiosity about mundane life and everyday occupations. As Hunter Davies wrote of Wordsworth and his sister Dorothy at this time:

> The locals far exceeded William's expectations; he pronounced them "a little adulterated". Being unsophisticated, they took William and Dorothy at face value ... Many of the local families still did home weaving and spinning ... and in the evenings, coming back from their twilight walks, they would see their neighbours' daughters, sitting at their spinning-wheels by candle-light...'[51]

In terms of the heritage of visual artists, Rowlandson would have been fully aware of the spirit of the lines from the huge best-selling volume of poetry, *The Castle of Indolence* by James Thomson, in which there are the lines:

Whatever Lorrain light-touched with softening hue,
Or savage Rosa dashed, or learned Poussin drew...[52]

The new feeling was that painters and draughtsmen would look at sublime landscape and feel the truth of it, not necessarily impose any religious thoughts on the scene. Gilpin, the great theorist of this area of thought, said that 'We rather feel, than survey it.'[53]

Wigstead and Rowlandson, setting off for Wales after no doubt several talkative and excited evenings of planning in the tavern, would have been imbued, as most of their middle and upper-class contemporise who cared about art would have been, with the idea of Edmund Burke's 1756 work, *A Philosophical Inquiry into the Origins of Our Ideas of the Sublime and Beautiful.* Here he addressed the question not merely of what is seen but of the 'passions' – the range of emotions, humans exercise in relation to nature. He wrote,

> The passions which belong to self-preservation, turn on pain and danger; they are simply painful when their causes immediately affect us; they are delightful when we have an idea of pain and danger, without being actually in such circumstances; this delight I have not called pleasure, because it turns on pain, and because it is different enough from any idea of positive pleasure. Whatever excites this delight , I call sublime.[54]

Rowlandson, between *c.* 1784-97, had been to France at a time of revolution; he had purposely gone to Spithead where there had been the celebrated wreck and great loss of life, and now there he was, treading the well worn path of the traveller into Wales looking for the picturesque beauty of everyday rural life and the sublime magnificence of the mountains. He had also been to Cornwall, visiting his wealthy friend, the banker, Matthew Mitchell, whose home, Hengar House, near Bodmin, Rowlandson painted in watercolour in 1795. Putting these journeys and aesthetic interests together, it can be seen how Burkes' words match this experience very closely. The idea was that artists and writers should meditate on both the grandeur of divinely-imbued nature and also on the significance of locality, human presence and memory.

The journey began in the Marches, and they entered Wales at the North, going towards Ruthin and then Welshpool, before heading into the mountains, and then south again towards Cardiff. Wigstead did what literate travellers were expected to in this genre: mix local lore and history with topographical writing with a very specific location. Their book is a workable mix of two styles: that of a young man wanting to find and describe the inconveniences of travel, and the depiction of the sheer vitality and abundance of people and animals, rooms and objects, in their path. Wigstead can write the former style very succinctly, as in this on Shrewsbury: 'In 1551 the sweating sickness made its first depredations here and extended fatally through the kingdom ... The ancient road called Watling Street comes hither from London and goes to the very extreme part of Wales.'[55] But in passages such as this we can almost sense the man writing after a conversation with his friend Thomas (on Oswestry): '... the fewest public houses we have ever witnessed ... We began to despair of finding any sort of quarters ... At a kind of inn, however, surrounded by a phalanx of waiters (such as they were) we obtained what we required...'[56]

Here, we may feel that spirit of testy satire and sideways comment on normality so typical of the visual narratives Rowlandson offers us. After all, as may be seen in so many of his drawings from the twenty years of work he did before this jaunt, what

emerges is a wonderfully entertaining series of images and impressions of life impinging acutely on an artist who is fully engaged with life. The simple drawing of 1784 for instance, Rowlandson at Dinner, is again from a journey, 'A Tour in a Post Chaise' and there the artist sits, back to the observer, eating at table, while a dog begs for scraps and a solid, rough-edged servant waits for him to finish the meal.

The world of Rowlandson's art is peopled by figures grabbed by time and perfunctory duty; the world he depicts continually is one in haste, at the same time escaping from itself and still trying to maintain dignity, duty and deadlines.

The Welsh tour created a number of drawings with delicate colouring, and the collection at the National Library of Wales, Aberystwyth, was bought by Sir John Williams in the Edwardian period; there are twenty-two aquatints in that library from the Wigstead tour. As the publications states on the frontispiece, other artists contributed also, notably Samuel Howitt, Rowlandson's brother-in-law, who generally specialised in images of sport. The drawings in the book range from simple country scenes of inns, farms and fishing, to industrial studies such as a picture of iron smelting at Neath Abbey and market day in Aberystwyth. He was, as usual, attracted to the notion of putting couples in the drawings: either lovers or contrasting people, such as in a drawing of a harpist, a young woman with her admirer, placed by the side of an old, fat man, who sleeps. There are few clearer examples of the art of drawing crowds and business activity in the Rowlandson canon than the Aberystwyth drawing: the scene at the junction of King Street and what is now Pier Street shows the technique of drawing deftly with seeming detail, so that the overall impression is one of a documentary exactitude of work, place and people; yet in fact on closer inspection there is very little detail and a predominance of apparent documentation of minor figuring, as the general shaping suggests more substance than there actually is.

The drawings included many of obscure villages, as well as images of the famous places such as Conway and Cardiff castle, or of the great towering sublimity of Plynlimon. For the classic image of the picturesque, there is a drawing of fishermen at a stone bridge.

Typical of Rowlandson, he also laughs at himself. In his print, An Artist Travelling in Wales, available by 1800, we see the man himself, on a pony – in fact a take on the stereotype image of the artist on the road, laden with equipment that was in several comic contexts in the media of the time. As Falk commented, 'The accessory detail is interesting, if only because it shows us how on a sketching tour Rowlandson reduced his impedimenta to the barest necessities – a box for provisions and spare garments, umbrella, churchwarden pipe, tea kettle, coffee-pot, sketch book, easel, palette and the various implements of the craft...'[57] We are reminded of just how much Rowlandson and peter Pindar, his friend from the tour to Europe, were kindred spirits, when we note the quote from Pindar beneath the print, and this confirms for Falk that this is indeed a self-portrait, not, as some might argue, a portrait of Richard Wilson, the famous landscape painter of that age, who died in 1782:

Claude painted in the open air,
Therefore to Wales at once repair,
Where scenes of true magnificence you'll find;
Besides this great advantage – if in debt,

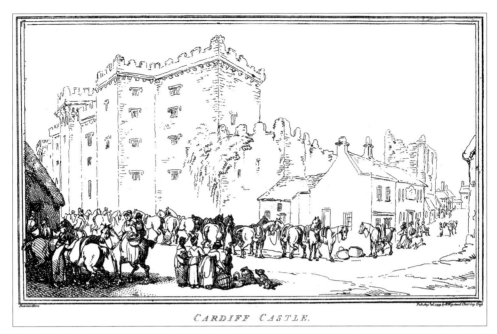

CARDIFF CASTLE.

Cardiff Castle, By permission of Llyfergell Genedlaethol Cymru/National Library of Wales.

You'll have with creditors no tete a tete –
So leave the bulldog bailiffs all behind,
Who hunt you with what noise they may,
Must hunt for needles in a stack of hay.[58]

Of course, the subject of escaping debtors is very likely an in-joke too, between friends.

In these years, between the leaving of the Academy and striking out on his own, Rowlandson's reputation was established. Hence the fact that his surname was enough in the advertisements for auctions and sales in London. Part of this rise to local celebrity was his knack of making friends who were also either patrons or, in modern terminology, 'contacts.' In the last years of the eighteenth century and the first decade of the nineteenth, the demand for prints, engravings and illustrations expanded rapidly. Rowlandson was in that world in which commerce meets art, and it was an arena of negotiation. William Blake was in that same world, and as one of his biographers notes, he had to learn to negotiate. The memoirist, Faringdon, wrote this, referring to Blake in 1796, when he was doing exactly what Rowlandson was doing, just a few streets away – trying to make money from his skills:

Blake has undertaken to make designs to encircle the letterpress of each page of Young's 'Night Thoughts'. Edwards, the bookseller of Bond Street, employs him, and has had the letterpress of each page laid down on a large half sheet of paper. There are about 900 pages. Blake asked 100 guineas for the whole. Edwards said that he could not afford to give more than 20 guineas for which Blake agreed...[59]

Richard and James Edwards were two brothers, each with a London bookshop, and at that time it was still the practice for booksellers to be also printers and publishers. Artists such as Blake and Rowlandson had to learn how to advance their careers by dealing with such people, and by starting to think commercially as well as aesthetically. In Rowlandson's case, the rise to success had been a matter of sheer hard work and productivity, as well as talent; on the trip to the Isle of Wight in 1784 he had produced almost seventy watercolours, and now he had extended his work with drawings from Cornwall, Wales and Europe.

Important in respect of friendship and career is Matthew Michell; in 1800 Rowlandson had moved to 1 James Street (now John Street) and before that he was in small rooms at 2 Robert Street, Adelphi. This place had only been in existence since 1773, designed by the Adam brothers, and created between 1769 and 1773, a range of buildings admired by Robert Southey in 1807: '... the handsomest in London because they are faced with a composition having the appearance of stone...'[60] He had had several addresses around the Strand and close to Fleet Street, but once in his attic room at James Street, that was where he remained, and sometime around these years of upheaval he met Michell, probably in 1794. Rowlandson was living in the very heart of the sex market: in the 1770s, Henry Mackenzie wrote of the area around Rowlandson's home in this way, when his hero, Harley, meets a prostitute: 'The company he was engaged to meet were assembled in Fleet Street. He had walked some time along the Strand, amidst a crowd of those wretches who wait the uncertain wages of prostitution ... and had got as far as Somerset House when one of them laid hold of his arm...'[61]

Michell was a banker, and a great enthusiast for the artist's work. In *A Book for a Rainy Day*, J. T. Smith describes Michell:

> He was extremely well proportioned and walked in what I have often heard the ladies of the old school style a portly manner. He was remarkable for a width of chin... and a set of large white teeth. His features altogether, however, bespoke a good-natured and liberal man.[62]

Rowlandson was settled in James Street, close to the London homes of Michell and his future employer, Ackermann, and next door to him until 1803 was Isaac D-Israeli, writer and father of the future prime minister. The area was in the very heart of the Strand 'cultural quarter' as we might say today, and although Rowlandson had a top attic room, it was spacious. Michell was in the Beaufort Buildings in the Strand (where now the Savoy Hotel stands); as Falk makes clear, the huge, corpulent figure of the bank Michell would have had to struggle up to the top floor when he visited his friend. However, the struggle was clearly worth it, as the two men got on very well. So close were the two men that Rowlandson was always welcome at either of the rich man's two country homes, one in Cornwall and the other at Grove House, Enfield Wash. He had inherited Hengar House in Cornwall from a relative who had no children, a colonel in the Coldstream Guards. Michell's father was captain of the ship that Commodore George (later, Lord) Anson used to sail around the world in 1744, and at his death he left a great deal of money to his son. He had indeed been fortunate to come home, as of the 1,854 men who began on Anson's voyage, only 188 returned home.

The place at Grove House which was frequented by Rowlandson provides an insight into the artist's life which we can only surmise: he was so often on the road, and so often staying with friends, that he knew the pubs, inns and taverns very well on the coach horse routes. In this case, it was the White Lion Inn at Ponder's End, but we can perhaps guess at his affection for the wayside inns by considering the George at Crawley, on the Brighton route, which he drew in 1789, showing the front not long before it was changed when the road to Brighton was busier than ever after the Prince Regent gave it a new glamour. The George was the half-way house on that route, and was very old. Inn historian Richard Keverne notes: '... the inn would not have done much trade until after 1696 when a causeway for horsemen was constructed from Reigate to Crawley. That causeway was widened sixty years later and the Brighton road, as we know it, came into being. Its rare gallows sign-post stretching across the highway became a feature of the road.'[63]

It is easy to imagine the attraction of the inn to a man like Rowlandson. Whether it offered the massive flow of human traffic he depicts in his drawing of the Salutation Inn at Greenwich, or whether it is simply the placid country inn in the middle of Wales, the image is always one of familiarity and affection, if we look closely. The friendship with Michell meant that he could have a country jaunt whenever he fancied an escape – and sometimes it may have been from money worries, as Peter Pindar wrote, tongue in cheek.

Michell's story is a charming one, too, and strongly human: he fell in love with a woman he saw haymaking one day, and though she was much younger, they married, and she looked after Hangar Hall for him. She lived thirty years longer than he and she married again, to a London solicitor. But he was also what so many wealthy men with country property were through English history – a justice of the peace, and in fact he also held the high office of Sheriff for Cornwall from 1800. That would not entail so many duties, and that would suit the man very well.

Michell had joined the banker William Hodsoll in his company in 1776, when the banking company became officially Hodsoll and Michell; then in 1795 they were joined by Sir William Stirling, and the Hodsoll office was listed in *The London Directory* for 1770 as being 'near St Catherine Street, the Strand.' He was immersed in the commercial and artistic life around him in The Strand. Michell was a steward of the Society for the Encouragement of Arts, manufactures and Commerce, which had been founded in 1754 by William Shipley. In 1794 he was on duty at an anniversary dinner held at the Crown and Anchor, with the Duke of Norfolk as the special guest. As that organisation was notable for its challenges and competitions, and of course for the encouragement of enterprises across the globe, it fits Michell's nature – he was a man who evidently believed in encouraging innovation and adventure. For years he subscribed to the Marine Society, for instance. The first seaman's charity, formed at the beginning of the Seven Years War to increase recruitment. Of course, it met at the King's Arms tavern at Cornhill, another inducement for Michell to be a subscriber.

Overall he was a *bon viveur* with a penchant for involvement in good causes, but it is obvious that he believed in encouraging talent when he encountered it. He appears to have been a unique personality with plenty of little interesting traits and habits. He was allergic to kittens but not to cats, for instance. He explained that it was a matter

of what he fancied when in contact with the animals – thinking that a kitten could become a huge monster in his mind whereas a cat was simply what it was. Kittens had to be taken out of his presence when the problem arose.

Henry Angelo, who knew both Rowlandson and Michell, makes much of the two men's appetite and relish for a good meal, particularly when on the road. They must have seemed a little similar to Johnson and Boswell on their Scottish Highlands tour – one really fat man and a thinner, more agile companion. Angelo joked that the servants in Europe, with the challenge of feeding Michell satisfactorily, thought him a strange, fabulous beast of a man. Falk expresses the nature of the two men on the move abroad very neatly: 'In the Low Countries the quaint pair mingled freely with the poorer classes, and of the spirited drawings, marked to a high degree by humour and whimsical passages, Michell claimed the greater proportion.'[64]

In fact, Angelo must have known Rowlandson quite well. He seems to have known almost anyone who was anyone in Regency society. He took over his father's fencing school in 1785; he was close friend of the fighter Gentleman Jackson, and the fencing academy was next to Jackson's boxing club in Bond Street. The Prince Regent was a fan of fencing, and along with Mrs Fitzherbert, he is recorded as having gone to see a match at Carlton House in 1787. Gillray made an engraving of the occasion. As for Angelo, he obviously relished a good story and a daredevil escapade, wine-fuelled and madcap. Rowlandson appears to have been someone who occasionally joined in these frolics. We know that he loved to walk to Greenwich, and we can soon work out that there was a large social circle of young blades and rakes around Angelo whom Rowlandson would have found fascinating and who would, naturally, have been 'material' for his art.

Also in the social circle was Caleb Whiteford, who lived close to Rowlandson; another friend, William Pyne, wrote about a meeting between the two, and part of this anecdotal record is most enlightening with regard to the society and bonhomie around Rowlandson; here, the two speak of their artist friend:

> "Yes", said Mister Whiteford, "Master Roly is never at a loss for a subject, and I should not be surprised if he is taking a bird's eye view of you and me at this moment, and marking us down for game. But it is not his drawings alone; why, he says he has etched much copper as would sheathe a first-rate man of war; I should think he is not far from the mark in his assertion..."[65]

Taking stock of Rowlandson's life at this juncture invites a fanciful evocation of his London life and his country jaunts. Life for him was a mix of the two, and it is surely the case that he was a man of real extremes: he was capable of long hours of application to close work, and equally, to the joys of travel, drinking and tomfoolery. Here was a tight-knit circle of like minds, gathered around the Adelphi and James Street. Around the corners from his home were taverns, coffee houses, the homes of other artist and print shops. A short walk away was Covent Garden and also the other conglomerations of print sellers along towards Fleet Street; also close were the academies. He was known by very many in both the commercial and the creative elements of his profession and every day must have offered new contacts or the hearty renewal of acquaintances. Commissions

Old Slaughter's Coffee House, St. Martin's Lane.

Tom's Coffee House, Great Russell Street, Covent Garden.

Coffee Houses, old prints (*Author*).

began to come his way regularly after the turn of the century, and one has the impression that he always had more to do than he had the hours to complete the work.

Rowlandson had patrons and he had businessmen who wanted more from him. In 1798, for instance, the printer S. W. Fores had published the drawings done for *The Comforts of Bath*. But the man who, more than anyone, was to employ the artist was Rudolph Ackermann, also living just around the corner in The Strand.

Rowlandson had mastered the skills of figure drawing, and it has been argued by many that this had been neglected in England, and that he had very much a French influence in this. It could be said that he was one of the very few English artists in his age who could draw with the assurance and ability of the French. He was existing in a microcosm in which he applied himself to what he did best, and influences we might have expected (such as from Turner) just were not there. He kept largely to etching copper, revelling in doing such genres as sporting prints, satire of topical themes, and studies of working life and play. One historian has said that, 'Rowlandson's French experience probably fitted him to collaborate with Pugin as smoothly as any artistic team in Paris. Before England and France stopped trading (1793–1812) Rowlandson repaid his debt to French art by setting a model of fishmongers and countesses, bully

boys and tarts.'[66] That writer compared Rowlandson's Vauxhall Gardens picture with the work by Philbert-Louis Debucourt called, La Promenade Publique in this respect.

He had perfected these skills, made a network of contacts and was surely fulfilled. London had not been so kind to a number of other artists in the late eighteenth century and Regency years, but many found ways to survive against the odds. Rowlandson was unusual in that he had a large social group and could call on help from many quarters. Isolation and depression were always waiting for those who worked hard and long but were unable to call on support when needed. Just as Rowlandson was studying at the Academy, for instance, Gainsborough was in London, making a living. Like Rowlandson, he was robbed, and it took some time to find patrons. One biographer writes about his situation in 1775 like this: 'A letter written by Gainsborough to the Hon. Thomas Stratford ... proves that up to that time he had not succeeded in obtaining Court patronage. "If I ever have anything to do at St James's" writes the artist, "it must be through your interest and singular friendship for me".'[67] In other words, it was find a patron or go under for many artists and writers. Even Johan Christian Bach, son of the great Johan Sebastian, who loved London, died in poverty, buried in the St Pancras churchyard in 1782.

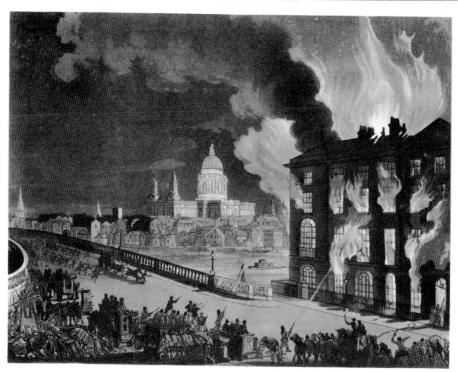

The Great Fire of London, from *The Microcosm of London*.

There is also the subject of Rowlandson's love of gambling and how this integrated into his life. Apart from the gaming tables, he was, as so many were at the time, drawn to the world of horse racing. In the 1780s, Dennis O'Kelly, Irish self-made man and partner of the notorious madame, Catherine Hayes, was more than likely an acquaintance, although there is no documentary proof of this. He painted the bulky O'Kelly at the betting post, in his dandyish dress, mounted on a shiny black horse and wielding a stick, and again when he painted the members of the Jockey Club, he would have known that O'Kelly was banned from that elitist group – something that probably attracted him to the Irishman. The pictures were done after O'Kelly's death just after Christmas 1787, in Half Moon Street, Piccadilly. For sure, Rowlandson was attracted to the races and the fights between bare-knuckle boxers that were also staged at meetings. O'Kelly's biographer thinks that the artist and the entrepreneur knew each other.[68]

In another print, A Kick-Up the Hazard Table – done in 1787 so therefore significant in this context – the man may well be O'Kelly again. Nicholas Clee is sure that this is the case and that the picture is based on an actual event:

> There is a great hubbub around the table: a spectator holds a chair aloft, and it about to bring it down on Dennis's arm; another is about to tackle Dennis's opponent; some gamblers reach for their swords … Joseph Grego, an early authority on Rowlandson's caricatures, said that the incident that inspired this print took place at the Royal Chocolate House in St James's…[69]

It is tempting to speculate that Rowlandson was there or was told of the event by a witness. Either way, his interest in O'Kelly was entirely in keeping with the affection he had for other businessmen and 'characters' who were rakish, loved risk, and who could not resist a flutter.

Rowlandson had it all sorted out, even after gambling away his inheritance. He had the contacts and he had the market by the 1790s. Maybe some of his acquaintances were not exactly desirable company, but most were exactly what he needed when he was unwinding, away from his work table. At that point, Rudolph Ackermann kept him busier than anyone else. According to Joseph Grego, we need to linger a while on Rowlandson's situation at the time and be sure not to underestimate him:

> From 1777 to 1781, five years of Rowlandson's residence in Wardour Street, with all the freshness of his academic studies and the laurels unfaded, with golden opinions as a youth of paramount promise …the artist practised the more laborious and prosaic but surer branch of portrait-painting without success … and his pictures had their place in the Royal Academy…[70]

Grego is here trying to account for the change from well rated student to jobbing artist. In his verbose way, he makes a worthwhile point about how and why Rowlandson closed in on the market place and why Ackermann was to prove so influential in his career.

4

The Microcosm of London

*When a man is tired of London, he is tired of life, for there
is in London all that life can afford.*

Dr Samuel Johnson, from Boswell's *Life of Johnson*

In Vic Gatrell's account of visual satire in Georgian London, *City of Laughter*, he writes: 'Thomas Rowlandson was the artist best equipped to express the vision of London we are reaching for here ... Rowlandson's art was never judgemental or satirical; it simply enlarged the viewer's sense of life's comic possibilities.'[71] That goes to the centre of the artist's achievement. It is important to realise that his art was indeed a 'vision' and that it went beyond the bounds that the word 'satire' suggests. The core of that vision was related to play in its widest sense: the subjects of most of his work on London was the pursuit of pleasure. He has played a major part in defining London as the city of play and recreation. His abiding projection of London and Londoners, as well as visitors and transient types, is one of involvement and escape. His scenes of life evoke the entrapments of the city, similar to the 'moral paralysis' James Joyce saw at work in Dublin in 1900. Something relentless held the population to their pleasures, as much as to their work. The vision did assuredly transcend satire.

Gatrell sensibly reminds anyone with any curiosity about the London of the late eighteenth and early nineteenth centuries that the time was one of great upheaval, and that was just as much in emotional and familial affairs as any social revolution that was going on. The years around 1800 were momentous in all kinds of contexts; The legislation around that time meant to suppress even the slightest hint of seditious talk or print involved a network of government spies and *agents provocateurs* to back up the suppression. But by the side of that there was the most extreme physical and sensual pleasure evident in the wealthier classes. Somewhere in the midst of that chaos was an urge by contemporaries with a sense of moral instinct to point out folly and transgression.

One of the undoubted experts on London, Peter Ackroyd, has evoked the city in *c.* 1800 in this way while discussing Blake's own version of a London theme, 'An Island in the Moon:' 'He manages to mention half the events and sensations of the day – the performing monkey Jacko was to be seen at Astley's theatre in Lambeth; Vincent Lunardi ascended in a balloon from Moorfields ... a Handel festival was held in Westminster Abbey, while exhibitions of the microscope and its slides were very popular...'[72]

Writers and historians have repeatedly compared Rowlandson with Gillray – the two great caricaturists of the Regency. Gillray focused on topical and political issues and Rowlandson went wider and deeper, in the sense that his images indicate certain inherent and universal aspects of urban life and manners. The city at play offered him more potential for his creative perspectives than the city at work: after all, London *c.* 1800 was accelerating in all ways. The population expansion had been a problem since 1580 when Elizabeth I's government were concerned about population pressures having an effect on food supplies and on the micro economy, but by 1800 there were other angles of understanding regarding the city's growth and character.[73] In 1801, the year of the first census, there were almost a million people in the city; by 1820 the figure was one and a quarter million. At the height of Rowlandson's powers, as it were, the city was burgeoning like never before. A number of social forces were brought to bear on the streets around him. Enclosure was steadily depopulating some rural areas; there were soldiers returning from France; the rookeries of St Giles and other places helped the criminal underclass to expand. Above all, hordes came in pursuit of work, and with a hunger for pleasure, for sensual and visual gratification.

Historian Donald A. Low has described this situation very powerfully:

Physically, Georgian London was a boisterous, noisy, confusing mixture of city, town and village, a strange amalgam of old and new. Its two ancient citadels, Westminster and the city …were separated from each other by a densely populated area of startling contrasts: on the one hand, fine squares and dignified thoroughfares – like Bond Street, all glitter and poise – and on the other warrens of evil-smelling and badly lit alleyways…[74]

Earlier in the century, Samuel Johnson, in his satirical poem, *London*, has specifically mentioned the Strand in a notably distasteful way:

For who would leave, unbribed, Hibernia's land,
Or change the rocks of Scotland for the Strand?
There none are swept by sudden fate away,
But all whom Hunger spares, with Age decay:
Here Malice, Rapine, Accident conspire,
And now a rabble rages, now a fire…[75]

Rowlandson only had to walk outside, into the Strand to see this flux and chaos before him. As Whiteford had said, subjects for art came all the time to the creative receptivity of the man in the attic room of James Street. All around him were those who had failed in his trade or in other work akin to his. The precarious edge of life in the city was everywhere visible. As George Gissing was to say seventy years later, 'For people who are not anxious about tomorrow's dinner life in London is very fine … otherwise it is a cruel sort of business.'[76] In contrast, after some tough times, by *c.* 1800 things were picking up, and above all, Rowlandson had a support network. Business projects were to come his way thick and fast.

Before looking at the work that came his way, some consideration is needed about the world of the reception of painting and related visual arts in the period. London

was the focus for collecting and for the society of the connoisseur. There was a craze for things Egyptian and for the ruined classical world in the Regency, and this was developing side by side with the effects of the earlier eighteenth century establishment of the wealthy collector and of the educated connoisseur of art and antiquities. All this provided an expanding market.

We can see this at work in the case of Thomas Hope, for instance. He had settled in London in his twenties, with a massive amount of wealth. From 1795 he travelled and collected objects; oriental artefacts were his special interest, and what he did was display both his collection and his knowledge, to intellectual London society. As Kathryn Sutherland wrote: 'Hope's house in Duchess Street off Portland Place, was planned as a showcase for his eclectic collections and his flamboyant talents. In 1804 he caused a stir by issuing admission tickets to Royal Academicians, with the implication that they might learn taste from him.'[77] Hope was one of many who had embraced the pleasures of being known as an informed collector; as Iain Pears has shown in his account of patronage and connoisseurs in the eighteenth century, there was a certain view of painters from the standpoint of the knowledgeable collectors which played a part in the market. Pears explains the opinion that the 'gentlemen' connoisseur was very different from the painter, referring to Daniel Webb, a writer who had said that painters were not the best judges of art:

He makes the specific distinction between a painter and a gentleman and clearly prefers the claims of the latter. Webb implies that if the painter is also a gentleman then he can legitimately claim to be as good a judge but that practical knowledge of painting itself, rather than being an advantage to appreciation, is in fact a mental distraction which has to be overcome before impartial assessment can be obtained.[78]

In other words, a major element in the market for art then was the implicit view that the gentleman buyer was in matters of aesthetics superior to the artist. Add to this the opinion that 'the painter's work carried with it the danger of mental imbalance'[79] and it opens up all kinds of questions about the nature of art in the marketplace. The generality of debt, deprivation, ill health and depression among the ranks of the artists of the eighteenth century and Regency becomes understandable in a new way if we accept Pears's words. Rowlandson and his peers depended on patronage (at the highest level) and on regular work from retailers in the burgeoning print shops for survival: some moved among the social class of the connoisseurs and others were marginalised. When we look at Rowlandson's good fortune in having a circle of friends as well as plenty of 'orders' from the retail outlets, we can understand at once his similarity and his difference from others, many of whom are now forgotten, and who ended their lives in poverty or behind bars.

He needed patronage of course, and he had to be adaptable, offering any service within his abilities, not simply drawing to order. We have no evidence of any desperation in this, but hints and fragments of evidence suggest that he would consider any one of a number of possibilities when offered. In Rowlandson's letter to 'Friend Heath' in 1804 we have a rare insight into his situation before Ackermann came along and he was in regular demand. This is the letter:

March 1. 1804

Friend Heath,

'Tis with sorrow I relate that my own finances and the little sway I have with the long pursed gentry obliges me retire before the plays are ended ... I hop you will not say as they do at Drury (no money returned after the curtain is drawn up)) The bill sent in says nine numbers, eight only have been received. The ninth mentioned in your bill being delivered November the first, since my Return to town, has through some mistake never come to hand ... I also possess a receipt from you of £2.2.0. and as I hope you call me a trader and poor, you will Make out a fresh bill, and that we shall verify the old proverb of short reckonings

Make long friends. I remain sincerely yours Thos. Rowlandson.

This letter, now held by the British Library, hints at a whole lifestyle as well as at the considerable balancing act Rowlandson had to play between charm and business 'spin'. He refers to being out of town: it becomes more certain that in having bolt holes provided by wealthy friends well away from London he had places to hide and forget

Letter to Friend Heath, Courtesy of the British Library.

the strains of his life of hard work and gambling, and all that followed from that. When he did return to town, letters such as this reveal a quiet desperation; beneath the literate and polite amiability there is a note of confusion and double think. This is a letter of a man having to project a confident self, while all the time he is under mental duress.

'Friend Heath' was James Heath, born in the same year as Rowlandson, but who outlived him by seven years. He was the founder of a dynasty of engravers, and in Rowlandson's time, experts agree that Britain led the world in engraving; James was in fact the Historical Engraver to George III and a comment by John Heath, who wrote the family history, states James was 'a much admired and gregarious figure in the close knit and artistic and theatrical circle in the London of his time' once again reminding the modern enthusiast for Rowlandson that the man mixed in some of the highest social groups at times. James Heath adds that Heath had '... a prodigious output' and was 'regarded as a touch more brilliant than any of his contemporaries.'[80]

Rowlandson's friendship with heath opens up another line of enquiry in the search for the attitudes and choice of work behind the masks, as Rowlandson tended to preserve his privacy. Heath, along with most other engravers, was living in a profession embroiled in argument and controversy, in a search for professional recognition, and this struggle extended from the turn of the century to 1812, and in other channels, even beyond that.

However, there were massively important advantages he had in the art market of *c*. 1800-20. One of the most significant of these was his knowledge of the French art scene, and as many have noted, the French influence on his style. Writers have often commented on the influence of Fragonard, for example, and we have already pointed out the debt owed to Debucourt. There was also the fact that for a short period at this time, England, often the follower of European fashion rather than the initiator, led others in watercolour, and that enhanced the French-English interplay. For instance, in 1824, John Constable had an influence on Delacroix, as Eric Newton has pointed out: 'In the midst of his [Delacroix's] struggle to achieve this vitality, he chanced to see a landscape by Constable that was being exhibited in Paris in 1824. It gave him a fresh insight and a fresh impetus...'[81]

In terms of direct influence, it has often been noted that Fragonard's lines as well as his subjects from the 1780s have striking similarities to Rowlandson's later closet scenes, most clearly in his erotic drawings of liaisons and adultery in well-off homes. The female figures in sensual poses in bedrooms, as in Fragonard's *Waterworks* and *Fireworks,* produced in the early 1770s, place a Rubens-like shape with a modern setting and a strong visual narrative of seduction and sexual pleasure. It is a plain matter to see and be aware of a French influence in his early work, and some of the study he did, perhaps on his own, of the old masters as well as the modern exemplars, surely played a part in his formative aesthetics.

Also, if we survey the other elements in the commerce and production of prints and of etching at the time, again we find innovation, and an excitement in the trade, with new men on the scene in a variety of locations. Rowlandson did plenty of etching, and he was working in a milieu in which improvements were always being made. The Scottish engraver and printer, William Lizars, for instance, apprenticed to his father

when he was only fourteen, later began as a painter, but he had to abandon painting after his father's death; After working in 1818 on the pictorial regalia of Scotland, he worked in 1821 on a more advanced method of etching away the background of a copper plate, so that the result was comparable to a wood engraving. The Annual Register explained: 'A great degree of facility will be obtained by etching out the first line with the common etching-needle, and afterwards putting on the cross line with the varnish; and by this means there will be much more variety...'[82]

Putting all this together, it is possible to assemble an interesting profile of Rowlandson on the eve of his first work with Ackermann. He was working in a market in which cultural factors of patronage and connoisseur buying practices impinged on his status; he was in a profession that was valued and which was open to innovation, and he was aware of the influence of France in drawing in particular. Certainly he knew hardship at this time; after his aunt, and his friend Wigstead, died (the latter in 1800) we can sense that he gave liberally of his time and energy to friends, yet still found time to work with his usual impressive application. Parallels with Sir Walter Scott are worthwhile: both worked every available hour to repair the effects of debt, and both were capable of sustaining friendships as well as professional status in spite of misfortune and character flaws.

Then, in 1808, arguably the most profound influence on his professional life and career happened. He was now to collaborate in a radically different way than simply going on tour with a sketch book.

*

A few hundred yards from Rowlandson's home in James Street was Rudolph Ackermann. In 1806 Lord Nelson's funeral took place and *The Gentleman's Magazine* described the opulent funeral car: 'Within the memory of any man now living, there has not been anything of the kind so transcendently beautiful and splendid as the outer coffin... It is constructed of mahogany, 6 feet 8 long and two and a half feet wide at the shoulders. It is covered with the richest black Genoa velvet, and ornamented with 10,000 double gilt nails...'[83] This wonderful creation was largely the work of Ackermann. He was, in short, an entrepreneur in that age of play, drama and performance. The death of the great hero deserved such ritual and splendour, and the businessman from the Strand was the man for the job.

Ackermann, born in 1764, was the son of a coach builder in Saxony (hence his usefulness for the Nelson contract); and in 1795, he set up his publishing business in the Strand, with the help of his new English wife. But his place was far more than merely a print shop: his establishment was called The Repository of the Arts, sited at 101, the Strand, combining publishing with retail, an art school and a place to eat and enjoy conversation – surely the Starbucks of the day. His shop was one of the first locations to have gas lighting in the city. His main production was of printed books, and he needed artists to provide drawings for the fine colour plates. Rowlandson was on the spot and had the right credentials. As Ackermann progressed, his main enterprise was to make travel books and to find for them a worldwide distribution. Between 1808 and 1810 he set to work with Rowlandson and the future architect Pugin on *The Microcosm of London*.

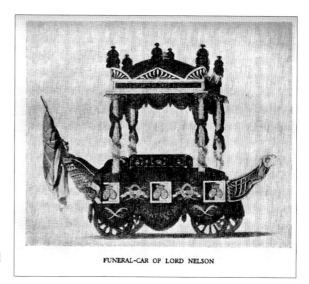

Nelson's funeral carriage, designed
by Rudolph Ackermann (*Author*).

FUNERAL-CAR OF LORD NELSON

Ackermann had the aim of producing highly illustrated books on travel, architecture and gardening (it was the age of 'improvement' in landscaping) and also self-help, individual tuition in handbooks for painting, in that age of amateur and gentlemen artists. The records show that his company produced almost two hundred books between 1800 and 1860; some of his best-sellers being a series called *The World in Miniature* (1821–1827) and *Repository of Arts*, which amounted to forty volumes, produced between 1809 and 1829. All this material included aquatints and lithographs.

He was a businessman as well as an impresario and facilitator. His central achievement was summed up by Francis Klingender: 'Ackermann took the principles of the division of labour established by the eighteenth century printmakers and developed them to a pitch of great excellence, combining fairly large editions with standards of illustration that have never been equalled, let alone surpassed.'[84] Klingender sees the result as being misleading with regard to the truth of the age: something created by a mix of surface elegance with a cheerful coarseness beneath. This seems to extreme: after all, art has always told beautiful untruths, as part of its nature. It is in Ackermann's sense of the contradictions in everyday society that impresses.

Of course, Ackermann merely had the role of middleman. There were several other people involved in his projects. Yet he was always generating ideas and projects, taking out patents and experimenting with technology: 'He laid on gas, not only in the public library, and in his warehouse, printery and workshops, but in his private apartments, to the total exclusion of all other forms of light.'[85] He always had the ability to stay one step ahead in his business, and planned ahead to make sure that when a textbook was needed on lithography, he was the one who did it, signing up a man called Senefelder for the job.

All the projects needed artists, and Klingender points out that his commissioned artists were established and had no tinge of the avant garde about them. He explains: 'He avoided the slashing line of men like Gillray, the apocalyptic ravings of John

Picture of Ackermann's Repository, a plate from the first issue of the magazine in 1809.

Martin or on occasions, Francis Danby... and the chiaroscuro of Turner. He preferred the calmer powers of illustration possessed by such artists as W. H. Pyne, J. C. Stadler, Joseph Nash and Auguste Pugin.' Klingender even claims that Ackermann 'tamed' Rowlandson when he gave him continuous employment.[86] Whether Ackermann tamed anyone is open to question, but when the concept of *The Microcosm of London* came along, it was a group effort.

The book was to be composed of over a hundred plates, the settings and architectural backgrounds done by Pugin, and the human presence added from Rowlandson. As Bernard Falk pointed out, the choice of that pair of artists was a wise decision, and it made commercial sense. He was pairing a steady beginner in book illustration with arguably the best around at the time. But Rowlandson would not perhaps have been completely reliable to finish everything on time if working alone. There was also the buyer to consider. Falk explains: 'The time was past when publishers could hope to foist on the public illustrations in which crowds of people were represented by meaningless hieroglyphics, or at the best by characterless puppets...'[87]

We have two very contrasting accounts of the genesis and the production of *The Microcosm of London*. Falk's story of the book, now done seventy years ago, very much leans towards defining Pugin as the rather limited and somewhat snooty partner, capable of architectural precision but offering no sparkle of human vitality in the image. More recently, Rosemary Hill has investigated more fully the part played by Pugin's wife. Catherine Welby, in the enterprise. Falk says, 'To conform to Pugin's ideas he [Rowlandson] repeatedly had to make alterations, though the finished plate was not necessarily improved thereby.'[88] However, now we must look at Pugin and Welby's input again.

Auguste had married Catherine, who was a member of a wealthy Lincolnshire landed family, in February 1802 at the church of St Mary in Marylebone. Auguste, like Rowlandson, was of French descent, but with much more drama and aristocratic status, although Auguste's father had exaggerated the drama somewhat. Catherine Welby was very much the 'advanced woman' of her time, with no worries about a supply of money she and her brother had indulged in their own version of the country idyll so popular in theorists at the time. But then she had been more radicalised and found enough to satisfy her imagination as well as her affections in Auguste.

When they settled down to work, they too found that the early years of the nineteenth century were a perfect time for a graphic artist to be in search of work. Catherine was the literary and highly driven force in their partnership, and they began by writing and drawing an account of the famous impeachment of Lord Melville at Westminster Hall; but Auguste was in demand for watercolours also; he was drawing the scene of the nelson cortege, no doubt being aware that Ackermann had designed the carriage. He was doing what Rowlandson and a thousand others had done – taking the first steps in forming a career and letting his skills be known more widely. He was helped in this by his wife, who was obviously a very adept communicator and knew about the importance of mixing in the right circles. Pugin's biographer has no doubt about Catherine's character in this context: 'Without doubt it was Catherine who set the pace in the Pugins' marriage. She was energetic, ambitious, her husband much less forceful and more indolent.'[89] He was listed in Holden's Directory, which had just appeared in its first form in 1805, and was soon to cover not only London but almost five hundred other British towns. This was upmarket: Rowlandson was not there. As for Pugin, he knew that watercolour was the art linked with the social status he needed, so he exhibited at the Royal Academy, and also became a member of the Society of Painters in Watercolour.

He met Ackerman, and as Rosemary Hill notes (and this is something unknown to Falk) Catherine was the person who conceived of *The Microcosm of London*: 'Catherine's idea was to produce a variation on the usual sequence of topographical views which "afforded little more than a representation of ... public buildings, churches etc." This would be a full "portrait of the metropolis of England.' It would also include 'the modes and customs of streets thronged by men and women."'[90] This was to be a comprehensive panorama of London, and in modern terms, it would mix a documentary method with both entertaining and informative impressions of a specific society – the hub of the most populous city in the world in 1800.

The concept was naturally something fully developed after Ackermann had met Pugin and Catherine; it would have been a momentous meeting; Catherine had put forward a synopsis, and that of course was based on the Pugins working in their usual partnership. Then, in Ackermann's hands, and after having been processed by him, it emerged as a project crying out for a very specific collaboration. His design was for a series that would span three years, and which would have 104 illustrations; the team then enlarged with William Pyne seeing to the letterpress, Pugin for the settings and Rowlandson for the people. Pyne was yet another example of an artist struggling with want and limited resources, dying in poverty in the King's Bench prison in 1843 after working on William Miller's The Costumes of Great Britain. As both Falk and Hill have noted and explained, Pugin and Rowlandson were chalk and cheese. After all, Rowlandson was used to pressing his own vision, done with speed and assurance, infused with his accustomed human dynamic. Pugin was naturally more retrained and precise. It is surely the case that Ackermann had to do what businessmen have done when working with creative souls all through history – find a compromise between his market, his artists and the nature of the product as he had it in his own mind. Therefore, when Rowlandson firmly suggested a practical change – 'With submission to Mr Pugin's better judgement, Mr Rowlandson conceives if the light came in ye other side of ye picture, the figures would be set off to better advantage'[91]

Aquatint was just right to reproduce watercolour, and this matched Rowlandson's affection for tints and wash over his line. *The Microcosm* achieved great things: the value of the publication continues to increase and it is in many ways a classic of book illustration, and marks a successful partnership, although it is significant that Pugin never worked with Rowlandson again. He very likely asked Ackermann that he be allowed to work alone in future.

The reasons for the success of the publication are not difficult to find. In the more static images such as the Court of King's Bench, Westminster Hall, or of the Dining Hall, Asylum, Lambeth, we have the dominant perspective generating grandeur and power, with the people appearing to be integral to the location. But in the crowd scenes we have Rowlandson in his element, as he was to show also in his work for The Miseries of London a little later. This is exemplified in Bartholomew Fair, for example. As a subject, this had a special poignancy and topicality in 1808. It was under threat: after being moved to Islington in 1810, its reputation degenerated and in 1855 it was completely suppressed. As Brewer's Dictionary of Phrase and Fable notes: '... the licentious revelry and rioting that went on... entirely changed its character which originally was that of a market for cloth and other goods.'[92]

The book slots into a long and fascinating history of London literature of this kind. In 1545 there had been *The Lamentations of a Christian against the City of London* by Roderigo Mors which was a survey of the 'vices' of the urban lifestyle. Closer to Rowlandson's time there was Tallis' *London Street Views* (1838-1840) and H. W. Dilworth's *History of London* (1722) but there had also been reprints of possibly the most comprehensive London classic, John Stow's *Survey of London*, the Elizabethan masterpiece of 1598: it was reprinted in folio in 1725 and then again updated in 1754-55. Ackermann certainly was one major place in the genre, and after him there were followers of the visual survey, notably Partington's *National History and Views of London* (1834) and Timb's *Curiosities of London* (1857).

In terms of Rowlandson's overall career development, *The Microcosm of London* shows him at his very best as a supreme artist of social commentary. Both Welby and Ackermann had seen the market, but had also seen beyond that, being certain that the spirit of the age and the place was ready for that kind of scrutiny: to show the vibrancy but also the towering institutional background to the transient life in the streets. The images depict, again and again, the vulnerability of life lived on the edge of reason and order: the very institutions Pugin drew, great edifices of power and indeed terror, were waiting for those who failed and went under. As Jerry White has shown in his account of the Marshalsea jail, the debtors who could not arrange, with help, to pay anything at all to creditors were lodged in what was called the 'Common side' of the jail. He describes this: 'Here the prisoners with no money or friends to support them were compelled to live in atrocious conditions ... Prisoners would starve until their friends or creditors helped them or until they starved to death.'[93] That contrast serves as a metaphor for the duality of London existence. Of course, not all the images of places are formidable, yet the ambiguity and irony are there; for instance, we have the Fleet prison in one plate – apparently, on the surface, no more worrying than a school playground. The families of debtors are there, frolicking in an open space. But then there is the high wall behind, and the prison block over them all.

Drawing of the Marshalsea prison, old print (*Author*).

On the other hand, there is also work, as well as play. The scene of Leadenhall Market for example, shows men at work, strained to push and pull: there is a slight reminder that a few decades later the Victorians would begin to idolise and advocate the dignity of work, with the human figures often dominating the observer's scrutiny. But in 1808 the built environment was seen and mediated as a firm, changeless and unforgiving backdrop to both work and play.

Working with Ackermann and Pugin, Rowlandson had demonstrated that he was able to co-operate and to share and comprehend the vision of what we would now think of as a 'brief.' As with all such endeavour, the market led the work, and without a co-operative venture there would have been failure. This is why in some opinions, as Klingender said, Rowlandson had to be 'tamed.' But of course, long before that he had handled an assortment of challenges and requests. He was to work with Ackermann for many more years, and as he lost his friend Michell, once again his pattern of life was disrupted emotionally. He had a private life, meeting and living with Betsey Winter, whom he jokingly called his wife. But they never married and there is no record of any children.

From *c.* 1810 he was to be forever linked with another partner, very different from Pugin: someone who knew the depths of poverty and who was one of the most impressive hacks in the history of Grub Street. Yet it has to be speculated to what extent working with Pugin was an educative experience for Rowlandson. Here was an instance in which a man who had come to indulge in his own set approaches was asked to collaborate with a very different personality. Once again, reading between the lines, it has to be said that Ackermann worked wonders in seeing this project through.

5

William Combe and Dr Syntax

Satire is a sort of glass, wherein beholders do
Generally discover everybody's face but their own...

Jonathan Swift, Preface to *The Battle of the Books*.

This collaboration was to be one of the strangest pairings in English literature. It was essentially a tale of a hack and a jobbing artist, as far as their contemporaries would think of it. As it turned out, it was a huge commercial success and it spawned a comic strip prototype.

By the time William Combe came to work with Ackermann and Rowlandson in 1809, to finish *The Microcosm* project, this jobbing writer was a guest of the King's Bench prison, and he had to return there at curfew. There must have been an affinity between the artist and the writer in this instance. Combe was sixty-seven then, and had crammed a great deal into his busy and eventful life, as Rowlandson had done; but this rather maligned literary hack linked with the supreme satirist of Regency England were destined to produce a big hit – the true commercial success of both artists' lives.

Combe is a figure of paradox and contradiction, and this was made more extreme by his unknown and uncertain years, and also by his sheer breadth of interests and publications. When he married Maria Foster, wife of a former school friend, in 1776, he was described in the press as 'A gentleman who is universally known, from having distinguished himself in this, and other countries, in various shapes and characters.'[94] He was at Eton College, and later after the death of his father he had a guardian called William Alexander, after whose death in 1762, Combe inherited considerable wealth. There was something of the dreamer and the actor in him: he fancied himself as a gentleman among the dandies and rakes, and signed himself 'Esquire.' Yet he was in some ways entirely typical of the young men of his generation; like Rowlandson he travelled in France, but was apparently penniless by 1770. His activities in the 1770s are a mystery: he may have been a soldier, and that never worked out, just as the earlier intention of having a legal career never worked out either.

What he did do well was make friendships and enter into a range of employment, developing himself as a jack of all trades. One close friend was the writer Laurence Sterne, author of *Tristram Shandy*; but by 1773 he had made his first venture into the lower reaches of the literary world, when he was given the chance of editing a book by Thomas Falkner called *A Description of Patagonia*. That was a common way into

hack writing, just as Dr Johnson had done when he translated a work on Abyssinia (as it was then). After that there was no stopping him, and with remarkable energy he wrote a play, *The Flattering Milliner*, which was staged in Bristol; what he did latch on to was the public's affection for parody. He wrote a volume of letters purporting to be written by Sterne to others, called *Letters to his Friends on Various occasions*. Combe the master of pastiche and copyist style was born.

In the 1770s he was well known – despite the fact that his early books were anonymous it was commonly known that he was the author. He was very much a journalist with an eye to topicality. In 1771 Henry Mackenzie published *The Man of Feeling* and it was a great success: it was no more that sketches of 'the new man' – one of refined sensibility and social grace. It had such an impact that it influenced various other writers including Charles Lamb. Richard Sheridan spoofed the whole notion in 1777 with his play, *The School for Scandal*. For Combe, it was there to be exploited, and he wrote *The Philosopher in Bristol* (1775). It explains much about Combe that this was self-published: he was desperate to strike while the iron was hot, even though it meant a rash experiment financially.

The core of survival in the Regency years for any number of people in all walks of life was the desperate search for financial security, with a universal search for patronage and for other ways of surviving in the arts by any possible means. Combe was entirely typical in this. It was an age when, for instance, large numbers of people managed to live in sinecures and pensions, doing very little. As a publication of 1819 called The Extraordinary Red Book shows, there were such posts as clerk to the dockyards, with pay of £100 per annum, along with thousands of pensioners such as Lady Collingwood who

William Combe's *The Flattering Milliner* playbill (*Author*).

received £1,000 per annum and her two daughters each received £500 simply for being her companions. Crowds waited in levee for favours of the rich, scribes and hacks wrote letters begging for patronage, and a lower rank of hacks hung around the booksellers of St Paul's trying to live on pence for writing paragraphs, obituaries and reviews. Combe was one who tried patronage and when it failed, he ridiculed the rich instead. The Regent (George, later George IV) himself loved portraiture and if, like Thomas Lawrence, a painter could specialise in doing flattering portraits, then patronage might be more possible. But for the Combes and Rowlandsons of the world, the printers and booksellers had the power, and with Combe in mind, it is worth noting that the writers generally did rather better than the painters in terms of the Regent's attention. As Donald A. Low put it: '... It made a difference to the social and intellectual climate that the Regent was as ready to talk with poets as with statesmen, and to confer a baronetcy on Walter Scott; in this way writers were made to feel that they counted for something in society.'[95]

In fact cash – the lack of it – became the formative influence on his life. Perhaps the stem of this was his debts related to the expense of keeping his wife in an asylum run by Stephen Casey at Plaistow in Essex. From the early 1780s he turned his attention to the easiest route to reputation in literature: he wrote satires. One of his targets was Simon Luttrell, Baron Irnham and later Earl of Carhampton. In 1744 he bought his country seat, Four Oaks, in Warwickshire, and by 1754 he was MP for Michael in Cornwall. Combe and others saw him as an excellent satirical target, and one ballad has him as a candidate for the title of King of Hell: 'But as he spoke there issued from the crowd/ Irnham the base, the cruel and the proud/ and eager cried, "I boast superior claim/ To Hell's dark throne and Irnham is my name.'[96]

His career up to meeting and working with Rowlandson was mixed, uncertain and risky; but one thing he did do that turned out to be successful was work with the new *Times* newspaper. When the writer and diarist Henry Crabb Robinson, wrote his memoirs near the end of his long life (he died in 1867) he had known virtually everyone of any note in the Romantic literature and culture of the time, and he had known Combe earlier in his life when Robinson was foreign editor and Combe was a regular contributor to what was then the *Daily Universal Register* but which would become *The Times*. Robinson gives us this impression of Combe:

> I understand that he was a man of fortune when young, and travelled in Europe and even made a journey with Sterne; that he ran through his fortune, and took to literature, when house and land were gone and spent, and when his high connections ceased to be of service ... I used to enjoy the anecdotes he told after dinner, until one day, when he had been very communicative, and I had sucked in all he related with a greedy ear, Fraser said, laughing to Walter, "Robinson, you see is quite a flat ... he believes all that old Combe says."[97]

Robinson was embarrassed that he had been too credulous, but the tale tells us a lot about Combe when he was older: he clearly had been minor celebrity in his time, and was still a good talker, but there was the 'imitator' of old – that man who had written so much in imitation of others, for laughs and for satire, was later perhaps out of control in that respect and exaggerated everything for the sake of a good story.

Combe was sixty-six when he began his four years in prison; this was in 1808 and in that year, Ackermann needed a writer to handle the text for the last volume and Combe stepped in. Combe's biographer points out that the vast output that followed, writing that kept him busy behind bars and out on what we would today call licence, was not all hackwork. He writes:

> The compilation of seven hundred pages on Westminster Abbey ... required a diligent
> search for information, and many volumes of antiquarian lore must have been brought
> to his quarters while he was performing this assignment. There was certainly a library
> in the Bench, yet Combe manages to cite learned authorities...'[98]

He definitely had a scholarly ability, and he could cope with that as well as with real journeyman penny-a-line stuff. Between 1810 and 1822 he produced fourteen solid volumes of topography and contributed a massive amount of material to such publications as would give him column inches.

With all this in mind, it becomes clear that the man Rowlandson was asked to work with had known a brief period of fame, and he had moved in high circles. When Georgiana, future Duchess of Devonshire's brother George, wrote *An Epistle from a Young Lady of Quality abroad to her Brother at School in England* in 1773, he was very much part of the vogue for supposed works by and about celebrities; William Combe pitched in, never one to miss a chance of some easy money. He produced *A Letter to her Grace the Duchess of Devonshire* and *The Duchess of Devonshire's Cow: A Poem*. He was creating a set of fabrications when other supposed printed responses followed. 'Count Combe' as he was known at the time, was on everyone's lips, at least for a few years. Yet by *c.* 1810 he was in dire straits, and surely Rowlandson would have known his collaborator's past life history and felt some sympathy. After all, Combe had also figured prominently in other notable lives: his oldest friend was the painter and miniaturist, Richard Cosway, and when Richard died of a stroke as he rode in Regent's Park, it was Combe who helped the artist's sisters to settle their affairs. He then wrote a memoir of Cosway, and although it was incomplete, there are practical reasons for that, mainly a lack of materials sent by the friends and family.

Richard Cosway and his wife Maria had held salons in their home in Pall Mall, where they lived close to Gainsborough, and their circle of guests and friends included the Prince of Wales, the Duchess of Devonshire and Horace Walpole. He had produced a wonderful miniature of Mrs Fitzherbert, the Prince's mistress, and he had been welcomed into the royal coterie. Graham Reynolds, writing on Cosway, explains his success: 'Cosway achieved in his life many of the social ambitions which Joshua Reynolds had staked out for the artist. It is possible to fill out his biography with copious further incident and anecdote, for he was constantly in the public eye.'[99]

Such were Combe's contacts. He had been at school with Cosway and knew him very well indeed. It takes just a little conjecture to imagine William Combe being known and spoken of in all varieties of interlinking groups in the arts and in journalism in the Regency years.

Such was the man, now a debtor and prisoner, whom Ackermann found and signed up to work with Rowlandson. To really understand what Combe's life was like at

this time we need to consider the debtor's life in the King's Bench at the turn of the eighteenth century. He was allowed out in the circumscribed area between stipulated times of day. John Walter, proprietor of *The Times* in 1806, was the man who employed Crabb Robinson, and we know from the latter's memoirs that Walter offered to pay Combe's debts, but Robinson then says, 'This he would not permit, as he did not acknowledge the equity of the claim for which he suffered imprisonment. He preferred living on an allowance from Walter, and was, he said, perfectly happy.'[100]

The King's Bench prison was destroyed in 1780 by the destruction brought about by the Gordon Riots, and it was a grim landmark to all Londoners, having been there in Southwark, less than a mile from London Bridge, since the fourteenth century to the east of Borough High Street. The conditions inside always depended on what prisoners could gather by way of finances, but in 1754 reports had shown what an awful place it was. However by the early nineteenth century, it was noted as a place where, if a small fee was paid, a prisoner could even be allowed to leave for a day or two. In Combe's case, the rules allowed him to live in the 'Liberties' – the area outside a borough where traditionally, freeman held customary rights. In an interesting sidelight on life in the Bench around 1800, Henry Angelo wrote in his memoirs of visiting a friend there, 'In the Bench ... everybody knows that there is plenty of space to play at racket, which serves for an amusement as well as to improve the health. Often we mounted the top of the prison there ... secure from being seen, and we played with the Highland broadswords.'[101]

Combe, because he still had work, had a small income. The idea was that creditors would wait until their debtor's circumstances changed and payments could be made to them. Obviously, if the debtor was thrown into a dark room and forgotten then nothing would ever be received from them. The debts Combe had were largely from Stephen Casey, the owner of the asylum in Plaistow where Come's wife had been for years. But also he had been taking a small pension and that had been withdrawn, and the printer he worked for, Boydells, were in straitened circumstances. They had been paying him a retainer and that had to be reduced. As if all this were not enough, he had lived beyond his means. In 1790 he was living the life of an urban gentleman with a horse and servant, and as he loved the harpsichord, he bought a new one at the time, but on credit. By the late 1790s all these pressed on him. He had even owed cash to the painter George Romney, and we know that Combe wrote to Romney in 1798:

> My dear Sir,
> I have called several times in Cavendish Square, & you were always at your villa – I have frequently designed to see you there in your rustic glory, but my engagements and the shortness of the days have prevented my enjoying that pleasure – It will not, however, be long before I shall take the opportunity to wait upon you, and to repay the obligation you were so very good as to confer upon
>
> <div align="right">Your faithful and obliged humble servant
Wm Combe.</div>

This is clearly the voice of a man accustomed to the required ruses and excuses of a situation of severe debt; it is also from a man who lives on the edge of order and rationality.

On 4 May 1799 the bailiff called and a week or so later he stood in the court of King's Bench; two men called Douglas and Lambert were suing for the sum of £40 11s 6d. Combe had some experience studying law and so had no attorney. He lost, and so began a second term in gaol. Stephen Casey was pursuing him for a vast sum of almost £200 without costs.

In the King's Bench he lived well, though. He was not a common debtor: he could eat and drink well. Tradesmen came into the prison each morning with food and materials; he would not have had to share a cell ('chum up' as it was called); Rowlandson and Pugin drew the Bench prison in *The Microcosm of London* in 1809, showing the large panoramic sweep of its interior open ground and the throngs of people walking and talking, behind them the high walls and the blocks, made along the lines of what would be the new penitentiaries.

However, he kept on writing, and much of what he did was light and entertaining. In a work for Ackermann called *The Schoolmaster's Tour,* written for the periodical called *The Poetical Magazine,* Rowlandson provided the prints; this was to become the work for which Combe was most celebrated and remembered: *The Tour of Dr Syntax in Search of the Picturesque,* appearing in 1812. Combe's biographer wrote of this:

> For over a century it was to be a household favourite in many countries, and not merely for the celebrated aquatints which it was written to illustrate.... The character of the absurd but somehow winning clergyman could not have caught the fancy of so many readers, however unsophisticated, had it not been conceived with imagination and portrayed in the verses as well as in the prints with verve and originality.[102]

In essence, Rowlandson and Combe were a very successful team. There was something of destiny, or at least, rare compatibility in these two men working together. Combe had been born in Wood Street, in 1742, fourteen years before Rowlandson was to be born around the corner in Old Jewry; they were children of the same neck of London in Cheapside. They both had money troubles, and both worked feverously to keep their heads above water; both were naturally suited to working to order from printers and other patrons, and of course, they relished the frisson of risk.

Where Combe was living beyond his means and over-reaching in all areas of his life, Rowlandson was at the gaming tables. He was also trying any number of ploys in order to earn more, as well. We know now that in 1804 he wrote this letter to Anna Maria, Viscountess Kirkwall:

> Mr Rowlandson respectfully ... waits on Lady Kirkwall ... returns his thanks for her patronage and partiality to his style of drawings. Mr R. will be happy in communicating to her Ladyship his manner should she wish to adopt it in preference to the one she now possesses – unfortunately for Mr R he has undertaken to etch two political plates which will occupy the whole of his time till Wednesday next. Should Her Ladyship remain in town beyond the expiration of that time, Mr R. will with pleasure (and punctuality) attend her commands.[103]

We owe this discovery to John Riely, and he adds that Lady Kirkwall was drawn by Rowlandson around 1805 and that she had bought some of Rowlandson's drawings.

Riely notes that this letter is our 'first glimpse of him in the unfamiliar role of drawing-master.'[104]

He was, like Combe, always open to new sources of income, and was quite happy to give lessons to the aristocracy. Lady Kirkwall was a subject of one of his drawings, done again around 1805; she was the daughter of John, the first Baron de Blaquiere, a soldier who was eventually raised to the status of an Irish peer. Lady Kirkwall fell out with her mother-in-law and then this also led to a split between herself and her husband, and they separated. He was John Hamilton FitzMaurice, the son of the Earl of Shelburne; he was MP for Heytesbury in 1802–06 and later for Denbigh. He died in 1820, and Anna Maria lived until 1843. She was indeed from a very high-ranking family, her father being Chief Secretary for Ireland, and he was made a Knight Companion of the order of the Bath.

Rowlandson was too busy to immediately turn up and teach Anna Maria to draw. He and Combe, too fond of risk and with something of the rake about them, careered giddily from extreme labour to extreme fun, and had to pay for this by working all day and night to fulfil commissions. They were at the height of their powers when the business of publishing and printing really took off. As well as Ackermann, there was a small shop open at the time (it had been there since 1792) in Grosvenor Street, owned by Henry Walton Smith. After his death, his wife and young son, W. H. Smith, began to improve the business so that by 1816 Smith brothers were doing well in bookselling, binding and paper selling. The future business giant of W. H. Smith was born, in step with Ackermann's Repository of the Arts. In that rising trade, as with the arts they needed, it was all about the work ethic: W. H. Smith was 'A hard worker who began early and ended late and never tired of devising new schemes for the expansion of the business.'[105] Printers and artists were both eagerly labouring for success.

Rowlandson was of course still gambling. His attraction to the gaming tables was typical of his time. London was the focus for gentlemen's clubs, most prominent of these being White's, Brook's and Boodle's. From the coffee houses of Augustan England and earlier, back to the late seventeenth century, clubs of all kinds had grown, and by the Regency period, the main attraction was gambling. But rather than being exclusive clubs, some of them were open to all, as Venetia Murray explains: 'Even highwaymen of the more presentable type were constantly to be met at the Chocolate House; judges were liable to meet the man whom they afterwards might have to sentence in the dock...'[106] That has to be a draw for a man like Rowlandson – the egalitarian search for pleasure, being close enough to smell the road and the field on the man next to you, being acutely responsive to the human interplay at the tables, when class takes a back seat, as it were.

Gambling was universal at the time. At the very top, the Prince of Wales was completely profligate; in 1783 parliament had to make him a gift of £30,000 to pay his debts. In addition he had £50,000 per annum from his father, the King. Regency society gambled on the turf and on fighting of course. This has to explain Rowlandson's drawing of O'Regan the owner of the great race horse, Eclipse, and his interest in racing generally. In boxing, the stakes were often as high as anything in the gaming houses. Lord Barrymore won £25,000 on a fight between Hooper and Watson, two bare knuckle men.

Most common games were Hazard, in which players cast the dice up against the bank of a certain number, between five and nine. There was also faro, in which players bet on the order of appearance of specified cards at table. There was no limit on the

number of players involved and money could be lost very quickly. This story is one of many typical of the potential ruin waiting men at the tables:

> January 1st 1787: summoned early this morning to the house of a lady of rank, whom I was to attend in her second pregnancy. Her pains had come on in the early hours and the midwife was sent for. About an hour later the lady's husband returned home in company with her brother; both were intoxicated, and the husband particularly had plunged very heavily at the Cocoa Tree, losing, it is said, upwards of £11,000 at the faro tables ... And so rose and came home, where making an excuse to his brother-in-law, stepped aside into the library and blew out his brains.[107]

One suspects that Rowlandson had a great deal of professional interest in watching humanity in these situations, held in the throes of extreme folly and excitement. We know that he was drawn into this frisson of pleasure, however, and that it must have held him in its power. The assembly rooms, as well as the clubs, grew apace in Rowlandson's time as well: Almacks was arguably the most prestigious, starting its existence in 1765 as an upper class social club for card games. But by Regency times it caused a stir by admitting upper class women inside to gamble. Almacks may have been a cut above most clubs, being so exclusive that it once turned away the Duke of Wellington for wearing the wrong breeches. It seems probable that Rowlandson patronised the card tables more than anything else. He actually appears in a mezzotint by Ward called The Gamesters, done in 1786. The card player holding an ace behind him is Rowlandson. Again, in a print called The Brace of Blackguards, he is the man ready for a fight. We know that Jack Bannister used to reprimand Rowlandson for gambling, and in the memoir of J. R. Smith we have a comment: '"You may spare your sympathy and advice" said the engraver, "for that Tom Rowlandson was, is, and ever will be, incurable."'[108]

This combination of talents, then, started work on Dr Syntax. The first Dr Syntax book, *In Search of the Picturesque*, was advertised and received very enthusiastically. In *The Times*, 12 May 1812, we have: 'R. Ackermann has the honour to inform the nobility, gentry and the public that a Tour in Search of the Picturesque by the Rev. Dr. Syntax, a poem in thirty chapters, printed with a new type, on large royal octavo vellum paper, and hot-pressed ...Was ready for delivery at his repository of Arts, 101 Strand, on the 1st of May instant. It may be had of all the booksellers in the United Kingdom.'[109]

Rowlandson was the originator of the book. Naturally, he was an ideal choice for a book based around a national journey. He had already done the tours of Wales and Europe, and he had been riding to Michell's house in Cornwall, and his other place in Essex, for many years, when he conceived of the notion of using a character based on William Gilpin as the centre of the narrative. He seems to have told his friend Bannister. Hamilton explains:

> One evening early in 1809 the artist talked the matter over with John Bannister the actor. He was planning, he said, "To sketch a series where the object may be made ridiculous without much thinking." He had recently been travelling in Devonshire and Cornwall making sketches along the coast, and his travelling companion on that trip had suggested himself as a sufficiently absurd hero of such a series...[110]

THE TOUR
OF
DOCTOR SYNTAX,
IN SEARCH OF THE
Pic
TURESQUE
A POEM.

Ut Pictura, Poesis, erit; quæ, si propius stes,
Te capiat magis: et quædam, si longius abstes.
Hæc amat obscurum, volet hæc sub luce videri:
Judicis argutum quæ non formidat acumen:
Hæc placuit semel, hæc decies repetita placebit.
 Horat Ars. Poet.

Frontispiece to Dr Syntax (*Author*).

Gilpin, who had died in 1804, was the vicar of Boldre and also a teacher; his writings, as mentioned in chapter 3, were often related to the concept of the picturesque, and from 1768 he had begun travelling over many parts of the British Isles, going to the travel hot spots of the time – Wales (the River Wye in particular) and to the Lakes and Scotland. It is clear that Gilpin was open to ridicule and criticism, as he published so much and those works have a solid, earnest, moral tenor to them. In 1779 he published *Lectures on the Catechism of the Church of England* and then he was described as 'William Gilpin MA. Vicar of Boldre near Leamington'; then in 1790 we have *An Exposition of the New Testament*; in 1802 he gave the world *Sermons Preached to a Country Congregation*, and when he produced Observations on the Western Parts of England he was noted as being 'Prebend of Salisbury' as well as the vicar and scholar already known to the reading public.

There is an element here of the professional scoffing at the amateur. Gilpin painted and drew what he saw, but as he dabbled in a range of activities, he was open to criticism from the specialists, as that is the way of the world. As a scholar there was a solid foundation for what he achieved: he had two Oxford degrees; and he then took up a curacy in London, then later was a master at a school in Cheam. He was remarkably ahead of his time in his educational ideas: he was an advocate of students working out their own discipline, anticipating some of the modern ideas of A. S. Neill at Summerhill. But his writing took off after he was forced to write (again, as with so many, pressed by debt) a biography of his grandfather, John Gilpin.

At his parish in Boldre he worked hard to improve conditions for the poor, including efforts to secure endowments for the parish school, and he even auctions some of his art work to raise funds for that good cause. What we need to grasp here, linking this

to Rowlandson's extension of the Gilpin character into Dr Syntax, is something of the boyish playfulness which delights in stereotypes and in bringing out the absurdity of set types in the professions and in social status. Also, Gilpin's travels in the south west, along with Rowlandson's own in the same place, were very topical and voguish. As Ian Maxted has shown, Devon and Cornwall were being travelled and written about extensively at the time. A typical example was Thomas Hewitt Williams:

> An important local undertaking in these early years was a series of works by the landscape artist and portrait painter Thomas Hewitt Williams, resident first in Plymouth and later in Exeter, who published accounts of three series of excursions, illustrated by about 20 etchings: Picturesque Excursions in Devonshire (1801), A Tour to the North of Devon (1802) and Picturesque Excursions in South Devon (1804).'[111]

It is also worth noting that Gilpin's travels and extensive writings on his tours had a massive influence. People actually became disciples, as we learn from the memoirs of Samuel Rogers, writer and friend of almost every literary character in London during the Romantic period; the routes he took and his manner of writing, took hold in the ranks of the wealthy connoisseurs. As Carl Barbier has explained in his study of Rogers and Gilpin (who knew each other well and corresponded): 'Among the travellers in the 1770s there was a small select band that could already be termed picturesque; many were former pupils of Cheam, where they had received the rudiments of drawing from William Gilpin, or from his more gifted brother, Sawrey Gilpin ...With these young men as they grew up, and with others interested in his ideas, Gilpin expressed himself freely years before he committed himself to print.'[112]

When Rogers himself set off to travel, he went to Scotland and the Lakes in search of the picturesque, and that phrase became an established cliché of the time, hence its use in Rowlandson and Combe's book. Barbier explains: 'He planned his route very carefully to cover most of the ground described by Gilpin. From a MS volume entitled *Various Heads of Tours*, in which Rogers kept a record of the routes of his early journeys, we can follow his progress north.'[113] Rogers, along with many others, followed Gilpin. The template was there for the satirists to follow, as is always the case with a vogue.

Of course, although there was this ready-made fashionable area to stimulate interest, the main point is that Rowlandson knew it well, after his visits to Hangar House. More important is the fact that it caught his imagination. The figure of a learned stranger, visiting rural locations and imposing his personality on the locals is the focus here; add to that the vision of caricature Rowlandson conceived and we have a formula for an entertaining satire. Combe would instinctively be attracted to this too, as he had been nurtured on imitation – in a modern sense, of 'sending up' his victims in verse.

The theme of a naïve, educated man setting out to visit the seedier side of England, along with other important people and locations, had also been done in the very influential novel by Henry Mackenzie, *The Man of Feeling* (1771). The hero, Harley, visits Bedlam, a misanthropist, beggars in the roads, and prostitutes, among other elements of contemporary life. Both Combe and Rowlandson would certainly have known of this book, and probably have read and discussed it. On its publication, Rowlandson was a

young student, and the notion of 'sentiment' and 'feeling' was everywhere, as happens with best-sellers among the glitterati. But there is no doubt that after thirty years had passed, the first impact of that book, in which the man of feeling responds with tears and an excess of emotion to scenes of distress on his travels, had abated and the theme was seen by many as being too affected and indeed laughable. That response in *c.* 1800 was in line With Jane Austen's poking fun at supposed heroes who 'feel' keenly on the surface but are in fact hypocrites. The theme had also been dealt with by Richard Brinsley Sheridan in *The School for Scandal* (1777) in which Sir Peter Teazle says of Joseph Surface, 'Well, well, you'll be convinced when you know him. 'Tis edification to hear him converse; he professes the noblest sentiments.'[114] The parson character came from an amalgam of these various sources, although clearly Gilpin was at the centre of this. In some ways, the journeys in search of the picturesque, although they were aesthetic adventures, were bound to include an incidental enquiry into what was later called 'the condition of England' in the 1840s. In fact, it could be argued that even in Rowlandson and Combe satirical mode, they gave a series of scenes which provided a profile of England at the time.

There was another person involved also – Bannister. He takes the credit, in the discussion with Rowlandson, of giving shape to the parson figure. Hamilton retells the tale:

> "I have it!" exclaimed the actor, and proceeded to describe a subject closely resembling Dr Syntax." You must fancy a skin-and -bone hero, a pedantic old prig, in a shovel hat, with a pony, sketching tools and rattle traps, and place him in such scrapes as travellers frequently meet with hedge ale-houses, second and third-rate inns, thieves, gibbets, mad bulls...[115]

It is not difficult to see the origins of this. In the mid eighteenth century there had been the novel of adventure, the on-the-road social melodrama and satire we see for instance in Henry Fielding's *Tom Jones* (1749) and in Tobias Smollett's *The Adventures of Peregrine Pickle* (1751). The open road and the various mishaps and inconveniences of the country and the rural types, from crime to fecklessness, are the strong element. We may also find some roots of Dr Syntax, though, in popular prints and cheap books.

<p style="text-align:center">*</p>

The cheap prints, showing scenes from rural England, were immensely popular in the eighteenth century: such scenes as 'The Roast beef of Old England' with a fat gentleman eating at table, and the common caricatures of clergymen, such as images of two vicars very drunk, one with the words, 'Why Moses you dog/ you're as drunk as a hog' beneath and another with, 'Why I'm tipsy 'tis true /and I think so are you.' We can see the subject of learned clergymen and scholars as objects of satire reaching far back across the centuries in popular culture. This may be traced back even to Chaucer at the end of the fourteenth century, where we have various clergy on the road, on pilgrimage, and much closer to Rowlandson's time we have the issue of pluralism, clergymen having additional income from parishes where they hardly ever appeared or gave sermons and guidance.

The picturesque was in the air, under discussion, in all quarters. It was a subject which was a natural topic for bores of all kinds, as Jane Austen was aware in *Northanger*

Abbey, which she finished in 1803. In that novel, Henry, out for a walk with Catherine, raises the subject:

> In the present instance, she confessed and lamented her want of knowledge, declared that she would give anything in the world to be able to draw; and a lecture on the picturesque immediately followed, in which his instructions were so clear that she soon began to see beauty in everything admired by him, and her attention was so earnest that he became perfectly satisfied of her having a great deal of natural taste.[116]

The project began, as Hamilton notes, more as a gentleman's agreement than a contract. As Rowlandson started work with enthusiasm, Ackermann had to find a writer, and Combe, who had shown his skills in descriptive writing most recently in a large-scale publishing venture called the *History of the River Thames,* came to mind. Combe was not hard to locate: he was in his prison quarters. The thorny problem of payments to Combe then arose. Should he be given a large amount of cash, the creditors would swoop; Ackermann wanted his writer where he could be contacted and where regular progress could be monitored. One friend of Combes wrote later that £400 had been paid, but in instalments, and Ackermann's son was sure that the writer had been well rewarded for his contributions.

The writer and the artist never actually met in the process of the work, but naturally they communicated and they definitely were in tune with the spirit as well as with the structure of the book. Combe wrote an account of this as he worked, included in the advertisement to the book:

> Those designs alone to which this volume is so greatly indebted, I was informed would follow in a series, and it was proposed to me to shape a story from them – an etching or a drawing was accordingly sent to me every month, and I composed a certain proportion of pages in verse ... the rest depended on what my imagination could furnish ... I continued writing, every month for two years, 'till a work, containing near ten thousand lines, was produced...[117]

The man who has been consigned to literary history largely as a hack deserves some reflection here: the situation is quite stunningly impressive. Here was a man who had moved in the highest society in the last two decades of the eighteenth century, now in the King's Bench, working methodically to order, living comfortably as much as could be done behind bars, with a level of discipline that few can match at any time or place in literary history. Across two streets in the Strand, Rowlandson also laboured away with the drawings, generating the potential for narrative and assuming that his material would be capable of development in tune with his own imagination.

It is difficult to think of any similar collaboration to this. Combe, at that stage in his life a figure of paradox and complexity, full of stories and a natural satirist, had found a kindred spirit. In between was the entrepreneur Ackermann, very much a product of his age, and capable of perceiving the nature of each of his contributors; he must have had a lucid notion of what product he wanted, because he always did so. He knew the track record of each of his contributors, and he surely must have hinted at the direction the artist was taking as he walked into the King's Bench to update and instruct Combe,

or perhaps at times Combe came to the Repository, as he had the time in his period outside the prison walls.

The first book, *The Tour of Dr Syntax in Search of the Picturesque*, is always glancing at its forebears – the classic of *Don Quixote* by Cervantes, but also at eighteenth-century parodies of that great work, such as *The Female Quixote* by Charlotte Lennox, published in 1752. The idea is very simple: Dr Syntax decides to take a tour on his horse, Grizzle; he asks his wife to oblige him with allowing him to set off, and Combe has fun at the intentions:

> I'll ride and write, and sketch and print,
> And thus create a real mint;
> I'll prose it here, I'll verse it there,
> And picturesque it everywhere.

The poem is split into cantos, as epic poems often were, and the lines are in iambic tetrameter – four metrical feet with a regular stress which gives the insistent, simple beat, together with end-rhymes on the couplets, so from the very start the rhythm evokes a popular, accessible narrative.

It is also self-regarding, even with in-kikes, such as:

> The milliner is now preparing
> A dress that will be worth the wearing;
> Just such an one as I have seen
> In Ackermann's last magazine,
> Where by the skilful painter's aid,
> Each fashion is so well displayed...

The poem simply takes the good pedant across England, meeting highwaymen, a country squire, simple country folk and including much contemporary reference, including the inclusion of Lord Carlisle, who had already been attacked by Lord Byron in his satire, *English Bards and Scotch Reviewers*, published in the same year as *Dr Syntax*. There is no depth to the satire: it simply matches Rowlandson's racy and vibrant images. Most telling are the pictures of Syntax contrasted with the actual rural people and places, as when he rides by a lake and sketches, with some ladies before him in a boat and a countryman behind, looking bemused at the sight. It is the absurd that attracts Rowlandson, of course. He looks for the irrationality in the clash of the idealistic and thoughtless with the real stuff of life. The sharpest satire is when Syntax imposes himself and his ego on the earthy world he meets, as in reading aloud from his tour notes to a bored company in a cosy inn. People sleep, couples kiss, a dog sleeps and a man in the doorway blows a horn to try to disrupt the proceedings.

After that, the formula was carried on with the other two Syntax books, with the clergyman going in search of consolation, and then of a wife (his first wife dies in the second book). The impact of the books was considerable. Jane Austen knew of him, and wrote in a letter, 'I have seen nobody in London yet with such a long chin as Dr Syntax.'[118]

Dr Syntax setting out on his second journey.

Above left: Dr Syntax, from the Ackermann edition of 1838.

Above right: Frontispiece to the 1838 edition of *Dr Syntax in Search of the Picturesque*.

The concept of Syntax was significant in the general history of graphic satire. In an article headed, 'Dr Syntax and the Birth of the Cartoon Star,' Anthony Ryan argues that Syntax is the first cartoon star – and that it was important for other reasons:

> But the most significant result of the character's popularity was the development of what future generations would call "merchandising". London vendors capitalized on the public's insatiability by offering branded tie-ins such as Dr Syntax coats, dishes, hats and wigs.

So, as Ryan says, 'It all started with a funny little grammarian and his steed.'[119]

At the time, the reviews missed the point, and little notice was taken of the books. Combe was known best for a poem he had published when much younger, called *The Diaboliad* in which he attacked several rakes and aristocrats of his time, and that reputation coloured some responses. But the vogue for the character was strong in the years *c.* 1812-25, and there were nine editions of the first book in print by 1819. Later volumes with all three tours were popular for several decades.

William Combe died on 19 June 1823, and that fact was mentioned by his friend, John Taylor, who edited *The Sun*. His old employer, John Walter of *The Times*, wrote the obituary for that paper, saying: ' He was a gentleman who, in the course of this protracted life, had suffered many fortunes, and had become known ... to so many people in every rank of society ... There was hardly a person of any note in his time, with whose history he was not in some degree acquainted.'[120]

'Old Combe,' in spite of his tendency to gather creditors, was a natural partner for Rowlandson, and it would be very gratifying to know more about what the artist thought of his writer-collaborator. Falk is sure that Rowlandson was lost for an original perspective in the Syntax books, and notes that 'his inspiration was beginning to flag'[121] and that may well be why there was little need for communication between the collaborators – Rowlandson being content to re-use old material.

As for Rowlandson, he was by 1810 thoroughly caught up in the business of print production. As the eighteenth century had gone on, prints became more affordable; print retailers urged artists to go into engraving in terms of the market outlets; an important point about this market is that there was no real chance for the general public to go and look at paintings. As Judith Flanders point out: 'Apart from the print shops, there was nowhere in Britain for everyone to be able to look at art without charge. Instead, many art-lovers ended up going to shows like the one attended by Mrs Lybbe Powys in 1798, when she went to see Miss Linwood's worsted work at the Hanover Square concert rooms where famous paintings were recreated in embroidery panels.'[122] With that in mind, it comes as no surprise that popular prints of places and scenes were immensely in demand in the metropolis and elsewhere. They would have been very much like the memento market of today: you visit a place, do the European tour or the journey to the Lakes or Wales, and you then buy the prints of key locations.

For Rowlandson, to be able to meet this demand was ideal. As Falk comments, it kept him out of mischief, and he adds: 'What with "pot-boilers" for the print shops and what with topographical drawings, mostly of London interest, for the small but

faithful band of admirers, he was kept busy the greater part of the week and often for long hours at a stretch.'[123]

In 1785 there were over a hundred letterpress printers in London and by 1824 this number had increased to over three hundred. In the early nineteenth century there were new iron-frame presses which could produce almost two hundred copies an hour. Rowlandson, in his later life, was in the centre of the new age of reproduction in popular cultural texts and pictures. In terms of both scenic prints and in graphic satire, it was an exciting time for a productive and talented draughtsman like Rowlandson; there was a steady growth in literacy, and organisations devoted to the publication of 'improving' moral works were increasing. As to the middle classes, the ones who wanted to be informed on political issues and on morality, the print shops knew they needed entertainment with this kind of context.

Rowlandson, by the time he was working on Dr Syntax, also had these social and media developments behind his working life, and he broadened his scope. From around 1812 he began to produce what must be called crude caricatures, selling at sixpence without colour and a shilling with colour. There is, in his work from the turn of the century, a change in style, and many have put this down to his reckless life and desperate need for money; it is easy to say that he wasted his true talent by shunning painting and remaining an Academy man, shifting into the low and suspect world of popular cultural production, and moving in the underworld of racing and gambling. But that view was an earlier one, when morality ventured more into biography and into aesthetic appraisal. A typical example of this stance was by Gert Schiff: 'Much of his former refinement was abandoned. And in his subject matter he strove after the sensational. Sometimes even after the downright vulgar. His own disillusionment made his wit more biting, his grotesqueries more savage...'[124]

What emerges from this, whether or not we take any kind of moral stance, is an art that engages actively and boldly with the moral raw, shameless sensual living of the English people: a Falstaffian take on a tough and turbulent age. Through modern eyes, we have to form an opinion on where he stands with regard to the criticisms levelled at him for wasting talent. Did he do so, or did he, through inner pain and struggle, find his instinctive and unique ability? There is no doubt that he was open to any project that would bring in the pounds, and the pictorial genres in his time did overlap somewhat. The mistake is to look and judge purely through modern eyes, and to forget that morals, transgressions and offences were very differently defined then, and notions of taste and acceptable subjects were restricted in art – or had been for centuries. Again, at the turn of the eighteenth century, the quiet revolutions were happening back stage in art and aesthetics, parallel to the great political revolution in France. By 1800, he had chosen the road of commerce, leaving the Academy behind. After all, he had no desire to get his feet into the house of the Establishment of artists. Joseph Wright of Derby, for instance, married in 1773, did a trip to Italy, and joined the Society of Artists. Agents began to buy his pictures, and portraits and landscapes were his destiny. Rowlandson and Wright make an interesting contrast: the former elected to step deep into the freelance world; the latter made a patch in the great garden of art and cultivated that intensively.

6

Erotica and Caricature

There are, of course, many people who are genuinely repelled
by the simplest and most natural stirrings of sexual feeling ...

D. H. Lawrence

In 1791 at the Old Bailey, John Ryall stood before the judge to await his sentence. He
had been found guilty of selling prints and books which would inflame the passions of
'the young and tender mind' and the Attorney General had wanted a quick judgement
from the court because he 'thought fit to bring several offenders before the court of
that description...' [125] The sentence was spoken by the Recorder of London:

> John Ryall, you have been convicted of publishing very obscene libel, so gross that
> common decency will not permit me to repeat any article of what must give offence to all
> who are here ... your sentence is, that you be fined six shillings and eight pence, that you
> be imprisoned twelve months in Newgate, and find security for your good behaviour for
> three years, yourself one hundred pounds, and two securities in fifty pounds each. [126]

Hopefully, for his sanity, the man had some friends. A year in Newgate would be hard,
and the sums of money involved are very large indeed. This offence, however, was quite
rare. Erotic art was widespread in Europe in the eighteenth century; many of these
works would now be defined as pornographic, so Mr Ryall's prints must have been
extremely offensive. In fact, the two key terms, 'erotica' and 'pornography' did not exist
in common parlance at the time of Ryall's court case, although in French, the word
'pornographie' had been used in 1769. In France, the so-called libertine pornography
had been put to satirical uses such as attacking the morality of churchmen. In England,
there was a literature of erotic fiction, stemming from John Cleland's novel *Memoirs of
a Woman of Pleasure* (known as *Fanny Hill* later) and Cleland was sent to gaol for that
publication, though not for long.

By *c.* 1800 there was certainly a market for erotic prints, with the libertine influence
on English culture being strong, and Rowlandson found the genre much to his taste.
Bernard Falk devotes a chapter to this aspect of the Rowlandson oeuvre and uses the
phrase 'too much frankness' as his heading. But more recently, Vic Gatrell has put the
case for the defence: 'Men and women were considered as equally capable of erotic
passion, and women as consenting participants or as sexual initiators.' [127]

In fact, as Peter Ackroyd reminds us, in 1800, discussing William Blake's moral strictures against one lady-friend: 'In fact it would have been a foolish complaint from a less idealistic young man, since it was a period of open sexuality and public licentiousness. Erotic prints and books such as Aristotle's Master-Piece were freely on sale, even to children, at print shops such as Roach's in Russell Court.'[128]

Rowlandson's erotic engravings were produced between *c.* 1790 and 1810; he was not alone in producing work in this genre. Gillray, Fuseli, Turner and George Cruikshank joined him in that interest. In Fuseli's case we know that he drew hundreds of such items, but his widow later destroyed them. It was a genre that had to be aware of the law. If we consider the European erotic traditions in painting, through the sixteenth to late eighteenth century, it is clear that artists such as Fragonard, Baudouin and Jan Steen for instance, produced images which are not all that far away from some of Rowlandson's boudoir scenes. Baudouin's painting, *Morning*, for instance, shows a woman reclined on a man, her legs apart, while a young man looks on at the door, covering the eyes of a small boy. Jan Steen's works *A Bedroom Scene* and *A Trollop* show explicit libertine scenes in bedrooms, clearly depicting a prostitute in one case and ardent lovers in the other. They are only a short way from being the kind of images Rowlandson made. But by *c.* 1800 in England, despite the popularity of the libertine lifestyle, publishers had to be aware of the boundaries, and if they crossed them, then they did it with care.

Rowlandson's market is not so easy to define. Biographers have ignored the erotic work in Rowlandson, as Gatrell explains: 'His erotic images they have passed by aloofly – as "accumulations of pictured filth, incredible elaborations chalked by gutter-snipes on street walls or worse," as one puts it – though what could be worse that street walls is not explained.'[129] In 1949, Falk puts much of the supposed fall from grace in Rowlandson's reputation in producing erotica down to the context: 'Unfortunately, he reflected, chameleon-like, the colour of the ground he walked upon – ground all too often evil and slippery. In an atmosphere calculated to corrupt men of weak and irresolute nature, his baser side freely gathered strength.'[130]

The attitudes of the libertine at the time should be made clear. The attitude began to grow in the last decades of the eighteenth century that in places away from the public projection of the social self, a gentleman should be allowed to speak and act freely, not restrained by too rigid social manners and morals; the spirit of individual liberty in the political sphere was filtering down to morals, so that many men of the wealthy kind, and free-thinkers, related moral and conventional transgression to a personal and sub-cultural freedom, a libertine perspective, often expressed in private – either at home itself or in clubs and other social contexts in which a man could be 'manly' in the full sense, hence to concepts of the rake and the 'blade.' Physical prowess was respected – hence Lord Byron also boxed well and went away to fight for Turkish independence. O'Regan – self-made Irish racehorse owner and socialite – and his partner, Charlotte Hayes, found that providing arenas for libertinism was very profitable.

Rowlandson's erotic prints are to be understood in that social framework. After all, when realism came along in European painting towards the end of the sixteenth century, efforts were made by artists from all places and backgrounds to express sensuality and sexuality – to show the erotic within daily life and as part of social relationships, matters as everyday as eating dinner or playing on the flute. Rowlandson's prints are

meaningfully placed within these notions of realism. But of course, he was deeply involved in the art of caricature, and so in his realistic settings there are also playful exaggeration. Time and again, the images are of female pleasure and indeed, of female delight in a woman's power in relation to her sexuality.

In this way the erotic in his oeuvre was yet another dimension on his complex selfhood. It is tempting to speculate on what it was in his personal life that had wounded him, turned him bitter perhaps, or at the very least, given him a delight in showing the repulsive element in mankind. In fact his erotic art is what is generally produced by artists who have an ambivalent attitude to established social institutions. Time and again, he contrasts old and young, impotent and virile, drunk and sober, degraded and respectable.

It is important here to speculate on his own relationships with women, and there is little to go on. He was never married, yet lived with Betsey Winter, referred to as his wife, a woman born in 1777 who was referred to also as his housekeeper and who often sat for him. She was his sole executrix at his death and all was left to her. He was like a married man. But also a man who knew at close hand the company of the less salubrious versions of womanhood at the time, at least his own drawings of him in that society that seems to be so. It is tempting to ask, with Gatrell, what hurt him? Gatrell suggests: 'Despite gambling and drinking, he was never other than a detached and amused voyeur upon life's feasts and disasters.'[131] Gatrell makes a convincing case for the argument that it was the moral rectitude and dogmatism of the Royal Academy when he was there in his student days that went deep in him and in fact became a factor in what he felt was a creative wound and indeed even a deeply detrimental force against his own natural urge to celebrate the fecundity of life.

This is believable. In the caricatures and notably in the erotic images, what there is in common is evidently a succession of images of excess and its results. The consequences of various kinds of excess may be disastrous (as he would have known from Hogarth's *Industry and Idleness* and *The Rake's Progress* series of images) and from his own near ruin. Yet it is too simplistic to say that he merely provided images across the whole spectrum of genres within caricature just to pay the bills and put food on the table. Excess, extremism revolt and dissent in aesthetics surely went deeper in him than the possibility that he merely adopted poses and scenes that opened up his potential as a voyeur, or one who knew how to entice and satisfy the voyeur in his buyers.

The story of his firing a pea-shooter at the nude model in the Academy drawing class has been retailed many times. Behind that is an attitude. It makes sense to see him, by the 1790s, on the cusp on turning away from what were perhaps his earlier idealistic dreams of being a painter in the mould of those who had influenced him, most obviously John Hamilton Mortimer. When the personal tragedy of losing his beloved Aunt Jane hit his emotional centre, it makes complete sense to see him as putting two fingers up to the constraints of life. He was no journeyman apprentice: he laboured alone in his own work space. Rowlandson was not a joiner in the sense of the guild or the official fraternity – he was a clubbable type, relishing society, in an age of clubs. Talking with his peers informally, over a few drinks, was as much trade status as he needed. After that, life was a matter of deadlines, not fraternity duties and roles. He was not the only creative soul of his generation who saw the stuffiness of the formal approach to the arts, the institutionalising of aesthetics applied to individuals – it was something parodied and satirised across the spectrum of writing and visual arts. Thomas de Quincey, for

instance, another wayward individual who was penniless in London at the same time as Rowlandson, chose the vocabulary of art criticism to write the acerbic irony of his essay, *Murder Considered as One of the Fine Arts*, in which he writes about murder in much the way that Rowlandson depicted sexuality: 'But what then? Everything in this world has two handles. Murder, for instance, may be laid hold of by its moral handle (as it generally is in the pulpit at the Old Bailey); and that I confess, is its weak side; or it may be also treated as aesthetically, as the Germans call it –that is, in relation to good taste.'[132] Good taste, in the world view of the libertine, could include the fine appreciation of erotic prints.

The erotica have one directing theme, a repeated thematic preoccupation: an assault on the pedantic, formal academician mind. His targets are often old gentlemen surrounded by bookshelves and pictures in opulent settings. With this in mind, it is a case of erotica being linked to satire and vice versa. What more incisive way to comment on moral and social impotency of the powerful older men in society than a series of sexual images which convey a metaphorical as well as a literal pictorial meaning.

We live in an age in which literary and art theory has found a place in the understanding of the process of the user of art and media in relation to the creator of the art. In other words, for fifty years now theorists have been using the word 'gaze' to define the nature of the interactive process of art itself, as an object, and the user of that art. We look at a painting and everything in the composition has been created so that our gaze is of a certain type. The male gaze, in terms of looking at images of women, has been written about extensively and in great depth. In the richest and most subtle works of art, the artist manipulates the gaze of the user with a sharp awareness of the layers of meaning implied.

In Rowlandson's erotic prints, this is evident. A perfectly clear example is *The Examination*, in which a group of raddled old men inspect a woman's sexual pudenda. She appears to be amused at the situation; the men are leering, and of course, as with everything erotic, the user or 'reader' of the image is implicitly asked to consider that curiosity and to position him or herself in relation to the exchange. In an age in which the Enlightenment was opening up all varieties of knowledge, this was, at one level, also a comment on ignorance and on the absurdity of the fact that such a topic would be the focus of such curiosity. Also, as this print shows, Rowlandson was aware that he was producing work within set traditional themes. *The Examination* arguably has its roots, for instance, in the kind of picture illustrated by Pierre Subleyras' *Scene of an artist painting a seal of chastity on his wife*. Subleyras died in 1749, and his example of erotic art is an ideal example for pinpointing the difficult subject of when art borders on pornography. That French art of the generation just before Rowlandson was very much interested in areas of voyeurism and sexual licence, so consequently once again, we find that Rowlandson's time in France was almost certainly a period when he knew and learned about these conventional genres and subjects.

There has been a great deal of commentary on Rowlandson's erotic prints in recent years, and web sites on erotica have taken all kinds of angles on him and this work. Some writers have insisted that he was obsessed with the 'Covent Garden Ladies' – the rather over publicised hookers of the time. But what is certain is that all around him, as he lived and worked in James Street, there was a market for erotic prints openly promoted. A publisher called Mary Wilson printed erotic material, and she was called by some the 'reviver of erotic literature.' Outlets for her wares and those of other print

shops would be particularly clustered around Holywell Street behind the Strand. Wilson published material for women as well as for men, and it is well recorded that the wealthier slice of society, the gentlemen with time and money to spare, felt it to be good 'street cred' to have what was known as a 'gallant library' of such prints.

The man Ryall – who stood trial in the Old Bailey – had clearly published something considered to be pornographic. But guidance is needed on exactly what is pornographic as opposed to what is erotic. The writer who has perhaps had most to say on this matter is D. H. Lawrence:

> But even I would censor genuine pornography, rigorously. It would not be very difficult. In the first place, genuine pornography is almost always underworld, it doesn't come into the open. In the second, you can recognize it by the insult it offers, invariably, to sex, and to the human spirit.[133]

This is very helpful. Nowhere does Rowlandson debase the human spirit. In fact, the erotic prints force us to look at aspects of humanity that are often neglected, and do so with skill and power. We are at once intrigued and enthralled by the pictorial subject, having to acknowledge the truths inherent in the image, as depictions of universal human concern, whether individually we love them or hate them.

The period which has passed since the arrival of the erotic prints from Rowlandson's hand has had difficulty in classifying them and judging them. This has to say something important about the modern openness, or lack of it. Rowlandson's erotica, after the priggish years between Regency and late twentieth century, was art consigned to what is known as Cupboard 205 at the British Museum. In 2009, Tony Barrell reported on this for *The Times*, and he discovered the current status of erotic art in the collection: 'There used to be sheaves of banned Georgian cartoons by Thomas Rowlandson in Cupboard 205, but now, providing you have come of age, you can go to the Prints and Drawings and study Rowlandson's images of gentlemen and saucy wenches having explicit intercourse on beds, on road journeys and beside gravestones.'[134]

*

Caricature in general has to be considered now. Rowlandson is labelled as such. David Low, the cartoonist, said that Rowlandson preferred a tavern scene to a political situation, and that summarises the theme here.[135] Caricature needs a definition, and the accepted one is from a standard reference work: 'A form of art, usually portraiture, in which characteristic features of the subject represented are distorted or exaggerated for comic effect or for critical comment.'[136] It is hard to omit mention of William Hogarth in the formative period of caricature: Boris Ford, explaining the origins of Rowlandson's art, summarises:

> Among his first published works were two emblematic prints on the subject of the South Sea Bubble (1720) and among the rich gallery of human types that throng the comic histories and occasional prints ... are figures of archetypal significance – corrupt lawyers, quacks, whores, skinny Frenchmen and plump, beer-swigging locals

– eagerly snatched up by the caricaturists who followed him.[137]
At its plainest, we can see it in Rowlandson in his Miseries of London. His interest in a tavern or a street is plain to see. In his depiction of a traffic accident, the exaggeration is in the standard types of fat ladies and gurneying physiognomies in the coachmen and onlookers. In other words, although Rowlandson could do the political types if required, his version was a social vision, a commentary on communal wrongs, failings or chaos.[138] There is something else at the heart of the appeal of the genre; as one historian noted: 'Apart from their informative aspects, caricatures are by nature immediately inspiring and alluring. Their bold colours are visually appealing, their expressions often comical, their subjects sometimes bawdy and indecent.'[139]

Caricature is absolutely the perfect medium for shining the light of absurdity and ridicule on men and manners. The word has defined, and perhaps diminished, Rowlandson's status over the years. Fifty years after his death, in a major catalogue issued for the South Kensington Museum, he was described simply as 'Thomas Rowlandson: caricaturist.'[140] This is entirely understandable when we consider the mass of works from his pen. In context, from the 1780s through to the Victorian years, the word 'caricature' was widely used. In a theatrical sense it meant a humorous character impersonation in ribald comedy, such as in a performance at the Theatre Royal, Haymarket in August, 1790 in which Jack Bannister's wife performed in 'a new piece in one act, called TASTE AND FEELING – a dramatic caricature' and her husband joined her on stage for that end-piece after the main presentation of The Spanish Barber.

There was clearly a rich popular cultural interchange of debate and comic relish about the subjects of caricatures. Magazines with names suggesting some kind of high literary manifesto were produced, such as Thomas Tegg's The Caricature Magazine, or Hudibrastic Mirror, lasting until 1810, crammed with hundreds of colour plates. One letter to *The Times* in 1785 has this suggestion with reference to a play: 'It might perhaps suggest to Mr Bunbury the idea of drawing a caricature of the plain honest Yorkshireman in the character of the bailiff's follower.' In another review of new artistic offerings, one reporter noted, after discussing new water colours, 'a miserable caricature.' Evidently, the genre of the caricature was subject to the censure of the higher-minded critics. Rowlandson, the Academy student, was siding himself distinctly with the popular taste of the time. In 1797 there was a library sale, and after an announcement of a long list of classic works of literature, appended was this note: 'With 100 caricature prints.' They were not only worth collecting then, but they would sell, and to the same buyers who would go along to inspect the works of the classic authors in a retail display. According to Joseph Grego, 'Print shops at home and abroad were ransacked whenever the alluring word caricatures occurred in the catalogue. The supply was remarkably limited, the demand considerably increasing.'[141]

A major player in this market was Fores the printer. Samuel Fores had his shop at number 3 Piccadilly. He had exploited the marriage crisis involving the Prince of Wales and Mrs Fitzherbert – who had been clandestinely married in 1785, and one print he produced, called *His Highness in Fitz*, shows the Prince in a copulatory embrace with Mrs Fitzherbert. The image is not that far removed from some of Rowlandson's amorous prints. It is plain to see what emerges here in this social context of the caricature: the focus was on the scandalously topical, and there was a wide spectrum of

depiction available, some bordering on the openly erotic, and others more restrained, yet still openly suggestive. In 1790 Fores was at a stage where he could advertise his 'Caricature Museum' and the advert helps us to achieve an impression of his clientele:

> Fores caricature Museum is now opened.
> To which is added the Head and Hand of Count Struensee
> Admittance is 1s.
> With prints of all kinds, wholesale and retail.[142]

A shilling was not a small sum then. He was appealing to the gentlemen collectors. Note also that he sold wholesale. This was big business. As the reference to Count Struensee hints, much of the appeal of some very popular caricatures was openly racial and xenophobic. Newspapers made a bold item in a chatty column out of foreign caricatures, as in a feature of 1802:

> A caricature has been privately circulated at Paris in which there are statues of St Peter and St Paul, represented on a bridge, opposite to each other, but to the figures of the saints are added the faces of two celebrated characters at present objects of suspicion to the CONSUL. St Peter has a pair of new spurs on his heels and St Paul asks him whither he is bound ... he answers that he is afraid of staying at home, for that the system of inspection gains ground rapidly in Paris and that he expects every day to be apprehended and perhaps transported for having denied his Master...[143]

The tenor and spirit of this suggest a widely popular interest in the fascination of caricature. Time and again in the 1790–1815 period in particular, caricatures occur in discussion and as news. What is crucial, in understanding what Rowlandson exploited, is the plain fact that even being a dandy or a well-known eccentric could open up a reputation as a subject of caricature, and that in turn generated scandal. In a gossip column in 1800 for instance, a certain Boothby Clopton was talked about after his death, as it had been a suicide. Caricature was blamed for his death. He had ridden home, walked into the back parlour and placed a horse pistol in his mouth. The ball went through him and lodged in the wainscot. The columnist noted a few days later, 'Mr Boothby was a man of fashion, and the companion of some of the first nobility. He was endowed with much sensibility, and it is supposed by his friends that his feelings were too acute at being made the subject of caricature and having his little peculiarities of dress and manner exposed to the derision of the public.'[144] There was another factor – he had been blackmailed. But essentially, this shows that at times caricature was linked to more savage intentions.

To sum all this up, it is without doubt that Rowlandson was an integral part of the satirical ranks of the artists and writers of the time. There was around him a culture of ridicule and restorative morality, as expressed openly through caricature and there is no doubt that the caricaturist was something of a media star, as hinted in the announcement of the new issue of *The Satirist* or *Monthly Meteor* in 1807: 'This day is published ... with a large caricature by a celebrated artist, number one of a new magazine...' This announced also the publication's values and aims: 'Satire will be its most prominent feature and they promise to weld the scourge with a rigorous and impartial hand.' They promised to attack

the 'votary of fashionable dissipation' and the 'profligate partisan of faction' would be a target also. The modern equivalent might be *Private Eye* perhaps. The well spring of this vibrant art, so hooked into the surface morals of the time is based on the kind of thinking Zinovy Zinik expressed when he said, 'The boundaries between civilization and barbarity, are, as we all know, easily transgressed because they are frequently invisible.'[145]

Social life was, in extremis, a case of projecting the self as an object of interest, in the world of the beaux and belles. Satire and caricature would naturally follow that, and as with our modern world of celebrity culture, to be a striking visual figure in the streets and clubs meant that attention was desperately needed. The *London Chronicle* definitely took notice:

> The Bond Street Bueas have recently adopted the Dutch hat worn at Walcheren. The crown is very low and the brim at least eight inches broad. This chapeau gives the wearer a Quaker-like appearance, and he differs from any animal of fashion exhibited during the last twenty years. We were surprised some time since by observing that many young men of ton with the dusky hue of the Spanish Indies on their visages ... they wish to be considered heroes of Talavera...[146]

The range of misdeeds and follies subject to satirical attack was wide. 'Dissipation' and 'profligacy' in any context, and by anyone, were fair game. Harriette Wilson, a society prostitute, took this to extremes when she wrote her memoirs. She had entertained the great and famous, including the Duke of Wellington, and she realised the potential for blackmail in the venture, writing this kind of note to those whom she might expose: 'If you like to forward £2000 directly to me, else it will be too late. Mind I have no time to write again as what with writing books & then altering them for those who pay out I am done up.. frappe en mort.'[147]

Rowlandson in the years after the death of his aunt was earning wherever he could, and joining the ranks of the new satirists was just one element in this. He was not alone in this of course: many artists of his age had to be chameleons, or at least capable of a workmanlike multi-tasking ability. A letter he wrote in 1820, to a Mrs Landon at Grove House, offers a rare insight into the activities he undertook above and beyond his art work. He was writing on behalf of Matthew Michell's widow. Michell had died the year before, and it looks as though the artist was, as he puts it, acting as a 'secretary'. Looking at and reflecting on this letter, it has to be said that recounting Rowlandson's life and relationships is like studying a radar screen: people dart across the screen from time to time, and the artist himself floats around, in blurred vision, somewhere in the centre. His life touched so many other people, and in a variety of social circles and specific sub-cultures, and that he was known by many makes it intriguing that solid life information is hard to find.

In this account, he is now in focus around the years 1815–20, a mature person with a steady relationship, living with his housekeeper/common law wife, Betsey, churning out prints for a range of outlets from erotic prints to incisive social satire. In between these activities he is, as with lady Kirkwall, always happy to give drawing lessons to wealthy patrons. Michell died in 1819, and here we have Rowlandson doing some chores to take the weight of responsibility off the shoulders of Mrs Michell. But once again, the context is temptingly interesting and it invites speculation. He is writing

to 'Mrs Landon' from Grove House. In 1820 there were two addresses in London of that name: one in Kensington Road and the other in Brompton. It seems highly likely that Mrs Michell was living in the address at the north side of Old Brompton Road, opposite the site where South Kensington Station was later built.

Was 'Mrs Landon' in fact the writer, poet and socialite, Letitia Landon or Letitia's mother? First, here is the letter:

> Dear Madam,
>
> At the request of Mrs Michell I have undertaken the office of secretary and you will soon perceive one less qualified for that station never held a pen. She returns you many thanks for your transmitting so kind and pleasant a description of your pursuits and the res-establishment of health in the rest of your family. The loss of the society of the lively Miss Fanny Wallis is very great, which however is soon to be filled up by a visit from her eldest sister, Miss Julia, who is a most amiable tempered young lady rather more sedate. Grove House has been enlivened by a visit from a sprightly widow of seventy two years of age who has buried three husbands without being much the worse for wear. Her memory as also all the rest of her faculties remaining in full blossom ... It seems she has treasured up bags of anecdotes of her former lovers and the pranks she played them, which has caused great laughter and has greatly kept up the spirits of Mrs M. – and I have the satisfaction to acquaint you the violent and acute pains in her head have greatly abated. But have left her in a very weak state but hope with careful nursing through the winter she will recover her health and enjoy the society of her friends the ensuing spring. Miss Wallis often regretted the disappointment of not being able to accompany you and Mr Landon in your sketching parties – we are pleased to find you are in a picturesque country and that Mr L has resumed the pleasures of the pencil. Mrs M looks forward with pleasure and expectation to welcome you as her guests. I beg leave to join also and hope I may have the good fortune once more to meet and shake hands with you both – with sincere wishes, remain,
> Your obedient servant
> Thomas Rowlandson

The only hint we have of any connection between the poet, Landon and Rowlandson is that she contributed a large number of verses to the first American edition of *The Dance of Death* in 1828. Tantalisingly, the Mrs Landon may have been Letitia's mother. From the tone and references in this letter, it appears that the Landons were around the same age as Mrs Michell, and they were very likely a couple who spent time with the Michells over the years. Landon is dabbling in sketching, along with his wife, and Rowlandson wants to be sociable and join them along with Mrs Michell.

Letitia Landon, born in 1802, won a high reputation as a writer, contributing to the *London Gazette*. She wrote under the name of L. E. L. and caused a stir. The novelist Bulwer Lytton wrote that he would rush every Saturday for the *Gazette* '...with impatient anxiety to hasten at once to that corner of the sheet which contained three magical letters, L. E. L. and all of us praised the verse.'[148]

Within a year of Rowlandson's death, Letitia was writing for what was seen as a commemorative volume for Rowlandson. Was that simply coincidence? Letitia would only

have been eighteen in 1820 when Rowlandson wrote this letter. She did not marry until 1838, to George Maclean, and the year after she was found dead, in South Africa, with a bottle of prussic acid in her hand. She had been engaged earlier in life to John Forster, the friend and biographer of Dickens. Society was well aware of Letitia; she wrote about 'female love rejected' and caused a stir in the literati, hence Bulwer Lytton's interest.[149]

Whoever the Landons were, the interesting aspect of the letter regarding Rowlandson and women, he obviously relished female company, and in his responses to the merry widow in the letter, he welcomes the jovial company of women and shares stories with them. In 1815 he had produced an etching called The Breaking Up of the Blue Stocking Club. It might be called a savage and very critical representation, but it would be pushing matters too far to say that there was a misogynistic impulse here. There had always been abuse aimed at the Blue Stockings, as women writers and intellectuals came to be called. Horace Walpole called Mary Wollstonecraft a 'hyena in petticoats.'[150] Blue Stockings – so called after Benjamin Stillingfleet visited Lady Wortley-Montagu's circle of ladies in 1756 wearing blue stockings – are shown by Rowlandson as having an argument. That may be intended to be a satirical take on women's intellectual groups, but it is unlikely that this was a target of any personal importance. He satirised that as he satirised anything around him. He never missed a creative opportunity. He once drew a dying man, when his friends had had enough of the sight and left him to it.

In these busy and productive years, Rowlandson's life bears out Osbert Sitwell's comment that he was one of those artists who was far too busy to have an eventful life.'[151] There is a list of items produced for Francis Rimbault in 1822 which has this diversity of items supplied:

Noblemen building and cutting down timber
Venus and Silenus
Small sketch
Politicians smoking
View of the Isle of Wight

*

Rimbault (1773–1837) had been painted by Joshua Stanesby and was a connoisseur and collector of considerable means. From the full list of items supplied by Rowlandson, totalling £9 1s 6d for fourteen productions up to April 1822, Rowlandson had been able to work in several categories for the man, from landscapes to caricatures.

He still found time to help out Mrs Michell of course, and to spend time over drinks with banister and Angelo. Grove House, where Mrs Michell had her London home, had been where Sir John Fielding, the Bow Street magistrate and brother of the novelist Henry Fielding, had lived. It survived until 1857. That is surely entirely fitting for a man so interested in crime and law. He was immersed in the fullness of life – humour, sensuality, vigour and excitement. As has often been noted, he had mastered watercolour by the early 1780s and from then he knew his best and favourite medium, moving from conventional watercolour themes and subjects to his drawings and wash. Bright colours and firm base lines are the answer for him: brighter colours are used primarily to clarify and balance the

composition, and he had become completely fulfilled by his choice of *modus operandi* by 1800. His focus was from then on what one writer has described so well: 'This is to me the essence of Rowlandson's view of life: all the vanity, conflict and venality of this world only proves we are clumsy creatures, crowded in the cold with a slippery footing...'[152]

When he was not working, Rowlandson was a party animal. His friend Angelo wrote that he always 'kept Good Friday at some little distance from town; my companions were Bannister, James Heath and Rowlandson' and he says that for years they were constant companions walking the city. He notes that Greenwich was Rowlandson's favourite place on these walks. He was also a friend of his fellow caricaturist, Gillray. So once again, even in his later years, Rowlandson was to many 'Rolly' – the good companion who, when enticed from his deadlines, would walk the streets and visit the clubs or, as Dr Johnson would put it, 'frisk' with his drinking mates.[153]

Overall, he produced an immense number of caricatures. On 7 December 1912, the library of a collector, Ralph Clutton, was sold. He had collected Rowlandson with determination as well large amounts of cash, and he had twenty-three volumes of Rowlandson prints. There were almost 2,000 items, mostly in colour, and forty-one pencil, pen and water-colour drawings. He had worked mainly for Thomas Tegg, who worked with another retailer called Castleman, with their base at St John's Street, West Smithfield. Later, he went alone, operating from Cheapside, and just three years before Rowlandson's death he expanded moving into the Old Mansion House there.

Beneath the grotesque, which he clearly enjoyed producing, there was always something that Bernard Falk defined neatly, referring to the work the artist did on book illustration (such as Goldsmith's *The Vicar of Wakefield*): 'The England he was called upon to illustrate was the England that lingered in his retentive memory – the England of his vicissitudinous boyhood.'[154] It is surely wrong to see the later work as, in the words of Joseph Grego, 'the last flowering of expiring genius.'[155] It is more a case of an artist having the gratification of knowing that someone actually wants his work, and he did enjoy producing the caricatures for which he is best known. No-one could produce that work, so full of life and dynamic action, so full of fluid life, without taking delight in the composition.

The genre does not convey success and interest to everyone in the ranks of the critics. Kathleen Raine, writing with the aim of contrasting Blake and Rowlandson, considers that Rowlandson's 'grotesqueries' are of a lower order, and that Blake was right to denigrate them.[156]

THE VICAR AND FAMILY LEAVING PRISON.

The Vicar of Wakefield, Goldsmith's novel shows the exit of the vicar's family from debtors' prison.

7

The Dance of Death

Death lays his icy hand on kings
Sceptre and crown
Must tumble down
And in the dust be equal made

James Shirley

In the preface to *The Dance of Death*, William Combe wrote about the history and main features of the art dealing with the theme: 'The predominant feature is, without exception, the representation of one or more skeletons, sometimes indeed in grotesque attitudes, and with a rather comic effect, conducting persons of all ranks, conditions and ages, to the tomb.'[157] The idea of the Ackermann book is very simple: as Combe adds, 'Mr Rowlandson had contemplated the subject with a view of applying it exclusively to the manners, customs and character of this country. His pencils accordingly produced the designs...'[158] The team that had produced Dr Syntax was signed up again, but this time they were tackling a major European theme in art and writing, with all kinds of roots in art and literature.

Historically, treatments of the theme had been in cheap popular literature, as in chap books such as *La Grande Danse Macabre des Hommes et des Femmes*, printed in Troyes in 1728, but also by major artists such as Hans Holbein in his 1538 *Dance of Death*, for which Wenceslas Hollar did copperplate engravings. The latter may well have been a direct inspiration, as an edition was published in 1803 with forty-six copper plates, produced in London by the Gosnell company for Scott and Ostell. The imagery there was something which found its way into popular print narrative, something in the general consciousness, filtering into chap books and broadsheets sold on street corners.

There are several chap books, particularly from the eighteenth century, in which Death is personified in the tale. Typical is *A Dialogue between a Blind man and Death*, a publication printed and sold around Bow Lane, Aldermary Church yard. This is a one-page tale with an 'argument' at the beginning:

The argument of this metrical dialogue is that Death comes to a blind man, who asks him his name and business, and on hearing it, tries to escape from him. Death, however, explains matters to him, and brings him into such a seraphic state of mind...

We can see the nature of some of the popular origins of Rowlandson and Combe's work in this. This dialogue is in the tale, and it relates closely to the spirit of the episodes in *The English dance of Death* in which faith and prayer figure largely;

Death
Sir, I perceive you speak not without reason, I'll leave you now and call some other season

Blind Man
Call when you please, I will await that call, and while I can make ready for my fall; In the mean time my constant prayers shall be, from sudden and from endless Death good Lord deliver me.[159]

The origins of the theme are very ancient. There are accounts from the Greek historian, Herodotus of Egyptians placing similar skeletal images on banqueting tables to remind feasters of the shortness of human life. In visual art, one of the very earliest paintings dealing with the subject was found in 1312 on the walls of the Klingenthal monastery in Basel, Switzerland. Then there was the religious element, with little guide books about dying being produced by the churchmen, called *ars moriendi* (the art of dying).

Closer to Rowlandson's time, Thomas and John Bewick made an adaptation of Holbein's work in 1789, using fifty one of Holbein's designs. When Rowlandson took up the theme, it must have been something perfectly matched to his perspective on the absurdity of his age. The basic idea was very simple: have Combe write the narrative verse and Rowlandson produce the illustrations, simply providing a bizarre guide to the routes to death in regency England, from the experiences with risk factors to the obvious examples of age and illness.

There is also another dimension however, lying behind the conception. The eighteenth-century poetic preoccupation with graveyards and the Gothic scenes of such places as Thomas Gray's country churchyard or the simple personification of Death, as in

The baffled Prince in Honour's flattering bloom
Of hasty Greatness finds the fatal Doom,
His foe's derision, and his subjects' blame,
And steals to Death from anguish and from shame.[160]

The literature of meditation on the old theme of *vita brevis* – life is short – had become, by *c.* 1800, something expressed in a variety of ways, yet with the common ground of surveying the crowd, the mass of humanity, across all classes and social stratification. There is a close similarity between Gray's lines,

The boast of heraldry, the pomp of power,
And all that beauty, all that wealth e'er gave,
Awaits alike the inevitable hour.
The paths of glory lead but to the grave.[161]

The concept of the book is very straightforward: the usual satire on the vices and vanities of the age, with the Rowlandson stance of the grotesque. Various commentators have noted how very carefully the hand colouring was done, and the stress has been on the differences between the thinking behind this, when compared with the often direct ad merciless caricature subjects.

What stands out here is the strength of the familiar iambic tetrameter from Combe – done with more skill than *Dr Syntax*, possibly because the subject suited his own reflective nature very well. The thoughts and ideas expressed are far from new: they are in fact hackneyed themes, relating to old maxims of everyday philosophy. They also relate to such Renaissance preoccupations as mutability, the poetic theme of 'everything changes' and that life is fluid, although Combe gives this a comic treatment:

> A goldfinch dies – but what of that?
> Though I inspired the savage cat
> To do the deed – though Betty huff'd
> For want of care – the bird is stuff'd
> And on its perch it seems to thrive;
> Nay looks as well as when alive...[162]

The subjects developed are a mix of 'Deadly Sins' and traditional moral satires, along with some recurrent targets of Rowlandson's own. The results are most impressive when the artist and writer fasten onto a subject that clearly gives scope to something which is at once both fashionable and universal, so that there is a great deal of scope for an expression of a topical Gothic element and a recognizable social custom. Typical of this is the 'Vision of Skulls' section in which the illustration has a group of refined ladies and gentlemen being addressed by a skeleton in some subterranean cellars with cloister-like arches behind, and skulls lining the walls, as in the catacombs in Rome. It suggests a parodic treatment of the kind of Grand Tour narrative which was so popular then. The universal layer of suggested commentary of the vain humans who follow fashion stare in awe at their destiny, just as we have in Hamlet's meditations with the gravedigger in Shakespeare's play.

Combe excels himself in the accompanying lines:

> The spacious cave which met my view,
> Was like a church without a pew.
> What I saw there was wondrous strange:
> Around the place, in various range,
> On every side, above, below,
> In order due, a dismal show
> Of skulls innumerable stood; [163]

Tetrameter, four metrical feet in the line, is ideal for comic verse and satire, but has been used for more sensitive and meditative subjects. Notably, in Andrew Marvell's dynamic love poem of robust seduction and twisted thinking, *To His Coy Mistress*, it

can handle a range of emotions and subjects with a quick pace and effective changes of mood and style.

When we consider Combe writing his instalments in prison, and again, the plates being done first, so that each step of the brief is directed by Rowlandson's choice of material, we surely judge Combe much more highly than his being a 'hack.' Even when Rowlandson returns to favourite scenes such as the accident during a journey, as in 'The Fall of Four in Hand' in this work, Combe injects interest and variety. The image is simply a man and woman hurled into the air while their carriage overturns, with skeletal Death riding the lead horse and cracking his whip to cause the disaster. To this Combe adds verse that takes this into the realms of metaphor, almost treating the image as a salutary and thought-provoking tract, such as:

> Look round, and view the various ways
> Mankind employ to purchase praise –
> The fulsome offering to secure,
> What will not vanity endure:
> The sleepless night, the daily toil,
> The pale lamp and the midnight oil
> Are borne or lighted up to gain
> The flattering tale, the applausive strain...[164]

The concept is an inviting one, meant to give Rowlandson the maximum possibility with a theme of both current and philosophical interest. He was not a painter who felt drawn to depicting symbolic representations of the eternal verities; he is best understood as someone who, like Rembrandt, was drawn to dynamic stories in figures and lines, and treated these as a discipline as well as a powerful projection of human experience. Rembrandt's drawing *The Raising of the Cross* for instance (done in 1633) shows what Rowlandson learned about the suggestion of movement and of curvature and facial expression. The idea itself is full of potential and Rembrandt was drawn to the savagery, similarly to that appeal Rowlandson felt, in the cruel retribution in his own time, with regard to the criminal law.

The English Dance of Death allowed Rowlandson to tell his visual stories of the follies and sins of his time in a way that gave him more scope to go beyond stereotypes, as in some of the ecclesiastical topics. Yet he also fastened on some of the most plaintive and emotive features of his time, such as infant mortality. In 'The Nursery' he has the skeleton rocking the cradle of the small child as an old lady sleeps nearby and the mother and family enter the room, screaming and flapping their hands in shock. Combe accompanies this with an assault on the wet-nursing habit in society:

> Can then the woman e'er be found,
> By the first laws of Nature bound,
> Who dares, in careless mood disclaim
> The nursing mother's tender name?
> Say, in the breast that yields the tide,
> Which fost'ring Nature's springs provide

Drawings of Heads and faces,
Courtesy of York Museums Trust
(*York Art Gallery*).

The suckling nurture to supply,
Will she by art the channels dry;
And let the new-born babe be thrown
Upon a bosom not her own?[165]

At the time this was published, adverts for wet and dry nurses were everywhere. In *The Times* in May, 1819, we have a typical 'want place' listed: 'As Wet Nurse, to take charge of one or more children, a steady young woman who can be recommended for great care and attention, where she last lived in the same situation...' But more typical of the time (with Dickens' Mrs Gamp in mind) is this advert from the Imperial Brewery at Battersea in 1806: 'The beer has therefore strong claims to all who wish to drink a wholesome and superior malt liquor; but in a still more particular manner to that of wet nurses whose general health will be improved.'[166]

This clearly shows that the illustrations and chosen subjects were mostly from current concerns, satirical targets and observable follies. The rarity in *The English Dance of Death* is in the unrelenting presentation of a common theme as something drawn down from the heights of refined art, and retold by Combe with wit and invention, always close to Rowlandson's abiding vision of a society torn apart by vanity, superficiality and by sheer inhumanity to man.

8

Everything to Order

Do like other widows – buy yourself weeds and be cheerful …

John Gay

In biographies, dying and deaths generally form the resolution of themes and preoccupations; there is a sense of a trajectory in the life considered. But for Rowlandson, it is hard to expand on the bare facts. He dabbled and did one-off commissions in ways that suggest failing powers and a lack of a design or real aim or purpose in the work undertaken. This offers many relevant thoughts on what his decline may have been like, but in the end, it is a plateau rather than a mounting rise to a pinnacle of achievement or to a tragic impasse. It is, in effect, quite perfunctory, as if the artist's death was the fulfilment of another brief: one to which he could not say no.

In *The Gentleman's Magazine* obituary and memoir for Rowlandson, the fact of his death is plainly expressed: 'April 22 [1827] At his apartments in the Adelphi, after a severe illness of two years, aged 70, that veteran graphic humourist, Mr Thomas Rowlandson.' In the last few years of his life, he was unable to produce very much, and his decline was as rapid as his eclipse in the public mind. As Bernard Falk wrote: 'Over night, as it were, he appears to have been almost entirely forgotten. Nobody outside a regrettably small circle of intimates was aware that he had taken to his bed, stricken with a mortal illness … Though his continued absence from his usual haunts must have evoked occasional enquiries tinged with regret, comment was conspicuous by its absence.'[167]

He was buried at the church of St Paul's, Covent Garden. His sale of goods took place at the end of June, 1828. He had a lithographic stone, a rolling printing press, Indian ink stones, plaster models and the other apparatus of his profession. He also had some pictures he had bought from the Michell estate, among them an Andrea del Sarto. At this sale, engravings brought him the equivalent of what would be today a figure of around £5,000.

Betty Winter (his common law wife and housekeeper) was his sole beneficiary, and probate was granted to her on 5 May 1827. She was called Mrs Rowlandson on the catalogue used by Sotheby's. Betty lived at the Strand address until 1829 and her name given in rate books is, again, Mrs Rowlandson. After that she lived at Queen's Gardens in Brompton, which had been built in the 1770s, and is now the place where Harrods stands. There she died in May 1835, and she was buried with Thomas. He did her portrait of course: she sits perhaps on a seat in the country, her hand to the side of her

face and a smile brightening the scene. She has a long, flowing white gown and a broad hat. Her figure was full and her general physique apparently sturdy rather than dainty. By the side of many other illustrations he produced of women, this is somehow homely and complimentary in an interesting way: she had firm, strong hands but a delicate foot in view, perhaps a touch of a Goya perspective on the feminine. Of course, the typical touch of humour is there too, in the fact that both the woman and the little dog by her side seem to be responding to someone or something 'off stage.'

Bernard Falk pointed out that there was a toughness in the family genes; that his grandmother Jane lasted until 1783 and that the Rowlandson's, '... must have been a tall, handsome, erect race.'[168] All the more poignant, then, is the picture by John Thomas Smith, showing the aged Rowlandson, dated June 1824, in which he is observed concentrating over a drawing or perhaps a letter, his spectacles gripping the sides of his balding head. Smith does manage to show the no doubt still sharp eye and intense preoccupation with work which had driven Rowlandson for many decades.

It is not clear exactly what the long and debilitating illness could have been which plagued him in his last two years, but there is no doubt that Betty nursed him. He may have had a stroke; there are no suggestions of any apparent physical signs of ill health in the Smith portrait. He merely looks rather tired. He would have visited print rooms and auction houses and tried to move in his usual circles, but Smith captured a moment in what was most likely a tough, demanding day for the artist.

As the 1827 memoir has it, in the last words about Thomas Rowlandson: 'His remains were followed to the grave by the two friends of his youth, Mr Bannister and Mr Angelo Senior, and by his constant friend and liberal employer, Mr Ackermann.' Even the last image of him leaves us guessing and speculating.

There is one oddity, though, that has to be looked at, with regard to his last years. In the issue of *Country Life* for 2 December 1933 there appeared a supposed work of fiction called Betsy's Marriage or What the Village Said, discussed by a Professor A. E. Richardson, who said that Rowlandson wrote the captions and produced the illustrations for the piece. The story is about a forced marriage – Betsy and an old gentleman and ex-soldier. As Bernard Falk explains, 'In the nick of time the wife of the would-be bridegroom, whose reputed death he had purposely neglected to confirm, turns up at the church door and dramatically puts a stop to the proceedings. Overcome by the excitement, Betsy faints away, only to be caught in the strong arms of her own dear sweetheart, young Henry Linton of Ringleton...'[169]

The story was allegedly printed in 1820. It may be that Rowlandson actually wrote the piece; certainly Prof. Richardson maintains that the spirit of the story matches Rowlandson, saying, as it was written in old age, 'It is perhaps more than significant that he should have stressed the crabbed outlook of the selfishly old in contrast with the waywardness of female beauty.'[170] What is really intriguing about the theory is that Rowlandson knew a Miss Baker: she was part of a Hertfordshire family living at Bayfordbury Park. The whole business does sit well with Rowlandson's humour, and four years earlier he had provided similar material for a chapbook called *The History of Billy Hogg and his Wife Margery*. It is entirely in keeping with the cultural affiliations Rowlandson had that he should contribute to chapbooks. Since the early years of the eighteenth century, they had been very popular, often retelling famous tales

such as *The History of Dr John Faustus* or *The Gospel of Nicodemus*, but there were also stories in keeping with the genre of the Betsy story, such as *The Constant Couple* and *The Life and Death of Christian Bowman*.

These little penny books, by the 1840s, were a notably successful business venture. John Ashton has looked into this: 'I have taken out the prices paid in 1845 and 1847 for nine volumes of them, bought at as many different sales. These nine volumes contain ninety-nine chapbooks and the price paid for them all was £24 13s 6d, or an average of five shillings each – surely not a bad investment...'[171] In other words, it raises the possibility that Rowlandson at almost seventy years old, was having a try with yet another genre, and that perhaps just a few years before his death, he was still chuckling at Betsy's story – and maybe even took her name from the Miss Baker he knew.

It is inviting to believe that the man in the coffin, mourned over by his few select friends and by his beloved Betsy, had managed to maintain his cheerfulness and sense of the absurd, even as a sick old man. It is hard to resist the thought that Rolly had the urge to caricature his own sad self in decline, such was his sense of the bizarre within the diurnal.

The burial and the mourners were hardly noticed. An artist, one of thousands of jobbing workers in the art trade, had died. Why should heads have turned or *The Times* take any notice? We have to thank the friends and the clients – and of course the myriad of editors of historical works over the years – who kept the name of Thomas Rowlandson prominent in the manner in which we see and try to understand the Regency and Hanoverian years.

9
Conclusions

We must grant the artist his subject, his idea...
Our criticism is applied only to what he makes of it.

Henry James

A recent biography was formed on the basis of fifteen questions being asked about a life from the past. As has surely become evident from the foregoing efforts to try to piece together the life of Thomas Rowlandson, questions are plentiful, but ascertained acts are few for his life. Without Bernard Falk's earlier work on the sources, there would have been little open to further scrutiny. Thanks to work done by later writers, there has been some more to add. Yet in the end, the questions remain and there will always be something elusive about Rowlandson.

His life represents the template of that species of artist who has immense talent but who has to cope with a dominant character flaw: in his time, the gambling weakness was almost universal, but in his case it meant that he had to tout for orders and commissions, above and beyond the flow of work from the regular contacts such as Ackermann. Hence, thanks to the tantalising letter to Lady Kirkwall, discovered by John Riely, we have to wonder how many more such openings for drawing tuition were offered to him, and also how far his range of secondary employment, other than the illustrations, went.

Throughout this book, I have written a contextualised narrative, so it seems fitting to add a chronology for the reader's assistance in bringing together Rowlandson's life and some of the great artistic movements of his age. After all, his life spanned the genesis and flowering of what has become known as the Romantic Movement in literature and painting. Not that there ever was a 'movement' but certainly there are key publications and events which assimilate ideas which later became massively influential. Not only was Rowlandson coming to maturity as an artist at the time of the popularity of the picturesque and the gothic; he was also an established professional middle-aged man when Wordsworth, Coleridge, Byron, Shelley and Keats had their deepest impact. Of course, he also lived at a time when Napoleon planned to send his armies across the Channel and invade England.

As has also been shown, he lived in London at a time when the excitement in the air was palpable, such was the vigour and bustle of life. As countryman William Wordsworth wrote on a visit in 1802, written as he stood on Westminster Bridge, no doubt while Rowlandson was drawing just a mile away:

Earth has not anything to show more fair;
Dull would he be of soul who could pass by
A sight so touching in its majesty:
The city now doth like a garment wear
The beauty of the morning; silent, bare,
Ships, towers, domes, theatres, and temples lie
Open unto the fields and to the sky...[172]

With only a limited amount of certain biographical fact established in some phases of his life, there has had to be some speculation, but at least many sensible answers to open questions have been found in the social context, as thankfully Rowlandson lived his mature years in arguably the most extreme, demanding and transmutable decade in English history: when he was busy with *Dr Syntax* in 1812, all around him were horrendous features of life which would, in 2010, make several historians vote the year one of the worst ten in British history. We were at war with America for that year as well as with Napoleon; there was extreme social and economic turmoil, including the regime of the Luddite machine wreckers in the West Riding, and both Newgate and York Castle were bursting with felons in a society in which the establishment feared sedition and treason in every dark corner.

The attempt to understand and explain the man has possibly led to his being more elusive, but at least the pursuit of truth has been tried. Arguably, the most fruitful approach to understanding the man and to assembling what we can of the facts of his life comes from the empathic effort to see him as someone who felt at the core of his being the creativity of conflict. He chose a path in his profession which led away from the establishment, from formal dinners, speeches and awards; he elected to work for patronage when it came along, rather than go searching strenuously for it. He was sociable but only with selected friends and with people who did not necessarily have the power to lift him up the slippery slope of the artist's life at the time. His letter to Mrs Landon makes it clear that he loved company of all kinds and never judged adversely or unfairly, as far as we know. Unlike Van Gogh he did not pour out letters as clues to the sources of his aesthetics. He was, in the very best sense, a jobbing artist. The history of all the arts tends to create hierarchies and preferences as tastes change and as theoretical thinking changes. This tends to be complicated by the issue of readership and commercial factors. In Rowlandson's case, he began by bestriding both arenas, the aspiring elite and the popular buyers. His reputation therefore echoed across the ranks, as it were, and people would refer to 'a Rowlandson' as it would guarantee, in most cases, amusement and insight into morals and manners.

In any number of instances, when writers and historians are pushed to place him or to define him, Rowlandson eludes classification. Playing safe, there is a tendency to include him in groups, rather than aim at meanings which relate to his specific achievements. Vic Gatrell has done a marvellously efficient and constructive job in redeeming Rowlandson's art as being very specially unique, and that was achieved by looking at him as a Londoner – in the sense of a resident and in the sense of him as an observer of that metropolis, a part of it, but able to stand out from it.

As the twentieth century rediscovered and reappraised him, he gradually became aligned with the art of the everyday, of Britishness and fun. In 1950, for instance, the art critic of *The Times* insisted that he was 'The master of the horse-laugh, the most persistent and

implacable of all adepts of the English tradition of philistine humour.' Yet when an exhibition of drawings was held at the Sabin Gallery in London in 1936 there was a genuine attempt to evaluate him. One reviewer wrote, 'This is an occasion for keen artistic pleasure. Because he was a caricaturist and did not paint in oil he has never been rated at his proper value in England.'[173] The puzzlement many have felt with him was neatly put by a reviewer in 1950: '...his rough outlook on life does seem to have prevented him from developing that last refinement of style which his specifically artistic gifts seem peculiarly fitted to achieve.'[174]

Personally, I find the most fitting footnote to the history of Rowlandson as a target for collectors came in July 1967, when his watercolour of Vauxhall Gardens, shown at the Royal Academy in 1784, turned up in a junk shop. It was taken to Christie's by the buyer to 'ask if it was any good.' It was sold in 1967 for £11,000. Rowlandson would have enjoyed the irony.[175]

There is also the issue of the status of the artist when Rowlandson was at work. As various social historians of art have made clear, very few writers provided commentaries or substantial reviews in the Regency period, when it came to the visual arts. Essayist William Hazlitt was unusual in this. Not only did he write a survey of galleries and collections across the land, but he also reflected on the mystery: 'The hand and eye are equally employed. In tracing the commonest object, a plant or the stump of a tree, you learn something every moment. You perceive unexpected differences, and discover likenesses where you looked for no such thing.'[176] There was little curiosity, generally, about men and women who were professional painters, in spite of the grand status of Sir Joshua Reynolds, founder of the Royal Academy in the previous century.

Yet it was an age of the connoisseur, and it is a vital factor in Rowlandson's life that he was well informed about the nature of 'taste' among the so-called cognoscenti. William Hazlitt asked the question whether the arts were promoted by academies at this time, and in his own answer he helps us to understand the context:

> Thus the number of candidates for fame, and pretenders to criticism, is increased beyond all calculation, while the quantity and of genius and feeling remain the same as before; with these disadvantages, that the man of original genius is often lost among the crowd of competitors.[177]

It helps us to understand Rowlandson's life to reflect on what Paula Gillett has explored with regard to the social position of painters and draughtsmen, etchers and engravers in the Regency. She summarises:

> If a painter was to become a member of polite society, it was essential for him to live in gentlemanly style. With a yearly income of six thousand pounds, Reynolds was easily able to do this ... It was not for almost a century after Reynolds' acquisition of the splendid house and carriage that substantial numbers of artists were able to live like gentlemen.[178]

The status of the artist may be understood by looking at Queen Victoria's comments on Sir Francis Grant, who was commissioned to paint for her a group picture of an equestrian scene. The Queen said of Grant, 'He is a very good-looking man, a gentleman, who has spent all his fortune and now paints for money.'[179]

Rowlandson, along with so many of his contemporaries, was certainly not the son of a gentleman; his roots were firmly in trade, and so he could never be considered the social equal of a wealthy and 'connected' portrait painter who purposely set about mixing in polite society. His place in between the lower level of jobbing worker, desperate for work, and the gentleman portraitists and water colourists was vulnerable in terms of how he was rated and appraised, but posterity has always perceptive on his virtues, as in the common opinion that he was, as one arts writer opined, '... unequal, and his characteristic calligraphy sometimes became mechanical, but at his best ... he produced works of extreme beauty.'[180] That rather back-handed compliment may be seen as a result of his status in the class-conscious world of his age.

Still, the question of his status is open to discussion. One way to consider this is to look at Horace Walpole's collection of anecdotal biographies, Anecdotes of Painting in England. This includes lives of painters, many now forgotten up to the time around Rowlandson's birth. In Volume two, he deals with painters active in the reigns of the first two Hanoverian Georges. When he included a paragraph on Peter Monamy, who died in 1749, he noted that the man was 'a good painter of sea-pieces' but then added, 'But when nature gives real talents, they break forth in the homeliest school.'[181] Interestingly Walpole finds interest, and makes space in the book, for men emerging from ordinary backgrounds. John Smibert 'served his time with a common house-painter' and Robert Woodcock was 'of a gentleman's family' so overall, Walpole shows that the social elevation of artists which really came in Victoria's reign, while a problem for some in society when they had to deal with men such as Rowlandson, was not an issue with the more open-minded.

Trades were clearly ranked according to esteem with regard to what was seen as 'low.' Looking at Blake taking up engraving, Peter Ackroyd explains:

> The London Tradesman, as early as 1747, described the professions of engraving and etching as very profitable and are reckoned among the genteel trades. Blake's decision was not an unwise or unworldly one. In any event, all his love and understanding of art had come through the medium of engraving, why should he not learn to practise that which he revered?[182]

If we substitute 'drawing' here for 'engraving' we have an explanation for Rowlandson's decision too when he thought ahead into his career.

In the end, the effort has been to achieve a small advance on the knowledge of Thomas Rowlandson; back in 1947, a reviewer of a new book on the artist noted that we needed to 'present Rowlandson as a fact' and by that he meant that the narrative of his life was needed as something distinct from a critical response to his work. That still appears to be a challenge in 2010.

It was unavoidable that, with there being so many shadows over events in Rowlandson's life, others who figure in his story should move centre stage at times. William Combe, whose life has not been written since 1969, by Harlan Hamilton, surely emerges here with incredible presence, and gathers respect. Hamilton sums up the man in such a way that we begin to understand why he found the creation of Dr Syntax so alluring and so naturally fitting to his talents:

Like Dr Syntax, Combe was a man of many friendships. Those of his youth have disappeared without a trace, except for such record as survives of his intimacy with Laurence Sterne and, vaguely, Richard Cosway. We are told in general of his social talents as a young man, but more personal information is altogether lacking until in his old age he cultivated friends much younger than he ... Combe was seventy years old when he was finally released from prison, but he resumed his social life with the old vigour...[183]

Reflecting on this makes us rethink, and imagine, Thomas Rowlandson's pattern of life. It is difficult to resist an interpretation of his life as one relating closely to the familiar 'piece work' system we find in English history on the clothing trades. The commissioning businessmen, like Ackermann, have a team of out-workers who may be called on when a new project arises and has to be planned; a team is assembled for the project and arrangements made. The result is that the artist or craftsman spends much of his time at home in the domestic workshop or studio. The deadline is set and the work begins, with the artist applying himself around the clock. To miss the deadline could be ruin.

In this situation, Combe worked from inside the debtor's prison and Rowlandson was in his studio in James Street. It is a tempting picture, but there is more to it. That scenario is surely too reductive. The reason for insisting on this is to say with certainty that Ackermann and Rowlandson were friends. Reflecting on the life of this remarkable artist we may pick out four phases.

One: In the face of the professional world of the Academy and of the rising medium of water colour, the young painter proves himself but he recognises his innate abilities and profound interests, and these do not lie in the patient groundwork of patronage and portraits. That is, he sees, an 'establishment' career. But in his young manhood, with backing from Aunt Jane, he does what all young men of his class do – he travels and gets to know what he wants from life. (1780s–1790s)

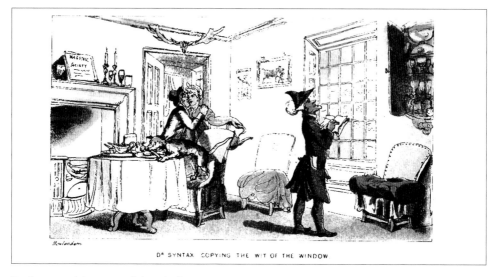

DR SYNTAX COPYING THE WIT OF THE WINDOW

Dr Syntax taking note of the window.

Two: He is now a man of real talent, and sees the need to be versatile in the face of the new possibilities open to artists in the commercial world. Patrons and connoisseurs may be marginal in that world (*c.* 1800–15). Commissions from Ackermann prove to him that he has a common touch. The subjects he is drawn to are out in the street and in the taverns; on the race track and in the gaming houses. The art he wants to produce covers both the aristocrats at play and the proletarians at work. What is fundamental to him is a vision of life as energy, as expression of the self in combat with survival, with the metropolitan challenge being paramount, though all life he sees is overflowing with conflict, pain and paradox.

Three: Established and yet flawed, his weakness is the urge to gamble and have the excitement of the games of chance so popular in London all around him, he extends a self –regard into his weakness with the need to show the world of vanity and failure to itself. Caricature is his real metier and he does this with flair. We know that he knew Gillray, and he must have learned in that relationship that the fad for political satire was not really for him: the universal directive to betray the follies of the world took over the artistic impulse.

Four: All the snippets about his activities from *c.* 1815 to the end of his life suggest that he was doing more variety of work but on a smaller scale, such as illustrating classic works and being involved in the erotic prints market.

<p style="text-align:center">*</p>

It has long been accepted that certain phases in his life are clearly discernible. David Rogers helpfully summarises phase one 'Early years and stylistic influences' as being explained largely by 'The easy elegance of Thomas Rowlandson's compositions and the highly Rococo treatment of landscape owe much both to French influence and to Gainsborough' and he also notes Mortimer again, 'In the 1780s Rowlandson developed his characteristic grotesque faces, which demonstrates a further debt to Mortimer and probably also to Thomas Patch, through whom they can be traced back to the caricatures of Pier Leone Ghezzi.'[184] Rogers then adds 'Middle Years 1784–1797' as being characterised by prints and illustrations, and finally 'Collaborations with Ackermann.'

He has also been generalised into meaninglessness, and few critics and historians who have used his work as part of their approach in explaining his art in relation to the harsh reality he described have looked beyond the obvious. John Barrell is an exception, most clearly in his argument about the poor and how they were depicted in the long eighteenth century. He takes particular notice of Rowlandson's drawing of *Labourers at Rest* (probably produced in 1795): 'The extreme exhaustion of the two central figures is conveyed particularly by an attitude which conceals their faces from us, as if they are too tired to solicit our concern: and the same attitude also protects them from Rowlandson's tendency to ironic caricature, which seems to have been only just retrained in his treatment of other figures.'[185] There is one writer who has taken the trouble to see the exceptions in Rowlandson's work which disprove the generalisations and the labelling of him in a reductive manner.

What about the family circle? His sister fades into the background, along with her husband, Howitt. After Aunt Jane's death, it becomes clear that tracing what we can of his life is a matter of conjecture, and that his heart is in his close friendships, life with Betsy and in his work. All around him the ruination and ignominious death of

friends and acquaintances happens: people such as Morland, Howitt, Combe and a hundred other minor figures in art have destinations either behind bars or in drink and desolation. He was, we may be sure, a stoical type who split his home life and his professional life into two distinct worlds. Something in him loved privacy, good conversation and the sheer deep satisfaction of having people he could trust in a world of shifting, transient allegiances and economic uncertainty.

Charles Dickens has a character in his novel, *Great Expectations*: Mr Wemmick. Wemmick works in the city as a clerk but goes home, and for him home is literally a castle:

> It appeared to be a collection of back lanes, ditches, and little gardens, and to present the aspect of a rather dull retirement. Wemmick's house was a little wooden cottage in the midst of plots of garden, and the top of it was cut out and painted like a battery mounted with guns. "My own doing" said Wemmick – "Looks pretty don't it?"

Wemmick then adds that '"If you can suppose the place besieged, it would hold out a devil of a time in point of provisions."'[186] Dickens' metaphor is one of holding the domestic values at all costs in the world of the cash nexus that was London. Something about the professional life in that great metropolitan flux of life tainted the human values Wemmick had.

This very much explains the private Rowlandson, one feels; he must have preserved the domestic life actively: never speaking of Betsy, his 'Mrs Rowlandson' and instead, projecting the fun-loving, articulate and humorous person who was 'Rolly' to his friends. Metaphorically, one senses that the home and studio in James Street was something of a Wemmick's castle.

There are subjects of biography whose lives tumble and overflow with incident; their actions link into other major lives; their mind is accessible. Then there are others who have been very much involved in their profession but who have eluded fame or even temporary notoriety. If Rowlandson had gone to prison, and if he had, like Combe, enjoyed chatting about his past to anyone who would listen, then there would be plenty to assemble when reconstructing his life for modern readers. However, at least we know what social circles he moved in, and we know much about his likes and dislikes; the rest is empathy.

If I empathise, if I stare and absorb the man from the many images we have of him, then I see a cautious, workmanlike person, someone who took pains and yet whose hand and eye were reliable. He was someone who persevered in every task set for him. We can also say with certainty that he learned from anyone, and everywhere when he was young. The journeys and jaunts, the friendships on the road, the small adventures and the shared humour – these formed his attitude to that world of bustle and romp he was born into. If I return to my first impression, inspecting his 'Mary Evans Hanged at York' I still sense the man behind that repulsive image: a man who wanted to show, close-up, that sick attitude of mind in the hangman, and the strangely accepting, child-like daintiness of the poor woman awaiting the noose. I can still relate to that man. One side of him strongly desired to show the cruelty around him. Yet again, another aspect of him was tender, capable of all those insightful and sensual images of young women.

The people inhabiting Rowlandson's pictorial world are either from nightmare or from richly human vision. His instinct is either to show youth, contentment, inherent happiness,

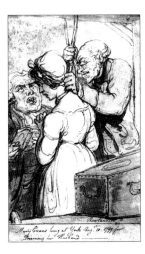

Mary Evans Hanged at York 1799, Courtesy of Yorkshire Museum Trust (*York Art Gallery*).

or the raging terror out of the door. In his picture of two burglars, armed, coming around the door of a couple who had been disturbed in bed, has these opposites in one. The villains are deformed, repulsive rogues; the man, though very fat, is emblematic of English character, and his attractive wife is at once both decorous and sensual. He revelled in contradictions, looked for the stupidity around him, but never overlooked the glory, the vitality and the sheer confusedly earthy Englishness he patently loved and despised in the same stare. In a sense, this vision and the negative views of humanity are perfectly explicable as elements grounded in the Rococo. As Eva-Gesine Baur has explained, the Rococo; paradoxically the surface elegance of that style and period appear to be refined and stylised, but this is a deflection of reality, a wishful creation of tranquillity: 'Indirect or ironic deflection is another important factor that played a major role in shaping the portrait.'[187] The subtlety in this is that the microcosmic peace and confidence of the eighteenth century portrait and conversation piece suggests a mere surface command of reason: artists could not resist hinting at the limits of reason in that context.

In one sense, Rowlandson's angle on life was to send up the rococo inheritance: where there had been a semblance of order and reason, family harmony and everything in the right place, there had been a long and elaborate pretence: the close of the eighteenth century brought with it artists who would begin to turn the angle of view to a more direct and comprehensive account of the 'sleep of reason' with the nightmares of Henry Fuseli's painting and the arrival of tough and challenging caricature.

<div align="center">*</div>

In the main spine of this biography and in the social contexts described, theoretical lines of thought have been purposely left out. But there is one perspective on Rowlandson that must be recounted at this point: this is by John Barrell, in his book, The *Birth of Pandora*. The reason this needs to be discussed here is that it offers a radical view of the work which helps to understand some of the rather elusive persona behind the works. Barrell sees Rowlandson's interest in, and depiction of, the ordinary workers on the land, the backbone of English traditional work in his time, as a 'private comedy' and explains that, against the

grain in his time, Rowlandson's art offered a private rather than a public vision through art of the proletarian life. He explains that in the main part of the eighteenth century, the comic was 'an essential resource for the painting of rural life and particularly the rural poor.

The essence of Barrell's argument is in this:

> The celebration of energy surplus to one's tasks, of inclinations imperfectly subordinated to duties, is... impossible to represent after 1780. But not for Thomas Rowlandson. Throughout the large number of drawings of the rural poor in Rowlandson's oeuvre, the image of them is unabashedly comic. This is most immediately apparent in Rowlandson's line, which even at its most delicate is never far from caricature, and this even when the tendency towards caricature is quite at odds with the usual treatment of the subject by other artists.[188]

He analyses the drawing The Cottage Door, a pen and watercolour piece produced around 1805. Here he points out that '... In particular, the contrast between the refined angularity in the profile of the daughter, and the rustic buxomness of her body, seems to separate even as it pretends to link the enjoyment of life ... represented in the expression. The two compete for the subject of the picture, which seems to celebrate the pleasures of an amoral physicality as much as of morality.'[189] Barrell extends his argument into looking at the public and the private man, and how he used art in his life in dual ways. He relates changes in these aesthetics to the life of the middle class and the aristocrats who placed art in their lives, creating spaces for display or for domestic gaze.

If we apply this to Rowlandson's career and his choice of artistic subjects, we find that he was placing himself within the spectrum of professional choices in his time very deliberately. As Barrell summarises: 'Rowlandson's practice ... would have marked him, certainly by 1805 or 1810, as an artist whose work could not be accommodated within this serious and elevated view of the work of art – a mark of whose seriousness was also of course the abandonment of comic subjects ... Rowlandson's picture seeks to occupy an entirely private place in the system of art.'[190]

This theory is encapsulated in the view that Rowlandson's pictures of working people 'have no public: they invited those who looked at them to put aside their responsibilities as members of 'the public'... and rediscover, as private persons, the anxious landscape of rural England as a place where public fears and public pieties could, for the brief period in which such 'rapid pictures' could engage them, be forgotten.' This is surely an insight which confirms the opinion that Rowlandson's art was subversive and questioning in deeply socially engaged ways: something far beyond the surface satire or comment. Barrell's thought has convinced me that Rowlandson was far more subtle a social commentator than we have previously thought, and that in fact he toyed with conventional social uses of art – being able to do this because he purposely put himself beyond the politics and career pressures of an 'establishment man.'

In some ways he represents the kind of subject who disappears in friendships and who chose table talk rather than lots of printed expression as his mode of communication. To make him speak from this shadowy place is indeed a challenge, but he stands there behind every image he created, his projected takes on life and people evident everywhere. D. H. Lawrence said that in judging art we must 'trust the tale not the

teller' but in many cases we have to read into the products some kind of profile of the artists, even if that profile is largely speculation.

The Rowlandson milieu was a fabric made of the stuff of life on the edge: writers and artists marginalised, seeking patronage or facing starvation and neglect. Few were as fortunate as Dr Samuel Johnson, who laboured on his massive dictionary for years, and was indeed rewarded, eventually, with a pension from the King. It has to be said that it would be a good wager to bet that Rowlandson would have lost his pension at the gaming table, had he been so fortunate as to have been the recipient of one. But for all his failings, Rowlandson made fast friends. Matthew Michell, for instance, who travelled with him for decades and spent many hours in jovial company, at his death had in his possession 550 Rowlandson drawings.

An informative and quite stunning contrast occurs with a brief cross reference to the composer, Joseph Haydn. Here was a man who had laboured for years, working for a patron, with commissions as regular as Rowlandson and with a total addiction to creative work which compares well with Rowlandson's life. When Haydn came to London in 1791 Rowlandson, along with everyone else ion his circle, would have known. The celebrity said at the time, 'Everyone seems to know me ... If I wanted I could dine out every day.'[191] He did exactly what Rowlandson was doing at the same time: travelling to Bath and Portsmouth. The artist and the composer had many similarities in personality, the chief characteristics being hard work, an obsession with their art forms, a love of documentation and a need to have deadlines and discipline. But the difference in their public image is staggeringly marked and extreme. That has to tell us a great deal about Rowlandson's social position and also about his attitude to the consuming public.

In 2007, at a sale run by Bloomsbury Auctions, five Rowlandson drawings were in the catalogue, including one, *A Trip to Gretna Green* (a forerunner of *Dr Syntax*) and the expected sale price was around £150–£300, with an average of £200. These were mostly etchings with hand-colourings. Mr Michell, along with many other Rowlandson collectors over the years, was a fan, but he was also most astute as an investor.

*

Writing the life of Thomas Rowlandson has been very much an exercise in imagining Rowlandson. But however difficult that has been, there is another, quiet narrative of him and his creative self in his work, of course. That has been the sustenance for trying to assemble the story and to make Rowlandson a 'fact' rather than some vague entity who relates in some way to all that massive amount of work which has been his legacy. Making Rowlandson stand out from his preferred anonymity has meant teasing out the meanings of his small acts – the letters, the signatures, the reported bons mots – and the result is a portrait of a man who was notably fulfilled by his work. As the poet Thomas Gray said, 'To be happy is to be perpetually employed.' Thomas Rowlandson would have agreed with that. If I have helped to demolish the verdict expressed by David Low many years ago, that 'Rowlandson was an inveterate gambler who was ruined and forced to work for a living, and he had not much interest in public affairs ... His tastes led him naturally to prefer the study the passing pleasures, sentiments and fashions...'[192] then I have contributed to the reappraisal of the reputation as well as of the man himself.

Appendices

1. Ackermann's Repository

The Rowlandson story was, in one sense, perpetuated by the Ackermann business, which still exists today in London. Rudolph had come to England in 1784, just as Rowlandson was emerging as an artist-traveller. Ackermann went from carriage design to book production in a short time, and when he died in 1834 he had produced over 300 books. Yet he did far more than the plate-rich topographical works which figure in Rowlandson's life so prominently. One other 'first' for him was the printing of a magazine called *The Repository of Arts, Literature, Commerce. Manufactures, Fashion and Politics*. This was not exactly a catchy title in full, but it was very much of its time, explaining the new technologies in all fields of endeavour.

The illustrations were all hand-coloured, and they were comprehensive in their span of interests across all areas of design, even having sample colours attached where needed with reference to fabrics and design. Ackermann's gallery in the Strand was also called The Repository of Arts, and there the new middle class could relax and browse, choosing their prints and books. A print of the shop done for the first issue of the magazine shows how airy the space was: the main retail and browsing area is under a broad sweep of light from the windows above, squaring and channelling light.

Ackermann also produced the first literary annual, *Forget Me Not,* which appeared in 1823. This was so successful that the lithographic press was closed down, so that his workers could concentrate on the making of a quarter of a million plates for each edition of the annual. The history of the annual goes back to his native Germany, where there was a tradition of gift books (*Taschenbuchen*). In Britain, these large and varied publications offered work to all kinds of writers and any new face on the literary scene was likely to be asked to contribute. Ackermann was thinking mainly of a female readership, and he had the staff to apply to the new venture, notably his editor, Frederick Shoberl. The new magazine was on the shelves for Christmas and the New Year 1822/3. In many ways the annual was an ideal outlet for Rowlandson. Had he not been ill in his last years, there may well have been something more prominent in his work. For writers who had been lionized and who had had their moment of fame, it was the natural market for their work; but for visual artists, the potential was there, and we only have to look at the early Victorian annuals which followed to see the demand for line illustrations in a boom period.

Other annuals appeared and competed. For instance John Clare, the Northamptonshire country poet, contributed not only to Ackermann's annual but to a

rival edited by Allan Ramsey. But Ackermann's book was richly produced, with a print run of 20,000 copies. John Ford describes the situation:

> The first *Forget Me Not* was published… with glazed paper boards and a cloth spine, the covers printed with a decorative title and in a slip case with the same design. That was unusual and showy enough, but as the competition in the market for annuals increased, the bindings were to become even more luxurious and Ackermann later used silk cloth…[193]

Notes in the logs refer to contributors such as: 'Jan. 31, 1825 to Dawson Turner asking him to contribute to *Forget Me Not* and to enquire among his friends for contributors.'

From 1825 steel plates were used for the printing. In engraving at the Bank of England these had been tried as early as 1811. There had been a very large number of engravers who worked in copper, and so forgery was not that difficult. Ackermann, with his usual entrepreneurial genius, suggested a method using stone engraving and lithography but the Bank did not like it at the time (though they used it later).

Ackermann found that as well as the methods used for the new annuals, he produced mezzotints, in addition to his established aquatints. As *The Times* correspondent for the arts wrote in 1961, 'As time went on a growing number of artist-craftsmen were employed in his workshops on the illustrations of architecture, landscape, fashion and sports for the periodicals and books which so accurately gauged the romantic and other tastes of his contemporaries.'[194]

Regarding Rowlandson's life, the Repository was of special importance. Bearing in mind that it was probably created in imitation of James Lackington's Temple of the Muses in Finsbury Square, it was proclaimed as a place for gentlemen, professors and lovers of fine art. The lending library was also an attraction. Rowlandson, when he met Ackermann, being fresh from the Academy and having made his choice to immerse himself in popular culture, would have found the Repository to be a welcome centre of conversation; there he would also meet clients from time to time. But on the whole he was a few streets away, toiling over the latest commission.

Nevertheless, Ackermann had created a focus for social intercourse, and later a publication, both exactly right for the burgeoning middle class market, in an age when the new rich had disposable income, came to London for 'the season' and generally aspired to absorb metropolitan culture – or at least the semblance of it. Rowlandson was an integral part of that new provision for those people: whether it be teaching Lady Kirkwall to draw, producing illustrations for Ackermann, or making a quick caricature for Fores' print shop or even the stalls in Holywell Street.

It must not be forgotten either, just what a prominent part Ackermann played in the private lives of his workers and contacts. He was there at Combe's funeral, for instance, helping with time and money. Charlotte, Combe's wife, wrote to Ackermann after the burial: 'To you I shall not attempt to express the grateful feelings of my heart for your unremitting kind attentions to my unfortunate husband. I can only assure you that I am indeed sensible of the full extent of your friendly assistance and lament that it never can be in my power to offer you a grateful remembrance.'[195]

Today, Ackermann's name is still around in business. The company is now Arthur Ackermann, in existence after a merger in 1992 in which Oscar and peter Johnson joined them. The website informs us: 'Oscar and peter Johnson Ltd was established in 1962 after Oscar and Peter left Leggatt Brothers where Peter had been since 1958, and Peter's father, Oscar, had worked for many years. Oscar and Peter has always specialised in British painting. Peter is an expert in the Norwich School of Painting.'

Ackermann prints are on hotel walls and his topographical works command high prices at auction or in specialist print shops. One of his true successes, and one that shows only one small fragment of Rowlandson the illustrator, is his work on Oxford. The illustrations show all the range of academics, from gentlemen commoners to dry scholars. The scenes of the colleges present a very evocative portrait of that beautiful place. That image of Ackermann is repeated across the land: in very small print beneath the picture, but still very much known and respected. The collections may have widened, but the name still applies to the kind of collecting that would have appealed to the founder.

2. Debt and Obscenity *c.* 1800

Debt and insolvency, prison and humiliation: these are a substantial part of the story of Thomas Rowlandson, William Combe and many of their social circle and professional peers. Until 1841, the legal condition of being a bankrupt was limited to debtors who owed more than £100. Debtors who also traded became bankrupts, whereas other categories of people who did not trade were insolvent debtors. The only group of 'traders' excluded from this were farmers. Therefore, in Rowlandson's father's case, and in Combe's case, this is illustrated: the former was bankrupt and so his affairs were sorted out and an income was provided; in the latter case, Combes was an insolvent debtor.

Bankrupts were simply listed in the press: their name and place of abode were given. As for insolvent debtors, they were imprisoned and most were there for the rest of their lives. In 1813 the Court for the Relief of Insolvent Debtors was established, and petitions could be received by that court.

*

Obscenity and its related concept of pornography, in terms of publishing, had first been controlled by the Licensing Act of 1662. The aim of that legislation was to control the printing of 'heretical, seditious, schismatic or offensive books or pamphlets.' Those words certainly leave out nothing in the various categories of obscenity. But this was repealed in 1695 and after that the church courts dealt with cases of obscenity. Anti-vice societies were formed to try to combat the perceived growth of obscene published works. By Rowlandson's time, the Proclamation Society Against Vice and Immorality appeared, and they published an annual blacklist of whores who had been prosecuted. Their arm did not stretch as far as erotic prints.

But in serious cases, pornographers could appear in the criminal courts, the most notorious before Rowlandson's time being Edmund Curll, who was tried at the Queen's

Bench in 1725. That introduced the offence of obscene libel, this being based on the description that a published work tended to 'corrupt the morals of the King's subjects and is against the peace of the King.' This meant that there could be prosecutions against obscene publications. The law would certainly act in clear cases of this offence. In 1749, for instance, John Cleland published *Memoirs of a Woman of Pleasure* (known popularly as Fanny Hill) and there were scenes of sodomy – which was a capital offence – these were edited out of later editions, and Cleland did a stretch in gaol.

But in the case of the market for erotic prints, such as Rowlandson and other caricaturists produced, there was a vibrant market, alive and well, to which the law turned a blind eye. The secret lay in the clientele: as they were meant for the wealthier classes, the law turned aside. Nothing more active and determined really happened until after the 1857 Obscene Publications Act.[196]

Once again, in the case of the erotica, Rowlandson had found that his skills matched his innate sense of Rabelaisian humour, and he did well: his productions were much in demand, and he was never in the dock as a result. It was very much a case of a specific market, with definitions of what was obscene and what was not being obscured. It has to be said that in England *c*. 1800, sex as a commodity in the market place had perhaps never been so much of a large-scale business. The market for erotica would naturally thrive in such an atmosphere. We also have to ask just why there was so much satire of clergymen and church professionals generally in this time. Beneath the concept of 'obscenity' there was also the whole range of satire on morals, with a stress on, above many other ills, hypocrisy.

The erotic prints also present problems when in print in more recent times. In 1983 William G. Smith produced a collection of these prints for Bibliophile Books. Smith's explanation for his enterprise is explained from the start:

> I stood in the witness box at a court in Southampton one day in 1977. A Philistine British customs officer had seized a book of Rowlandson's works, Similar to this one, which my bookselling firm had imported from America. The customs man admitted his ignorance of art and had never previously heard of Rowlandson. To him it was just a collection of obscene paintings...[197]

Smith, to his lasting credit, recalls his actions in that court: 'Pompously pirouetting to the judges, I declared, "If the paintings are good enough for Her Majesty, they are good enough for her subjects.' It worked, The court collapsed in laughter and Rowlandson was freed from the bureaucratic Babbitts.'[198]

What this shows, very dramatically, is how much we have had to learn, and in some quarters are still learning, from writers and artists such as D. H. Lawrence, who took on the restrictive formality of the prudes and who made the erotic genres in writing and art matters to be taken as part of the physicality of human life, while at the same time knowing what was pornographic and what was not. In the 1950s, trials for obscenity were numerous, and often they were thoughtless and brutal against local retailers. The phrase 'of literary and historical interest' began to be used as a defence. But, as mentioned in my introduction, the 2009 report on the discovery of Gillray's cheekily erotic prints, found in a bundle in an office, was still of enough interest to feature in *The Times*.

In *c.* 1800 the erotic was closer, and often integral, to the sense of the corporal, the knowledge of flesh and figure. Rowlandson and Gillray's aesthetic interest came from the same curiosity as the more modern novelists' aim of putting into print areas of human selfhood which have been previously eclipsed and made taboo. Hence, comparing *Lady Chatterley's Lover* (1928) with Rowlandson's erotic prints shows very little in common in terms of the methods and styles, but there is a fundamentally open-minded, curiosity about mankind there – the writer and the artists share an intention to depict areas of human behaviour and of sensual life: Rowlandson's was social, communal, and Lawrence's was private, personal, unseen. That must tell us something about Regency morality. It was a society in which every aspect of life was visible and known. It is no accident that it was the time in which the government had spies among the people, and small groups of men gathering on street corners could be arrested. Everything was subject to being *known*.

It would not be too simplistic to say that in 1800 there was no shame. With hindsight, we can see that Rowlandson, Gillray and others were producing something that was very advanced, true avant-garde art, but it was too soon followed by Victorian prudery and misunderstood. Such is the destiny of any bold stroke in the arts, creations well outside the walls of the establishment, and in Regency England, the notion of 'the establishment' was a key concept in the definition of success. It was a game he chose not to play, and in the end, our understanding of him begins in seeing that element in him for what it was: an artist who would not join in the main circuits of preferment, but would cultivate patrons when the chance came. Otherwise, he was always his own man.

3. The 1827 Memoir

This is the full text of the 1827 memoir from *The Gentleman's Magazine*. From this, distortions came, but it still needs to be read and considered. A biographer usually has an embarrassment of riches available if the subject has left a paper trail of any kind. Thomas Rowlandson never wrote a diary; he appears to have avoided too much letter-writing, and he was too busy to monitor what he did. He certainly never had a Boswell. This brief memoir is therefore the springboard for everything which has followed.

> Mr Rowlandson, April 22. At his apartments in the Adelphi, after a severe illness of two years, aged 70, that veteran graphic humourist, Mr Thomas Rowlandson.
>
> This well-known artist was born in July, 1756 in the Old Jewry, where his father was a tradesman of respectability. He was educated at the school of Dr Barvis in Soho Square at that time, and subsequently an academy of some celebrity. Richard Burke, son of Edmund Burke, M.P., was his schoolfellow. Mr Holman, the celebrated tragedian was also educated there. The academy was then kept by Dr. Barrow. At a very early period of his childhood, Rowlandson gave presage of his future talent; and he drew humourous characters of his master and many of his scholars before he was ten years old. The margins of his school books were covered with these handy works.

In his sixteenth year he was sent to Paris, and was entered a student in one of the drawing academies there, where he made rapid advances in the study of the human figure; and during his residence, which was nearly two years, he occasionally indulged his satirical talent, in portraying the characteristics of that fantastic people, whose outré habits, perhaps, scarcely demanded the exaggerations of caricature.

On his return to London, he resumed his studies at the Royal Academy, then held in some apartments at old Somerset House. He had been admitted to the list of students before his visit to Paris. The celebrated Mr John Bannister, who had evinced an equal predilection for the graphic art, was at this time a fellow student; and it was here that their friendship commenced.

The elder Rowlandson, who was of a speculative turn, lost considerable sums in experimenting upon various branches of manufactures, which were tried on too large a scale for his means; hence his affairs became embarrassed, and his son, before he had obtained his manhood, was obliged to support himself.

He, however, derived that assistance from an aunt which his father's reverse of fortune had withheld. This lady, who was a Mademoiselle Chattelier, married to Thomas Rowlandson his uncle, amply supplied him with money; and to this indulgence, perhaps, may be traced those careless habits which attended his early career, and for which he was remarkable through life. At her decease, she left him seven thousand pounds, much plate, trinkets, and other valuable property. He then indulged his predilection for a joyous life, and mixed himself with the gayest of the gay. Whilst at Paris, being of a social spirit, he sought the company of dashing young men; and among other evils, imbibed a love for play. He was known in London at many of the fashionable gaming houses, alternately won and lost without emotion, till at length he was minus several thousand pounds. He thus dissipated the amount of more than one valuable legacy. It was said to his honour, however, that he always played with the feelings of a gentleman, and his word passed current, even when with an empty purse. He assured the writer of this hasty memoir, who knew him for more than forty years, that he had frequently played throughout the night and the next day; and that once, such was his infatuation with the dice, he continued at the gaming table nearly thirty-six hours, with the intervention only of the time for refreshment, which was supplied by a cold collation.

This uncontrollable passion for gaming, strange to say, subverted not his principles. He was scrupulously upright in all his pecuniary transactions, and ever avoided getting into debt. He has been known, after having lost all he possessed, to return home to his professional studies, sit down coolly to fabricate a series of new designs, and to exclaim, with stoical philosophy, 'I have played the fool; but,' holding up his pencil, 'here is my resource.'

It is not generally known, that however coarse and slight may be the generality of his humorous and political etchings, many of which were the careless effusions of a few hours, his early works were wrought with care; and his studies from the human figure, at the Royal Academy, were scarcely inferior to those of the justly admired Mortimer.

From the versatility of his talent, the fecundity of his imagination, the grace and elegance with which he could design his groups, added to the almost miraculous

despatch with which he supplied his patrons with compositions upon every subject, it has been the theme of regret among his friends, that he was not more careful of his reputation. Had he pursued the course of art steadily, he might have become one of the greatest historical painters of his age. His style, which was purely his own, was most original. He drew a bold outline with the reed-pen, in a tint composed of vermilion and Indian ink, washed in the general effect of chiaroscuro, and tinted the whole with the proper colours. This manner, though slight, in many instances was most effective: and it is known, on undoubted authority, that Sir Joshua Reynolds and Mr West have each declared that some of his drawings would have done honour to Rubens, or any of the greatest masters of design of the old schools.

For many years, for he was too idle to seek new employment, his kind friend, and it may justly be added his best adviser, Mr Ackermann, supplied him with ample subjects for the exercise of his talent The many works which his pencil illustrated are existing evidence of this. Many suggestions for plates for new editions of those popular volumes, *The Travels of Dr Syntax*, *The Dance of Death*, *The Dance of Life*, and other well-known productions of the versatile pen of the late ingenious Mr Combe, will remain the mementos of his graphic humour.

It should be repeated that his reputation has not been justly appreciated. In a vast collection of his drawings in the possession of Mr Ackermann, and which have often been seen with admiration and delight by the many professional artists and amateurs who frequented Mr Ackermann's conversazioni, at his library at the old house in the Strand, it cannot be forgotten that some are inimitable. No artist of the past or present school, perhaps, ever expressed so much as Rowlandson with so little effort, or with so evident an appearance of the absence of labour.

His remains were followed to the grave by the two friends of his youth, Mr Bannister and Mr Angelo Sen., and by his constant friend and liberal employer, Mr Ackermann.

Several clues and hints in this suggest that the author was Jack Bannister. It has the tone of a compilation, quickly done, with a listing of achievements and an explanation of perceived potential not fulfilled. Even the bad habits are explained away. More than any other feature, though, is the feeling that this is a piece of entertaining and formal prose, much as an actor might have learned. The vocabulary is lifted to grandeur and tribute, and artificiality mixed with an element of genuine love and affection for the man beneath the official memoir which had been requested.

Whoever the author was, on analysis, this is the work of someone who knew the artist well, and who felt that there was an interpretation of his friend's life and work to be made. The euphemisms regarding both his father's business failure and Thomas' lack of success in the art establishment both need to be read with a sense of the author protesting too much.

There is also the question of the polite formality, rather too laboriously done, and the efforts to commend the close friends. All this has the note of a representative of a close group of good friends who have lost someone they valued for who he was, as a personality, rather than as a man with a notably esteemed professional life. After all, this is an obituary without notable public awards and achievements, and it must have

struck every reader that the success made at the Academy schools was way back in his youth, and was followed by no others.

The memoir had the unfortunate effect of leading astray the writers who came afterwards with good intentions, insisting on the truth and significance of the supposed two years in France for instance, and on the over-emphasis on the artist's whimsicality and impish fun as the basis of his only worthwhile art. As Bernard Falk noted in 1949, 'all statements made in respect of the artist call for the utmost scrutiny before being accepted, so bound up are they for the most part with what is purely hearsay...'[199] With reference to the supposed French stay, Falk summarises:

> It is a statement impossible to reconcile with the known, as opposed to the imagined facts. We repeat there was no rich aunt in Paris willing to shower her superfluous wealth on the young artist. Every penny he had, or that was spent on him, came from the real aunt in Soho, who, if she had intended to have her nephew taught in Paris, would scarcely have gone to the trouble of entering him for the Royal Academy schools.[200]

In fact, the sources of the memoir, by deduction, have the feel of an oral origin, that is to say, that the writer had gathered opinions and memories from the group of friends. We have Falk to thank for the laboured and meticulous dismissal of the exaggerations and errors. He quotes Grego at length, showing how that verbose and fanciful writer was carried away into the realms of speculation, as a result of the memoir.

Finally, the memoir is one absolutely brimming with feelings of affection and a strong desire to make sure that the piece stood out in the section of obituaries in the magazine.

That is of real significance for a biographer. It is one of the finest examples of a tribute to a friendship and a worthwhile life on record, and whoever was the author, the fact is that he felt to pressure to do justice to a friend, not merely fill the column inches of the magazine.

References

Full references of all texts below are in the bibliography. Main works by Rowlandson and Combe referred to here are the editions in the bibliography, as in, for instance, *The English Dance of Death*, which notes relate to the 1903 edition. I have given full details of journal references also, to help in the easy location of academic sources.

Note: for the sources quoted most extensively, I have simply used the surname, so that the reader only has to check the bibliography for the full information. These main texts are Falk and Hayes Also, there are abbreviations used below for the works of Combe/Rowlandson, and these are:

AI *Amorous Illustrations*
EDD *The English Dance of Death*
DOL *The Dance of Life*
MOL *The Miseries of London*
TSSP *The Tour of Dr Syntax in Search of the Picturesque*

Other abbreviations used:

ODNB Oxford Dictionary of National Biography

I have also included references cited from periodicals and other sources, so this is a comprehensive range of sources, all fully explained in the bibliography.

Chronologies

1742 – William Combe born.

1756 – July – date uncertain – birth of Thomas Rowlandson.

1764 – Death of William Hogarth.

1766 – Christie's Auction House founded.

1768 – The Royal Academy founded.

1771 – Vertue's *Anecdotes of Painting in England* published.
Henry Mackenzie's The *Man of Feeling*.
The Adelphi buildings completed (Adam design).

1772 – Rowlandson enters the Royal Academy schools.

1774 – Rowlandson in Paris.

1777 – Rowlandson receives the silver medal of the Academy.
The School for Scandal opens at Drury Lane.

1784 – Bewick's engravings for *Select Fables*.

1785 – William Combe arrested and imprisoned in the King's Bench prison.

1789 – The French Revolution – fall of the Bastille.
Blake's *Songs of Innocence*.
Rowlandson's Aunt Jane dies.

1791 – Francis Wheatley's *Cries of London*.
Tom Paine's *The Rights of Man*.

1792 – Death of Sir Joshua Reynolds.
Rowlandson is living at 52 Strand.

1793 – War between Britain and France.

1793–95 – Rowlandson at 2 Robert Street, Adelphi.

1794 – Humphrey Repton's *Sketches and Hints on Landscape Gardening*.
William Blake's *Songs of Experience*.

1797 – Rowlandson and Wigstead tour Wales.

1798 – Wordsworth and Coleridge's *Lyrical Ballads*.

1800 – Rowlandson moves to James Street, Adelphi.

1802 – Death of George Romney.
Peace of Amiens.

1803 – War with France resumed.

1804 – Death of George Morland.

1807 – Death of Angelica Kauffman.
Turner's Sun *Rising through the Vapour*.

1808–10 – *The Microcosm of London.*
1810 – George III suffers a mental illness (porphyria).
 His son, George, is declared Regent.
1811 – Prince of Wales becomes regent.
 John Nash starts the construction of Regent Street.
1812 – Combe and Rowlandson, *The Tours of Dr Syntax in Search Of the Picturesque.*
1815 – Elizabeth Fry visits prisons.
 Jane Austen's *Pride and Prejudice.*
1815 – 16 – The *English Dance of Death.*
1816 – Flaxman's Nelson monument.
1817 – Blackwood's Magazine founded.
 Constable's Flatford Mill.
1818 – Death of Matthew Michell.
 Blake's *Jerusalem.*
 Death of George III: George, the Regent, becomes George IV.
1823 – Death of William Combe.
 J. T. Smith draws Rowlandson.
 22 April, death of Rowlandson.
 Death of George IV.

Chronology: Rowlandson's Work

With so much of the biographical details being subject to conjecture, it is helpful to have some idea of when the works in the Rowlandson oeuvre were produced.

Biographers, scholars and art historians owe a debt to Richard M. Baum, who, in *The Art Bulletin* for 1938 attempted to put dates to a massive number of watercolour drawings by Rowlandson. At that time, Baum looked at 150 drawings held in the Widener Memorial Collection at Harvard University, but his problem was that he could not access the watermarks on the paper because the material was fixed to boards.

The value of being able to find a chronology for work in the case of Rowlandson is inestimable. Such was the massive and voluminous output from him at all times, and so high was the number of reproductions, that thousands of water colour drawings placed in order to parallel his life would be near impossible, but also extremely valuable. So piecemeal is our biographical information that, as is the case here, guesswork will happen. The evidence from his works is also beset with another difficulty: many of the signatures are forged. However, in spite of all this, Baum managed to offer a chronology which is logically acceptable. He suggested three definite periods in Rowlandson's career:

Early work
Transitional – after 1790
Mature or final – 1800-1827

The nature of Rowlandson's line is the focus of Baum's study. This, added to commentaries on the use of colour, forms the basis of study. This kind of approach

works best, as in literary analysis also, if there are accepted template works which may be used as touchstones for each period or style. Baum does so, as Falk points out – taking for instance a drawing called The Enraged Physicians, when pencil lines are substantiated by further pen work.

Another approach used by Baum is the period-based comparative one. As in literary studies where the rhymes of poets in a specific period may help to date other, anonymous and puzzling new texts, in the visual arts, borrowings, influences and copies may effect the same kind of study. In this way Baum notes that Gericault's painting Raft of the Medusa may have been inspired by Rowlandson's drawing called Distress. Baum equally looks for influences on rather than by Rowlandson, and as Falk comments, 'Rowlandson may have been influenced by landscapes painted on the Louis XIV and Louis XV lacquered cabinets, some of which recall the great Sung masters.' Falk more or less agrees with this summary. Of course, much of this has to be guesswork, but there is more understanding of the development of Rowlandson's art now, and the trajectory of his professional life.

Determining the chronology has been made more difficult because Rowlandson made copies of his work. As Bernard Falk wrote:

> It is fairly obvious that Rowlandson's practice of making copies of his work, if not of long standing, was of spasmodic frequency and quite distinct from experimental variations of ambitious designs which, when first tried out, failed to satisfy his artistic conscience. He made several versions of Vauxhall Gardens before entering on the wonderful performance in the possession of Mr A E Pearson.
> (Falk p. 198)

As John Barrell's books placing Rowlandson in the wider contexts of art and politics in the Regency have shown, it is possible to find significance in the work produced at particular times, and theoretical writing on Rowlandson, though rare, has proved to be invaluable in understanding his changing attitudes and his arguably quiet but strong dissent, working against the ideological grain of many of his contemporary intellectuals. In fact previous opinions and evaluations have refused to see him as an intellectual at all, but rather as someone who insisted on a popular audience. His subtleties are even today not yet fully appreciated, at least not by historians; he has been written about in relation to aesthetics, perhaps at the expense of a useful historical perspective.

Bibliography

This compilation is concerned primarily with biography and with contextual sources; there is very little on the art criticism connected with Rowlandson. Readers interested in the more analytical element are advised to look at the general works cited below from Hayes and Paulson. Also, for the same purpose and it spite of numerous criticism, Grego's long-winded work of 1880 will be useful, if only to challenge and to sift out the valuable material from the purple prose. For specialised studies of specific technique and genre, see Wark, Robert R. *Rowlandson's Drawings for a Tour in a Post Chaise* (1963) and Baum, Richard *A Rowlandson Chronology* in Art Bulletin for 1938.

There is also the need, for a biography of an artist, to have some idea of the dates at which work was produced or was published. The most useful assistance in this regard has come from Richard M. Baum, and he sets about answering the question: 'What are the sources on which one may depend ... in order to establish the development of this master's art?' (See 'A Rowlandson Chronology' above) It has not seemed necessary to include any great quantity of material on art criticism. Other works in print have dealt with this and it is not directly relevant here.

For scraps of anecdotes from contemporaries, we have Angelo, Smith and Adolphus, all listed below. Each of these is known a little in the records, as with Angelo, for example, who was appointed Superintendent of sword exercise to the Army, and was described by *The Gentleman's Magazine* as 'sociable and amiable in private life.' This body of work, a melange of scraps and anecdotes, still forms the real basis for any insights into Rowlandson the man, beneath the surface features of his public and professional life. He was a man with all kinds of social connections, and the routes leading to knowledge of the man are obscure and circuitous, so many of the following sources exist in the byways of history only.

Trying to understand the social and professional context in which Rowlandson worked necessarily involves a determined attempt to see the workings of that network of artists and connoisseurs around central London at the time. The following sources relate to all major aspects of this, from prison history to the growth of print culture and popular literature. Late in his life, Rowlandson was almost certainly beginning to extend his work into new areas. The number and variety of plate books to which he contributed is vast. Falk listed several pages of these in his biography and notes that 'lengthy as is the catalogue which follows, it makes no pretence of covering all the ground.' (Falk, p.209) Unfortunately, Falk's book is out of print, and it still holds

the best available listings of the books containing Rowlandson's plates. There are hundreds extant, typically with these details: 'Annals of Sporting by Caleb Quizem, 1809. Duodecimo, 29 colour plates ... designed by Banbury. Woodward and others, etched by Rowlandson. 8pp. brown paper boards, no printed title page.' Though clearly of most value to art collectors, the listing is of use to historians in that it shows the sheer diversity of work Rowlandson undertook. We have to live with the situation that accounts of the books with his plates are limited to scattered catalogues and monographs.

Without the large-scale survey works by Gatrell and others, it would have been very difficult to establish a platform for conjecture about the 'hidden life' of Thomas Rowlandson.

Note: the first date given refers to the first date of publication; the second date to the edition cited.

Books on Rowlandson/William Combe

The long eighteenth century was a time of the great artists of the Romantic period, but it was also a time of several minor talents, industrious and very talented. Combe, so essential to Rowlandson's life and work, was in that second rank.

As has become obvious, the career of Combe is inextricably linked to that of Rowlandson from *c.* 1810, so I have placed Combe information here. Combe produced a huge amount of literature and not long before his death he was asked to compile a list of his publications. This was printed in *The Gentleman's Magazine* in 1824 (XCIV, Part II 643–44) and also in 1852 (NS XXXVII, 467-472) Ackermann supplied a list, and he noted, for an edition of Dr Syntax in 1858, 'Most of these publications went through multiple editions and the writer had no reason to be dissatisfied with the public reception of any of them.' It is clear from Hamilton's life of Combe that the writer was always hard pressed and his publications are legion. With regard to his *The History of Madeira* for instance, he wrote, 'My only reason for preferring Friday for dining with the Ackermanns was that I fear I shall not have prepared sufficient copy of *Madeira* to go to press before that day.'

The most thorough bibliography for Combe online is at www.booksandwriters. co.uk/writer/william-combe.asp, but there is also a very substantial listing in the John Camden Hotten edition of Dr Syntax's Three Tours (1869)

Combe, William *Dr Syntax: His Three Tours in Search of the Picturesque* (Ackermann, 1838), Frederick Warne edition (1880).
[Note: The first edition, 1812, The Tour of Dr Syntax in Search of the Picturesque
A poem with 30 coloured aquatint plates and coloured vignette by Thomas Rowlandson
(London: R Ackermann, 1812)]

Combe, William *The Second Tour of Dr Syntax, in Search of Consolation* (Ackermann, 1820).

Combe, William *The Third Tour of Dr Syntax, in Search of a Wife* (Ackermann, 1821).

Combe, William *The Diabolad: A Poem.*

Combe, William *The English Dance of Death* (1814–1816) Methuen edition (1903).

Combe, William *The First of April or The Triumphs of Folly* (1777).

Combe, William *The History of Johnny Quae genus, the little foundling of the late Dr Syntax: a poem by the author of the three tours.* [Twenty four colour engravings by Rowlandson] (Ackermann, 1822).

Combe, William *The Royal Interview* (Logographic Press, 1789).

Falk, Bernard *Thomas Rowlandson: His Life and Art, A Documentary Record* (Hutchinson and Co. 1949).

Grego, J. *Rowlandson the Caricaturist* (Chatto and Windus, 1880).

Hamilton, Harlan W. *Dr Syntax: a silhouette of William Combe Esq. 1742–1823* (Chatto and Windus, 1969)

Hayes, John Rowlandson, *Watercolours and Drawings* (Phaidon, 1972)

Paulson, R. *Rowlandson: a New Interpretation* (1972)

Smith, William G. *The Amorous Illustrations of Thomas Rowlandson* (Bibliophile Books, 1983)

Rowlandson: Early Editions

The details of the early editions, in terms of bibliographical study, are complex and varied. Here I have simply summarised the essential publications.

Ackermann, R. *The Dance of Life* (1816–17). 26 illustrations by Rowlandson.

Ackermann, R. *The English Dance of Death 1815–16.* Vol. 1. 37 colour plates / Vol. 2 36 colour plates (printed by J. Diggens)
 Both *The Dance of Death* and *The Dance of Life* were first issued in monthly parts.

The first book form edition was Ackermann, R. *Dr Syntax's Tour in Search of the Picturesque.* 31 colour plates by Rowlandson, published in 1817.
 It quickly passed through many editions.

Ackermann, R. *The Microcosm of London* (1808-1816). 104 aquatint engravings by Pugin and Rowlandson. Letterpress by W. H. Pyne.

Ackerman, R. *The Second Tour of Doctor Syntax in Search of Consolation* (1820). 24 coloure plates by Rowlandson.

Ackermann, R. *The Third Tour of Doctor Syntax in Search of a Wife* (1821). 25 colour plates by Rowlandson.

Ackermann

Note: The search for more information on Rudolph Ackermann, so important in Rowlandson's life, appears to have begun in 1931, when in the Connoisseur, W. Russel Ackermann of Arthur Ackermann's company in Chicago, appealed for materials on Rudolph. 'We thought a good way to get in touch with the outside world would be through the medium of your columns.' Connoisseur Vol. LXXXVII No. 353, January 1931 Anon – a correspondent. 'Ackermann and the Age of Aquatint' in *The Times* (Aug.6, 1961) p.12.

Bayou Bend Collection, Museum of Fine Arts, Houston, Hirsch Library.

Culbertson, Margaret *Engines of Our Ingenuity*: feature on Ackermann at www. Uh.edu/engines/epi2075htm

Ford, John *Ackermann 1783-1983* (Ackermann, 1983)

Jervis, S London, *World City 1800-1840* (Yale University Press, 1992). This has a chapter specifically dealing with Ackermann's business.

Leigh, Samuel, *Leigh's New Picture of London* (Leigh, 1819). This publication reviewed Ackermann's Repository of Arts, Sciences and Literature in 1819:

> This work is necessarily of a mixed character. It is richly embellished with engravings and various specimens of British manufacture, conveyed in a form at once pleasing and useful to those for whose benefit it is intended. The literary department is not distinguished for erudition, but generally contains a pleasing variety of information.

Unpublished sources: archives

Beinecke Rare Book and Manuscript Library at www. Library.yale.edu/beinecke

Combe, William *The Literary Waste Book*. A commonplace book in one volume. University of Cambridge Library. Add. 8274

Prison Records for Combe

British Library: Notebooks compiled while in debtors' prison, deposit 9426.

The National Archives: PRO 30/8/229 PRO discharges Pris. 7/7 PRO King's Bench. Commitment Books no.10 and no.16 PRO Plea Roll King's Bench 122/723 no. 1064

PRO Pris. 5/1 and Pris. 10/201.

University of Newcastle: white papers and a miscellaneous album.

Proceedings of the Old Bailey www.oldbaileyonline

Unpublished Sources: Theses

Hassall, Lee 'I have Played the Fool' thesis, University of Wales, on Wigstead and Rowlandson's journey into Wales, 1797. (2002)

Contemporary Sources

This list includes all works cited in the text: some relate directly to Rowlandson and some are contemporaries who referred to the social context and to Rowlandson's immediate environment.

'A Commoner' *The Extraordinary Red Book containing a list of all Places, Pensions and Sinecures* (J. Johnston, 1819).

Adolphus, John *Memoirs of John Bannister* (Richard Bentley, 1839).

Angelo, Henry *The Reminiscences of Henry Angelo* (1904) reissued 1969 by Benjamin. Blom in New York. First published in 1830 as *The Reminiscences of Henry Angelo, with memoirs of his late father and friends, including original anecdotes and curious traits of the most celebrated characters that have flourished in the last eighty years.* (Henry Colburn and Richard Bentley, 1830).

Annual Register 1821, Anon. 'New Style of Engraving Upon Copper' pp. 705-707.

Anon. 'Mr Rowlandson' obituary in *The Gentleman's Magazine*, June, 1827 pp. 564-5.

Anon. Review of Revd William Barrow's An Essay on Education (Rivingtons, 1802) In *Monthly Review* Vol. XLI (R. Griffiths, 1803).

Austen, Jane *Letters* (Ed. R. W. Chapman ((OUP, 1932)).

Austen, Jane *Northanger Abbey,* first published 1803, (Signet, 1965).

Austen, Jane *Selected Letters* (Penguin, 2007).

Boswell, James *London Journal* (Ed. Frederick A. Pottle) (Penguin, 1966)

Cleland, John *Memoirs of a Woman of Pleasure* (G. Fenton, 1749).

De Quincey, Thomas 'On Murder Considered as One of the Fine Arts' (1821) in *Confessions of an English Opium Eater* (Cassell, 1908).

French, Yvonne and Squire, Sir John *News from the Past 1805–1887. The autobiography of the nineteenth century* (Gollancz, 1950).

Goldsmith, Oliver *The Vicar of Wakefield* (1766) Willoughby edition (1845).

Hazlitt, William *Selected Essays* (Ed. Geoffrey Keynes) (Nonsuch press, 1948).

Hazlitt, William *Selected Writings* (Ed. Jon Cook) (OUP, 2009).

Johnson, Samuel *The Complete English Poems* (Ed. J. D. Fleeman) (Penguin, 1971).

Mackenzie, Henry *The Man of Feeling* (1771) (Edited Stephen Bending and Stephen Bygrave, Penguin, 2001)

Robinson, Henry Crabb *Diary, Reminiscences and Correspondence of Henry Crabb Robinson* (Ed. T. Sadler 3 Vols (Macmillan, 1869).

Romilly, Samuel *Memoirs of the Life of Sir Samuel Romilly, with a selection From his correspondence* (1840) Irish University Press edition (1971).

Sheridan *The School for Scandal* (OUP, 1998).

Smith, John Thomas *A Book for a Rainy Day* (Richard Bentley, 1845).

Southey, Robert *Letters from England* (1807) Alan Sutton edition (1984).

Tegg, Thomas *Memoir of the Late Thomas Tegg abridged from his autobiography by his son, William* (Collingridge Press, 1870).

The Times, Combe Obituary 20 June, 1823.

Walpole, Horace *Memoirs of King George III* (Colburn, 1847).

Walpole, Horace *Some Anecdotes of Painting in England* (Ayer Publishing, 1937).

Wigstead, Henry *Remarks on a Tour into North and South Wales in the Year 1797* (W. Wigstead, 1800).

Wilson, Harriette *The Interesting Memoirs and Amorous Adventures of Harriette Wilson* (Chubb, Blacketer and Reed, 1825).

Locations and Topography

Rowlandson's frequent changes of address, up until he settled at James Street (now John Street, behind the Charing Cross Hotel), mean that contemporary maps are useful in locating exactly where he was and what the neighbourhood was like at the time.

A Street map of London in 1843 (Old House Books, 2007). This was drawn and engraved by B. R. Davies of Euston Square. Originally printed by Chapman and Hall in 1843.

Online there are other maps: in 1786 there was John Carey's Actual Survey of the County fifteen Miles around London. Between 1972 and 1799 Richard Horwood produced his Plan of London and Westminster, and in 1801 there was John Fairburn's Plan of Westminster and London.

For a topographical survey we also have Leigh's New Picture of London (Samuel Leigh, The Strand, 1819)

Following Rowlandson's movements is one of the key approaches to trying to dredge information from the path of his life, strewn with minor clues, but no more.

Related Books

Ackroyd, Peter *Blake* (Vintage, 1999)

Ackroyd, Peter *London: The Biography* (Vintage, 2001)

Altick, Richard D. *The English Common Reader: a social history of the mass reading public 1800-1900* (University of Chicago Press, 1957).

Alexander, David *Richard Newton and English Caricature in the 1790s* (Manchester University Press, 1998).

Andrews, Malcolm *'The Search for the Picturesque' in Language, Aesthetics and Tourism In Britain 1760-1800* (Stanford University Press, 1989)

Anon. *Catchpenny Prints: 163 popular Engravings from the Eighteenth Century*

Ashton, John *Chapbooks of the Eighteenth Century* (1882) Skoob Books edition (1976).

Baer, Marc *Theatre and Disorder in Late Georgian London* (OUP, 1992).

Barbier, Carl Paul *Samuel Rogers and William Gilpin: their friendship and correspondence* (Glagow/ Oxford University Press, 1959).

Barr, John *Britain Portrayed: A Regency Album 1780-1830* (British Library, 1989).

Barrell, John *The Birth of Pandora and the Division of Knowledge* (Macmillan, 1992).

Barrell, John *The Dark Side of Landscape: the rural poor in English painting 1730-1840* (Cambridge University Press, 1980).

Baur, Eva-Gesine *Rococo* (Taschen, 2002).

Bindman, David *William Blake: His Art and Times* (Constable, 1982).

Boine, Albert *A Social History of Modern Art: Art in the Age of Revolution*, (Chicago University Press, 1993).

Brander, Michael *The Georgian Gentleman* (Saxon House, 1973).

Briggs,Milton and Jordan, Percy *Economic History of England* (University Tutorial Press, 1967).

Burford, E. J. and Wotton, Joy *Private Vices-Public Virtues: Bawdy in London From Elizabethan Times to Regency* (Robert Hale, 1995).

Burke, Thomas *English Inns* (Collins, 1944).

Chilvers, Ian *The Oxford Dictionary of Art and Artists* (Oxford, 2009 ed.).

Clayton, Tim *Caricatures of the Peoples of the British Isles* (British Museum Press, 2007).

Clee, Nicholas *Eclipse* (Transworld, 2009).

Christiansen, Rupert *Romantic Affinities: Portraits from an Age 1780-1830* (Bodley Head, 1988).

Colley, Linda *Forging the Nation 1707-1837* (Yale University Press, 1992).

Dickens, Charles *Reprinted Pieces* (Chapman and Hall, 1907).

Dyer, G. *British Satire and the Politics of Style 1789-1832* (Cambridge, 1997).

Eaves, Morris *The Cambridge Companion to William Blake* (Cambridge, 2003).

Flanders, Judith *Consuming Passions* (Harper Collins, 2007).

Ford, Boris (Ed.) *The Cambridge Cultural History of Britain Vol. 5 Eighteenth Century Britain* (Cambridge University Press, 1992).

Foreman, Amanda *Georgiana, Duchess of Devonshire* (Harper, 1999).

Fuller, Jean Overton *Shelley: A Biography* (Cape, 1968).

Garner, Lawrence *The Georgian and Regency Legacy 1730-1840* (Swan Hill, 1990).

Gatrell, Vic *City of Laughter: sex and satire in eighteen century London* (Atlantic Books, 2006).

George, M. D. *English Political Caricature: A Study of Opinion and Propaganda* (Oxford, 1959)

George, M. D. *Hogarth to Cruikshank: Social Change in Graphic Satire* (revised edition, Viking, 1987).

Gillett, Paula *The Victorian Painter's World* (Alan Sutton, 1990).

Glinert, Ed *East End Chronicles* (Penguin, 2005).

Glinert, Ed *The London Compendium* (Penguin, 2003).

Govier, Louise *British Painting 1700-1850* (Yale University Press, 2006).

Godfrey, Richard T. *Printmaking in Britain* (Phaidon, 1928).

Gregory, Jeremy and Stevenson, *John The Routledge Companion to Britain in the Eighteenth Century* (Routledge, 2007).

Hallett, Mark *Hogarth* (Phaidon, 2000).

Heath, John *The Heath Family of Engravers* (Scolar Press, 1999).

Hibbert, Christopher *George IV Prince of Wales* (Longman, 1972).

Hill, Rosemary *God's Architect: Pugin and the building of romantic Britain* (Penguin, 2007).

Hinks, John, and Armstrong, *Catherine Printing Places: locations of book production and distribution since 1500* (The Oak Knoll Press, 2005).

Hudson, Roger *Hudson's English History: a compendium* (Weidenfeld and Nicolson, 2005).

Hughes, Christine *The Writer's Guide to Everyday Life in Regency and Victorian England 1811-1901* (Writer's Digest Books, 1998).

Hughes, Robert *Nothing if Not Critical: Selected Essays on Art and Artists* (Collins, 1990)

Hunt, T. L. *Defining John Bull: Political caricature and National Identity in Late Georgian England* (Ashgate, 2003).

James, Louis *Print and the People 1819-1851* (Penguin, 1976).

Jefferson, D. W. *Eighteenth Century Prose 1700-1780* (Penguin, 1956).

Johnston, Kenneth R. *The Satiric Eye: forms of satire in the Romantic period* (Palgrave, 2003)

Jones, Stephen *The Cambridge Introduction to the History of Art: Eighteenth Century* (Cambridge University Press, 1985)

Keegan, Paul *The Penguin Book of English Verse* (Penguin, 2009).

Keverne, Richard *Tales of Old Inns* (Collins, 1949).

King, Francis *The Studio and the Artist* (David and Charles, 1974).

Klingender, Francis D. *Art and the Industrial Revolution* (Granada, 1973).

Klingender, Francis D. *Hogarth and English Caricature* (Transatlantic Arts, 1944).

Lamb, Charles *The Essays of Elia (1820-1823)* (Routledge, 1910).

Laneyrie-Dagen, Nadeije *How To Read Paintings* (Chambers, 2004).

Lester, Valerie Browne *Phiz: The Man who Drew Dickens* (Pimlico, 2006).

Low, Donald A. *A Portrait of Regency Britain* (Dent, 1977).

Low, Donald A. *The Regency Underworld* (Alan Sutton, 1982).

Lucie-Smith, Edward *Sexuality in Western Art* (Thames and Hudson, 1972).

McCreery, Cindy *The Satirical Gaze: Prints of Women in Late Eighteenth Century England* (Oxford, 2004).

McLynn, Frank *Crime and Punishment in Eighteenth Century England* (OUP, 1991).

Margetson, Stella *Regency London* (Praeger, 1971).

Mayor, A. Hyatt *Prints and People: a social history of printed pictures* (Metropolitan Museum of Art, New York, 1971)

Meslay, Olivier *J. M. W. Turner: the man who set painting on fire* (Thames and Hudson, 2008).

Morley, Edith J. *The Life and Times of Henry Crabb Robinson* (Dent, 1935).

Muller, J. E. *Rembrandt* (Thames and Hudson, 1968).

Murray, Venetia *High Society: a social history of the Regency period 1788-1820*

Myers, Sylvia H. *The Bluestocking Circle: women, friendship and the life of the mind in Eighteenth Century England* (OUP, 1990). (Viking, 1998).

Newton, Eric *European Painting and Sculpture* (Penguin, 1962).

Paley, Ruth and Fowler, Simon *Family Skeletons* (National Archives, 2005).

Parissien, Steven *Regency Style* (Phaidon Press, 1992).

Paulson, R. *Rowlandson: A New Interpretation* (Littlehampton, 1972).

Peakman, Julie *Lascivious Bodies a sexual history of the eighteenth century* (Atlantic Books, 2004)

Pears, Iain *The Discovery of Painting: the growth of interest in the arts in England* (Paul Mellon Centre for Yale University Press, 1988).

Picard, Liza *Dr Johnson's London* (Phoenix Press, 2001).

Pierce, Helena *Unseemly Pictures: Graphic satire and Politics in Early Modern England* (Yale, 2009)

Pocklington, G. R. and Foat, F. E. K. *The Story of W H Smith and Son* (London, Printed for private circulation, 1949).

Porter, Roy *London, A Social History* (Hamish Hamilton, 1994).

Porter, Roy and Roberts, Marie Mulvey *Pleasure in the Eighteenth Century* (Macmillan, 1996).

Price, Frederick G. *Handbook of London Bankers* (1870) Reprinted by Burt Franklin, (New York, 1970).

Raine, Kathleen *Blake* (Thames and Hudson, 1998).

Reynolds, Graham *English Portrait Miniatures* (Adam and Charles Black, 1952).

Richardson, Ralph *George Morland, Painter* (Elliot Stock, 1895).

Rickword, Edgell (ed.) *Radical Squibs and Loyal Ripostes: Satirical Pamphlets Of the Regency period 1819-1821* (Adams and Dart, 1971).

Robinson, Alan *Imagining London 1770-1900* (Palgrave, 2004).

Rosenblum, Robert *Transformations in Late Eighteenth Century Art* (Princeton, 1967).

Russell, Ronald *Guide to British Topographical Prints* (David and Charles, 1979).

Schama, Simon *The Power of Art* (Bodley Head, 2009).

Scaiman, Malcolm *The Print Collectors Handbook* (G. Bell, 1912).

Schwartz, L. D. *London in the Age of Industrialisation: Entrepreneurs, Labour Force And Living Conditions 1700-1850* (Cambridge University Press, 1992).

Stott, Andrew McConnell *The Pantomime Life of Joseph Grimaldi* (Canongate, 2009).

Straus, Ralph *The Unspeakable Curll* (Chapman and Hall, 1927).

Tannahill, Reay *Regency England: the great age of the colour print* (Folio Society, 1964).

Taylor, Brandon *Art for the Nation: Exhibitions and the London Public 1747-2001* (Manchester University Press, 2006).

Thomas, C. *Life and Death in London's East End: 200 years at Spitalfields* (Museum of London, 2004).

Thomas, Donald *Freedom's Frontier: Censorship in Modern Britain* (John Murray, 2007).

Thomson, A. T. and Wharton, Philip *The Queens of Society* (Harper Brothers, 1860).

Turberville, A. S. *English Men and Manners in the Eighteenth Century* (Oxford, 1960)

Turner, Jane *The Dictionary of Art (6 volumes)* (Grove, 1996).

Turner, W. J. *Aspects of British Art* (Collins, 1947).

Uglow, Jenny *William Hogarth: A Life and a World* (Faber and Faber, 1998).

Vaughan, William *British Painting: The Golden Age* (Thames and Hudson, 1999).

Wark, R. R. *Drawings by Thomas Rowlandson in the Huntington Collection* (University of California Press 1975).

Wark, R. R. *Early British Drawings in the Huntington Collection 1600-1750* (Huntington Collection Press, 1969).

Wharton, Grace and Philip *The Wits and Beaux of Society* (James Hogg, 1890).

White, R. J. *The Age of George III* (History Book Club, 1968).

White, T. H. *The Age of Scandal* (OUP, 1987).

Whiteman, Bruce *The Age of Caricature: Satirical prints in the Reign of George III* (Yale University Press, 1999).

Whitley, William T. *Thomas Gainsborough* (Smith Elder, 1915).

Wilson, Mona *The Life of William Blake* (Hart Davis, 1948).

Wu, Duncan (Ed.) *Romanticism: An Anthology* (Blackwell, 2006).

Articles in Journals and Newspapers/ Chapters in Books

Anon. 'Early caricature Drawings' *The Times* 4 Aug. 1956 p. 9.

Anon. 'The Art of Thomas Rowlandson' *The Times* 10 Oct. 1950 p. 8.

Anon. 'Rowlandson the Caricaturist' *The Times* 11 Aug. 1882.

Attar, Rob 'The Horrors of a London Gaol' *BBC History Magazine* January 2010 p. 17.

Barnes, James, and Barnes, Patience P. 'Reassessing the reputation of Thomas Tegg, London Publisher, 1776-1846' *Book History* Vol.3 2000 pp. 45-60.

Barrell, John 'The Private Comedy of Thomas Rowlandson' *Art History* Vol.6 (4) 1983.

Barrell, Tony 'Rude Britannia: Erotic Secrets of the British Museum' *The Times* 30 August 2009 (online also at ww.entertainment.timesonlin.co.uk/tol/arts_and_ anetertainemtn/visual_arts).

Baum, Richard M. 'A Rowlandson Chronology' *Art Bulletin* (1938).

Beck, Peter J. 'Pages of History: Daumier's Political Eye' *History Today* Feb. 2008 pp. 34-35.

Boden, Helen 'Review essay: Clare, gender and Art' in Goodridge, John (Ed.) *The Independent Spirit* (John Clare Society, 1994).

Borman, Tracy, 'The Girls Who Had It' *BBC History Magazine* Vol. 6 no. 12 December 2005 pp. 50-53.

Bryant, Mark 'Boy Wonder of the Golden Age' *History Today* May, 2009. pp. 70-71.

Byron, Glennis 'Landon, Letitia Elizabth' *Oxford Dictionary of National Biography* (Sept. 2004)

Carpenter, John 'Weaving Across the Waters' *Ancestors Magazine* 1 July 2008 pp. 48-51

Carretta, Vincent 'Combe, William' *Oxford Dictionary of National Biography* (OUP, 2004)

Chancellor, E. Beresford 'Some Scarce London Books' *The Connoisseur* Vol. LXIV No. 253, September 1922 pp. 18-25.

Cohen, Ruth 'Howitt, Samuel' *Oxford Dictionary of National Biography* (OUP, 2004).

Cole, R. 'William Combe and his Works' *Gentleman's Magazine* 1852 pp. 467-472.

Fordham, Douglas 'New Directions' in *British Art History of the Eighteenth Century Literature Compass* 5/5 (2008) pp. 906-917.

Gage, John 'An Early Exhibition and the Politics of British Printmaking 1800-1812' *Print Quarterly* Vol. VI No. 2 June, 1989 pp. 123-138.

Gibb, Frances 'Rowlandson Etchings sets faked' *The Times*, 28 March 1978 p. 12

Gilbey, J. 'Samuel Howitt, Sporting Artist' *Apollo 63* (1956) pp. 25-26.

Grundy, C Reginald 'Wright of Derby' *The Connoisseur* Vol. LXXXVII No. 353, January 1931, pp. 13-19.

Hodge, Warren '18th-Century Bad Boy Who Fathered English Art' *New York Times* 14 June 1997.

Keates, Jonathan 'A Cruel Sort' review in *Times Literary Supplement* 2 May 2008 p.11.

Keates, Jonathan 'Haydn's Visits to London' Review of Christopher Hogwood's Book of that title *Times Literary Supplement* 12 Feb. 2009 p. 18.

Low, David 'British cartoonists' in *Turner* (1947).

Nevill, Ralph 'Thomas Rowlandson' *The Connoisseur* Vol. II no. 5 Jan. 1902. pp. 42-46.

Nokes, David 'Peter Pindar: Laughing at the King' 11 Dec 2009 p. 28.

Riely, John 'New Light on Rowlandson's Biography' *Burlington Magazine* Vol. 121 No. 918 (Sept. 1979) pp. 582-586.

Robson, Martin 'A Ministry of all the Talents – a Cautionary Tale' *BBC History Magazine* January 2006 pp. 38-39.

Sherry, James 'Distance and Humor: the Art of Thomas Rowlandson' *Eighteenth Century Studies* Vol. 11 no.4 summer, 1978 pp. 457-472.

Smith, Joan 'Blues Sisters' *New Statesman* 13 March 2008.

Sutherland, Kathryn 'At the Dawn of Interior Décor' review of a Thomas Hope Exhibition, Victoria and Albert Museum, *Times Literary Supplement*. 2 May 2008 p. 12.

Thomas, David, 'The Real Little Dorrit' *Ancestors magazine* No. 80, March, 2009 pp.36-41.

Tillyard, Stella 'Double Fronts' *Times Literary Supplement* 11 Dec. 2009 pp.8-10.

Vickery, Amanda 'How we kept the Burglars and Witches at Bay' *BBC History Magazine* Jan. 2007 pp. 45-48.

Wardroper, John 'Daumier, Gargantua and the "Citizen King"' *Cartoon Museum News* no. 46, May 2008.

Whiteman, Bruce 'The Age of Caricature' Review in *Eighteenth Century Studies* Vol. 33, Number 1 autumn, 1999

Zink, Zinovy 'Freelance' *Times Literary Supplement* 12 Feb. 2010 p. 16.

Catalogues and Special Publications and Collections

Bliss was it in that dawn to be Alive: British watercolours and drawings 1750-1850 Ed. David Wootton et alia (Chris Beetles Galleries, 2007)

Bloomsbury Auctions: Oil Painting, Watercolours, Drawings and prints 25 Oct. 2007 (Bloomsbury Auctions, 2007)

British Museum Catalogue of Political and Personal Satires Vols. V–XI London: British Museum – Cupboard 205. See Barrell, Tony, 'Rude Britannia: Erotic Secrets of the British Museum in *The Sunday Times* 30 Aug. 2009.

Cartoon Museum News www.cartoonmuseum.org

O'Donoghue F. and Hake, H. M. Catalogue of Engraved British Portraits Preserved in the Department of Prints and Drawings in the British Museum (British Museum, 6 vols. 1908-1925).

Seventeenth and Eighteenth Century English Drawings in the Ashmolean Museum (Ashmolean Museum, Oxford, 1974).

Sharp, Richard, Portrait Prints from the Hope Collection (Ashmolean Museum, 1997).

Redgrave, Samuel Watercolour Paintings in the South Kensington Museum (Chapman and Hall, 1877).

Journals and Periodicals Cited

Art Bulletin
Art History
Burlington Magazine
Connoisseur
Eighteenth Century Studies
London Gazette
Monthly Review
Morning Post
Print Quarterly
The Times

Web Sites

(a) Rowlandson: sites with sections devoted to biography or collections
www.artcyclopaedia.com/artists/rowlandson_thomas.html
http://www.nndb.com/people/171/000095883 (biographical summary)
http://www.llgc.org.uk/index

(b) General related reference
www.artandpopularculture.com/image: Cardinal_Armand_de_Rohan-Soubise.gif
http://query.nytimes.com/gst/fullpage.html
http://www.british-history.ac.uk/report.aspx?compid=41034&strquery=Thomas Rowlandson (British History Online with details of Rowlandson's place of abode and of the Soho Academy.
www.britishmuseum.org/research

hal.ucer.edu/reg.html The regency Page site: all aspects of the period
www.nga.gov/collection/gallery/french
http:/historicalresources.suite101.com/article
www.icons.org.uk (on Spitalfields silk weaving.)
http://www3.interscience.wiley.com/journal
www.jasa.net.au/london/clubs.htm
www.oldlondonmaps.com
www.19princeletstreet.org.uk (an unrestored Huguenot silk weaver's home)
www.rakehell.com/article.php?id Henry Angelo's Fencing School. This is part of a
 useful resource called The Georgian Index. (www.georgianindex.net)
www.theluttrells.com/Simon_lord_Carhampton.html
http:www.umich.edu/~ece/student_projects/comicart/ 'Origins of Comic Art.'
www.walterscott.oib.ed.ac.uk/portraits/engravers/lizars
http://www.wga.hu/tours/english/18_cent.html (British art in the eighteenth century)

Sites related to Rowlandson Themes

http://classic-comics.suite101.com/article.cfm/dr_syntax_and_the_birth_of_the_
 cartoon
www.handprint.com/HP/WCL/artist54
www.ilab.org/eng/documentation/33_dance_of_the_death.html

Collections and Exhibitions Material

Chris Beetles Gallery: Rowlandson and his Time (2009) See www. Chrisbeetles.co,/
 exhibitions.html
Huntington Collection – prints and drawings. See www.huntington.org/
Lewis Walpole Collection
Woodward Collection of Prints and Drawings. Derbyshire Record Office. Ref.D5459
 (George Woodward (1765-1809) artist and writer, Derbyshire and London.)
His writings are at ref. D6052, also with his sketches York Art Gallery:
 www.yorkmuseumtrust.org.uk

Organisations

The Cartoon Museum and the Heneage Library
35, Little Russell Street
London WC1A 2HH
The Heneage Library has 4,000 books on cartoon and caricature history.
Also linked to the Cartoon Art Trust,
7, Brunswick Centre,
London WC1N 1 AF

Notes

1 Falk p. 12

2 Ralph Nevill, 'Thomas Rowlandson' The Connoisseur Jan. 1902

3 Jack Malvern, 'Obscene Gillray cartoons released after 170 year' The Times 10 Dec. 2009

4 Warren Hodge, '18th-Century Bad Boy Who Fathered English Art' New York Times 22Oct., 2008

5 Donald A. Low, The Regency Underworld p. xvi-xvii

6 Mark Bryant, 'Boy Wonder of the Golden Age' History Today May, 2009 pp 70-71

7 Charles Lamb, Essays of Elia p. 200

8 Morning Chronicle 30 April 1807

9 Obituary of Mr Rowlandson, Gentleman's Magazine June, 1827 p. 564

10 Nevill see ref. 2 p. 43

11 NNDB at www.nndb.com/people

12 Richard Godfrey Printmaking in Britain p. 76

13 Hayes p. 12

14 Note to an exhibition from G. J. Saville Collectables 2007

15 William Vaughan, British Painting: The Golden Age p. 147

16 David Rogers, entry for Rowlandson in Dictionary of Art Vol. 22 p. 277

17 Joseph Grego, Rowlandson the Caricaturist p. 46

18 Falk p. 32

19 1827 Obituary p. 564

20 Paley and Fowler, Family Skeletons p. 78 .There could also be horrendous abuse of power in debtors' prisons. In 1812, the MP a reformer, Samuel Romilly, noted, 'This day I presented to the House of Commons a petition from Thomas Houlden, who was lately a prisoner for debt in Lincoln Castle, complaining of his having been Confined by Dr Illingworth, a magistrate, eleven days and nights in solitary imprisonment in one Of the cells appropriated to convicts condemned to die...' Rimilly, Memoirs and Correspondence p.40

21 Hansard 9 May, 1815 Insolvent Debtors Bill

22 1827 obituary p. 564

23 Falk p. 41

24 1827 obituary p. 564

25 Falk p. 43

26 Anon. review in Monthly Review Vol. XLI 1803 p. 344

27 Ibid. p. 345

28 Ackroyd, Blake p. 27

29 Peter Ackroyd, *Blake* p. 73

30 Peter Walch, 'Mortimer' in *The Dictionary of Art* p. 152

31 Ibid. p. 153

32 David Bindman, 'Blake as a Painter' in *William Blake* (Ed. Morris Eaves) p. 91

33 Falk p. 45

34 Hayes p. 62 quotes this, from Henry Angelo's *Reminiscences* Vol. 2 pp. 324-6. Hayes adds that 'Rowlandson was already sufficiently well known to be recognised by his assailant, the paper Reporting that 'the fellow appeared to have some presentiment of this artist's forte, for he Desired him to deliver his watch and money without making any *wry faces*!'

35 Jean Overton Fuller, *Shelley: A Biography* p. 66

36 See John Kiely, 'New Light on Rowlandson's Biography' *Burlington Magazine* Vol. 121 no. 918

37 Ibid. p. 587

38 Grego, Joseph *Rowlandson the Caricaturist* (1880) p. 50

39 1827 obituary p. 564

40 William Hazlitt, *Selected Works* p.156

41 Brewer, E Cobham *Dictionary of Phrase and Fable* 1898 entry for 'Bannister.'

42 See Andrew McConell Stott, *The Pantomime Life of Joseph Grimaldi* p. 128

43 Quoted in British History Online: Russell and Bedford Squares see www.british-history.ac.uk

44 Henry Angelo *Reminiscences* Vol. II p. 66

45 Ibid. p. 95

46 1827 obituary p. 565

47 Henry Angelo *Reminiscences* Vol. II p. 220

48 Robert Southey, *Letters from England* p. 207

49 Wigstead, *Remarks on a Tour into North and South Wales in the Year 1797* p.38

50 Ibid. p.6

51 Hunter Davies, *William Wordsworth* (Sutton, 1997) p. 115

52 Quoted in Malcolm Andrews, *The Search for the Picturesque* p. 39

53 Ibid. p. 44

54 See www.sites.scran.ac.uk/ada/documents/general/sublime p.1

55 Wigstead *Remarks* p. 12

56 Ibid. p.15

57 Falk p. 118

58 Ibid. quoted on p. 118

59 Quoted in Mona Wilson, *The Life of William Blake* (Hart-Davis, 1948) p. 78

60 Robert Southey, *Letters from England* p. 408

61 Henry Mackenzie, *The Man of Feeling* p.37

62 Falk p. 121

63 Richard Keverne, *Tales of Old Inns* (Collins, 1949) p. 81

64 Falk p. 122

65 Ibid. p.127

66 See Ronald Russell, *Guide to British Topographical Prints* p. 606

67 William Whitley, *Thomas Gainsborough* p. 116

68 Nicholas Clee, *Eclipse* p. 226

69 Ibid. p. 227

70 Grego, Joseph *Rowlandson the Caricaturist* p.60

71 Gatrell, *City of Laughter* p. 45

72 Ackroyd *Blake* p. 91

73 See Peter Ackroyd *London, The Biography* p. 103-4

74 Donald A. Low *The Regency Underworld* p. ix

75 Samuel Johnson *The Complete English Poems* p.61

76 Quoted by Jonathan Keates: 'A cruel sort' in *Times Literary Supplement* May 2, 2008 p. 11

77 Kathryn Sutherland 'At the Dawn of Interior Décor' *Times Literary Supplement* May 2 2008 p.12

78 Iain Pears *The Discovery of Painting* p. 192

79 Ibid. p. 193

80 See 'The Heath Family of Engravers' web site discussion at www.jjhc.info/heathengravers.htm

81 Eric Newton *European Painting and Sculpture* p. 208

82 Annual Register 1821 'Arts and manufactures' p. 705

83 *Gentleman's Magazine* Jan. 1806 p.72

84 Francis Klingender *Art and the Industrial Revolution* p. 130

85 Ibid. p.130

86 Ibid. p. 131

87 Falk p. 151

88 Ibid. p. 152

89 Rosemary Hill *God's Architect* p. 34

90 Ibid. p.37

91 Quoted in Falk p.152

92 Brewer's *Dictionary of Phrase and Fable* (Wordsworth Edition, 2001) p.99

93 Quoted in Rob Attar 'The Horrors of a London Gaol' *BBC History* January, 2010 p. 17

94 Quoted in ODNB article by Vincent Carretta p. 2

95 Donald A. Low *A Portrait of Regency Britain* p. 7

96 Quoted in the text of The Luttrells.com

97 H. C. Robinson *Memoirs* pp. 291-2

98 Hamilton *Dr Syntax* p. 241

99 Graham Reynolds *English Miniature Portraits* (A and C Black, 1952) p. 147

100 H. C. Robinson (see note 75 above) p. 293

101 Henry Angelo *Reminiscences* Vol. II p 222.

102 Hamilton (above, note 76) p. 242

103 See John Riely 'New Light on Rowlandson's Biography' *Burlington Magazine* Vol.121 No. 918 Sept. 1979 p.587

104 Ibid. p. 587

105 Clear, Gwen *The Story of W H Smith & Son* p. 4

106 Venetia Murray *High Society* p. 163

107 Quoted in Michael Brander *The Georgian Gentleman* p. 184

108 Falk p. 95

109 See Hamilton (above, note 76. p. 317. Hamilton provides a very full account of all Combe's publications In the addenda to his biography.

110 Ibid. p. 143

111 Ian Maxted, 'Production and Publication of Topographical Prints in Devon *c.* 1790-1870' in *Printing Places* (Ed. Hinks and Armstrong) p. 102

112 Carl Paul Barbier, *Samuel Rogers and William Gilpin* p. 5

113 Ibid. p.20

114 Richard Brinsley Sheridan *The School for Scandal* pp. 233-234

115 Hamilton p. 244

116 Jane Austen, *Northanger Abbey* p. 94

117 Ibid. p. 146

118 Quoted ibid. p. 255

119 'Dr Syntax and the Birth of the Cartoon Star' http://classic-comics.suite 101.com/article

120 Quoted and discussed in Hamilton p. 274

121 Falk p. 158

122 Judith Flanders *Consuming Passions* p. 391

123 Falk p. 130

124 Quoted in William G. Smith *AI* p. 29

125 Case of John Ryal: Old Bailey sessions papers 16 Feb. 1791 oldbaileyonline p.2

126 Ibid p. 3

127 Gatrell *City of Laughter* p. 390

128 Peter Ackroyd *Blake* p. 76. There, he also informs the reader that at a contemporary exhibition of Waxworks 'was a penis, injected to the state of erection'

129 Ibid. p. 389

130 Falk p. 137

131 Gatrell p. 395

132 Thomas de Quincey *The Opium Eater and Other Writings* p. 217

133 D. H. Lawrence 'Pornography and Obscenity' in A Selection from Phoenix p. 312

134 Tony Barrell, Rude Britannia: Erotic Secrets of the British Museum *The Times* 30 August 2009

135 David Low in *Aspects of British Art* p. 217

136 Ian Chilvers *Oxford Dictionary of Art and Artists* p. 110

137 Boris Ford (Ed.) *The Cambridge Cultural History of Britain* p. 116

138 MOC discussed also in Gatrell p. 47

139 See Michael T. Davies, review of a Richard Newton exhibition at www.questia.com/ google/Scholar

140 Samuel Redgrave *Watercolour Paintings in the South Kensington Museum* p. 185

141 Joseph Grego, *Rowlandson the Caricaturist* p.9

142 Advertisement in *The Times* for Aug 5 1790

143 *The Times* 2 Sept. 1802 p.2

144 *The Times* 30 July 1800 p. 3

145 Zinovy Zinik, 'Freelannce' *Times Literary Supplement* 12 Feb., 2010 p.16

146 *London Chronicle* October 21 1809

147 Donald A. Low *The Regency Underworld* p. 188 (quoted from his source)

148 A. T. Thomson and Philip Wharton *The Queens of Society* p. 152

149 See Helen Boden in *The Independent Spirit* (John Goodridge) p. 201 for more on this.

150 Joan Smith 'Blue Sisters' *New Statesman* 13 March, 2008 p 1

151 See Hayes p. 12

152 See anon. 'Thomas Rowlandson: Watercolour Artist' www. Handprint.com/HP/WCL/ artist54.html

153 John Hayes has a very good summary of these anecdotes. See p. 23

154 Falk p. 169

155 Grego, Joseph *Thomas Rowlandson, Caricaturist* p. 58

156 Kathleen Raine *William Blake* p.102

157 Advertisement to *The English Dance of Death* (Methuen, 1903) p.vi

158 Ibid. p. vii

159 John Ashton *Chapbooks of the Eighteenth Century* p. 460

160 Samuel Johnson *The Vanity of Human Wishes* ll. 251-254

161 Thomas Gray 'Elegy Written in a Country Churchyard' Penguin *Book of English Verse* p. 485

162 EDD p. 6

163 Ibid. p.192

164 Ibid. p. 46

165 Ibid. p. 30

166 *The Times* Nov. 13 1806 p.1

167 Falk p.181

168 Ibid. p. 29

169 Falk p. 178

170 Ibid quoted from Richardson p. 178

171 See John Ashton *Chapbooks of the Eighteenth Century* p. ix

172 Wordsworth 'Composed on Westminster Bridge' in Penguin *Book of English Verse* p. 590

173 'Watercolours' *The Times* 7 April, 1936 p.14

174 'The Art of Thomas Rowlandson' *The Times* 10 Oct. 1950 p.8

175 See 'Junkshop Rowlandson find makes £11,000' in *The Times* 13 July, 1967 p. 12 The painting was bought in the junkshop for £1.

176 William Hazlitt, 'On The Pleasure of Painting' in *Selected Essays* p. 614

177 William Hazlitt 'Whether Arts are promoted by Academies' in *Selected Works* p.263

178 Paula Gillett *The Victorian Painter's World* p. 18

179 Ibid. p. 19

180 Anon. 'Drawings by Rowlandson' *The Times* July 1950

181 Horace Walpole *Anecdotes of Painting in England* p. 287

182 Peter Ackroyd *Blake* p. 32

183 Hamilton *Dr Syntax* p. 262

184 David Rogers, entry on Rowlandson in *Dictionary of Art* Vol 22 p. 277

185 John Barrell *The Dark Side of Landscape* pp. 119-120

186 Charles Dickens *Great Expectations* p. 189

187 Eva Gesine Baur *Rococo* p. 9

188 John Barrell, *The Birth of Pandora* p. 4

189 Ibid. p.6

190 Ibid. p.20

191 See Jonathan Keates' discussion of this visit in *Times Literary Supplement* 12 Feb. 2009 p. 18

192 David Low, 'British Cartoonists, Caricaturists and Comic Artists' in Aspects of British Art p. 220

193 John Ford, *Ackermann 1783-1983* p. 65

194 'Ackermann and the Age of Aquatint *The Times* 8 August, 1961

195 See Hamilton *Dr Syntax* p. 276

196 For a full discussion of this, and an account of Edmund Curll, see Paley and Fowler, *Family Skeletons* pp. 173-182

197 William G. Smith *Amorous Illustrations of Thomas Rowlandson* p. 11

198 Ibid. p. 11

199 Falk p. 34

200 Ibid. p.47